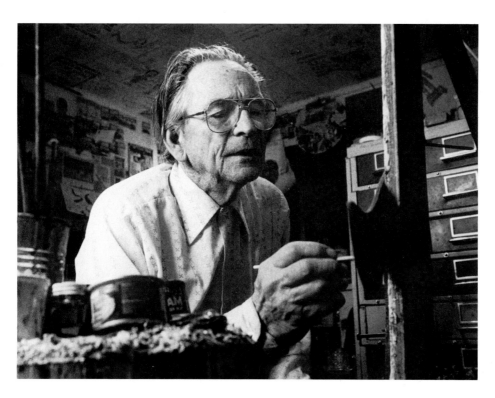

(Photo: © 1986 Marianne Barcellona)

# HOWARD FINSTER

## MAN · OF · VISIONS

ALFRED A. KNOPF / NEW YORK / 1989

# HOWARD FINSTER

## MAN · OF · VISIONS

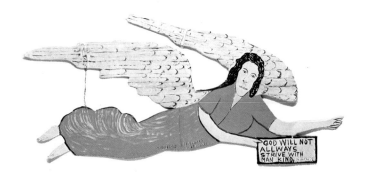

## J. F. TURNER

THIS IS A BORZOI BOOK

PUBLISHED BY ALFRED A. KNOPF, INC.

Library of Congress Cataloging-in-Publication Data

Finster, Howard
Howard Finster, man of visions / J. F. Turner. — 1st ed.
p.   cm.
Bibliography: p.
ISBN 0-394-57961-5. — ISBN 0-394-75851-X (pbk.)
1. Finster, Howard   2. Artists—United States—Biography.
3. Primitivism in art—United States.   I. Turner, J. F. (John F.)
II. Title.
N6537.F464A2   1989
709'.2'4—dc19
[B]                    CIP                    89-1876

MANUFACTURED IN HONG KONG
FIRST EDITION

*Title page illustration:*   ANGEL: enamel
on tin, 18 × 41", 1978, #1000 79. (Chuck
and Jan Rosenak. Photo: Robert Reck)

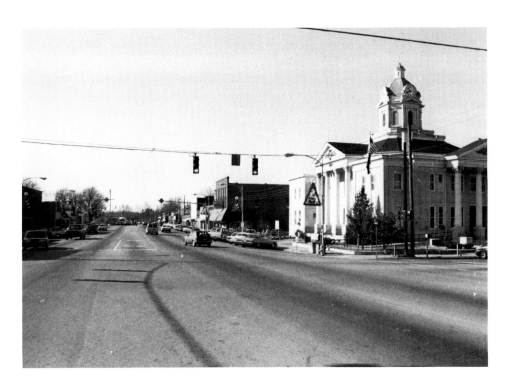

Main Street, Summerville, Georgia (Photo: Summerville *News*)

Howard Finster lives in Pennville (an unincorporated business and residential community) on the northern border of Summerville, Georgia, the county seat of Chattooga. It is in the northwestern corner of the state, due south of Chattanooga, Tennessee, and northwest of both Rome and Atlanta, Georgia.

"This is the mountain region. You're in the mountains of northwest Georgia, close to northeast Alabama and east Tennessee. We are mountain people, as opposed to what we call flatlanders, who are a different sort of folk altogether."

—Bobby Lee Cook, Sr.,
Summerville, Georgia

# CONTENTS

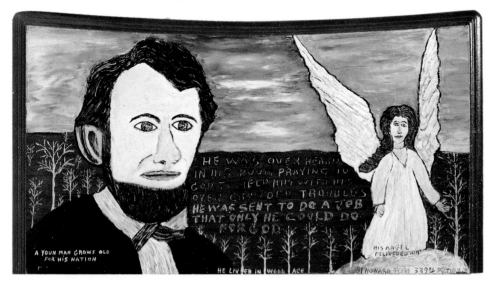

A YOUNG MAN GROWS OLD FOR HIS NATION: enamel on furniture veneer panel,
16¹/₂ × 30″, n.d., #339. (Robert Arneson and Sandra Shannonhouse. Photo: M. Lee Fatherree)

# ACKNOWLEDGMENTS

I would like to thank all the people who opened their hearts and homes to me, sharing their experiences with Howard. Like Finster's art work, the list could go on forever, yet I would especially like to mention those who helped with the painting of this portrait:

Meredith Tromble, John Ollman, Arnella Turner, Ann Oppenhimer, George Mattingly, Jose Tavel, Liza Kirwin, Jeff Camp, Susan Ralston, Andy Nasisse, Mike Vosse, Becky Kikumoto, Steven Jenkins, Beverly and Pauline Finster, and the residents of Summerville, Georgia.

And thanks to the man who said, "I think you got nearly all my life's story, except for that which I was either too young or too old to remember"—Howard Finster.

J. F. Turner

# A NOTE ON SOURCES

The sources used for this book include interviews with Howard Finster conducted over a period of thirteen years, as well as Howard's journals, poems, songs, notes, and "thought-cards." Other sources include his tapes, his self-published book, *Howard Finster's Vision of 1982*, his newspaper columns, and LP recordings of his sermons and stories. A vast assortment of newspaper and magazine articles and a number of show catalogues have appeared on Howard and his work. The most important of these are listed in the Bibliography. In addition, I viewed videotapes and films of Howard and interviewed family members, friends, and people who figured prominently in his career. Because of the volume of sources, it is impossible to acknowledge each by name.

Howard will tell his many stories to anyone within earshot who has five minutes or five hours. The stories, like sermons, are well rehearsed. As in the oral tradition of good storytelling, these stories have changed and evolved over years of countless retelling. In some cases I documented up to four variations of the same story, by listening to Howard on tape from 1975 through 1988, and by reading countless articles. For this book I took the earliest version of each story and combined it with whatever remained, consistently, throughout the other versions.

Because Howard only finished the sixth grade, his writing is unconventional. I corrected much of his work (done mostly on scrap paper), but left some errors in grammar, spelling, and usage, in the belief that many of his messages are more powerful with the "mestakes" intact.

I don't apologize for my mestakes on this work
for I got my education from my mestakes.
A miss printed coin is worth much more than a perfect coin.
Things from the press are throwed away
but my mestakes will live to the very end of the world.
Men are more liable to notice your mestakes
more than your good work.

— *William Howard Finster*

# HOWARD FINSTER

## MAN·OF·VISIONS

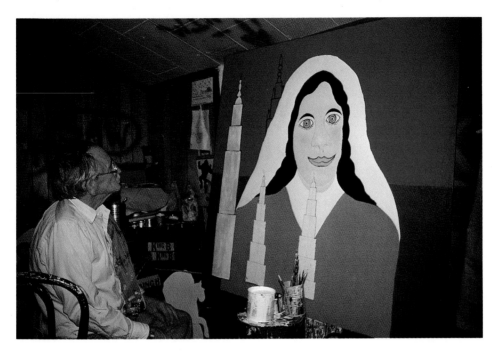

Howard and painting # 6000 908, *Vision of Mary's Angel*. (Photo: J. F. Turner)

A shattered mirror in a simple frame, reflecting a new universe, is what comes to mind when I try to describe the many personalities of Howard Finster, Man of Visions.

As a child of the Depression, he was resourceful and inventive when it came to the use and reuse of materials at hand. Peddling his handcrafted "family picture clocks" from the hood of his car, Howard was the consummate business-man, shrewd but honest. As a carpenter, plumber, and mechanic, he was a quick study on "how things work." When spinning tales of youthful escapades or picking a tune on his banjo for the neighbors on a warm Summerville, Georgia, eve, Howard is an engaging entertainer. As a father of five, he is a loving, understanding, and forgiving parent. However, it is when he preaches the word of God—something he has done since the age of sixteen—that Howard Finster joyfully affirms the reason for his existence. With passion fueled by faith and rock-solid conviction, he spreads the message to sinners and converted alike with the urgency of a second Noah, "the world's last red light."

One major struggle in leading people to the Lord's pathway has been Howard's constant search for a profession that could support his family and yet provide sufficient time to fulfill his mission. Fittingly, the solution to this problem eventually manifested itself in the form of divine inspiration. At the age of sixty,

as he was putting the finishing touches on a bicycle repair job, using his finger dipped in white paint to cover some minor scratches, he noticed what appeared to be a simple face on the tip of the paint-smeared finger. Simultaneously, he experienced a divine sense of serenity as his spirit heard a voice saying, "Paint sacred art."

Although totally inexperienced in "art," Howard trusted the voice, and taking a dollar bill from his wallet, he painted his first likeness, that of George Washington, one of his childhood heroes. The choice of subject was an auspicious one, leading both to the start of a new career and to a new level of personal prosperity.

Gaining confidence in his new profession through sales of his work, Howard decided in 1976 to devote himself full-time to being an artist, believing that his true mission in life had just begun—rendering "sermons in paint" that would be seen and read throughout the world. "Nothing I ever tried or wrote amounted to anything until I discovered art," said Howard. "Then the woodcraft, poetry, and painting all came together. It was like taking schooling on all three of them for no profit separately and then having them all come together and join together in my art. This is my last trade out of twenty-one trades I can do."

As a practitioner of the "trade," Howard was one of America's representatives at the 1984 Venice Biennale. He has created and sold more than ten thousand works, and has made a significant contribution to the world of contemporary art. What follows is an account of the path, crossroads, and avenues of artistic evolution of an extraordinary individual: Howard Finster, Man of Visions.

---

He said the lights would be on and they were, illuminating a small clapboard house, its sides ornamented with portraits of people two times life-size. The studio was situated on the corner of a country block consisting of twelve houses, on ten of which Howard was paying. I could just make out the wedding-cake steeple of the World's Folk Art Church. The time was between very late at night and the first of morning, before the chickens and the ducks out back in Paradise Garden started stirring in

Noah's barnyard. The Georgia night's humidity watered the roses and sunflowers coloring the garden pathway that leads to the mirror house, the giant's foot, and the bicycle tower that always amazes visitors.

As I stood on the porch of the studio, I could hear the used-car salesman on the TV pitching the best deals in Summerville. The offer of a Chevy pickup loaded with everything led into something that sounded western, with sound-stage guns and Indian war whoops. As I looked through the screen door, I saw walls covered floor to ceiling with photographs of friends and family, clippings from *People* magazine, and the local newspaper proclaiming "Howard Finster Day"; letters that probably contained orders for paintings; and the album jacket from the Talking Heads record that the Reverend Finster had painted in just a day and a night's time.

At the back of the studio was the kitchen, cluttered with empty chili cans, a half-eaten Hostess cupcake, and four tubes of Pringle's potato chips. On the counter, untouched and covered with Saran Wrap, was a plateful of greens, fried chicken, and fresh corn from the garden that Pauline, Howard's wife, had brought over, hours earlier, from her house next door. The telephone on the chair hadn't been ringing since the night before, when Michael and Andy, his grandchildren, talked to their girlfriends and made their evening plans. A rag on the linoleum floor looked like one a housepainter used to clean his mistakes. It lay next to an opened can of Fixal white tractor enamel. A brush was dipping in and out of the can and transferring Fixal to the wings of an angel being painted by the sure hand of a seventy-one-year-old man with tousled gray hair. His work clothes were paint-spattered and stained by tobacco juice.

Howard was concentrating intensely and working very fast. I watched him in a loving way, not wanting to break his trance, yet excited about entering his world. "Howard, it's me, John." He turned. "John, what are you doing on the porch? Come on in. I'm working on Mary Magdalene's vision angel. She'll be looking out between a city. She will be gigantic, like a spirit. I don't know of anybody that's drawn Mary Magdalene's angel. I believe everybody has a guardian angel. It is my six thousand nine hundred and eighth work of art."

# CHAPTER 1

## Is Santa Claus Real?

*Howard Finster came from a close-knit farm family in a rural churchgoing community with an agricultural economy. Like most farm children, he had his share of daily chores. A lively-minded boy, Howard became adept at using whatever materials were at hand to make something out of nothing.*

My name, Howard, is a rare name. You don't find it in the Bible. I was born December 2nd in Valley Head, Alabama, about twelve miles north of Fort Payne. My Mother told me I was born in 1916, but maybe it was 1915. There was thirteen of us children. I was the last child home. My Dady [Samuel] was a lumberjack and owned a steampower sawmill. He cut timber and built our own colonial home. My Mother [Lulu] was a Christian but my father was a sinner. He would not even go to church, and when good people would come to our house from the church, Dady would dart out the back door and go to the woods. My Mother made our bed quilts and I only had flour-sack diapers when I was a baby. I remember just about everything since I was about a year old. The only thing I can't remember is when I first nursed. They didn't have bottles back in them days. Babies nursed their Mothers. I can remember when I was kinda being weaned off the breast but I can't remember when I started on the breast.

We had a forty-two-acre farm and Mother was our boss. My first job was

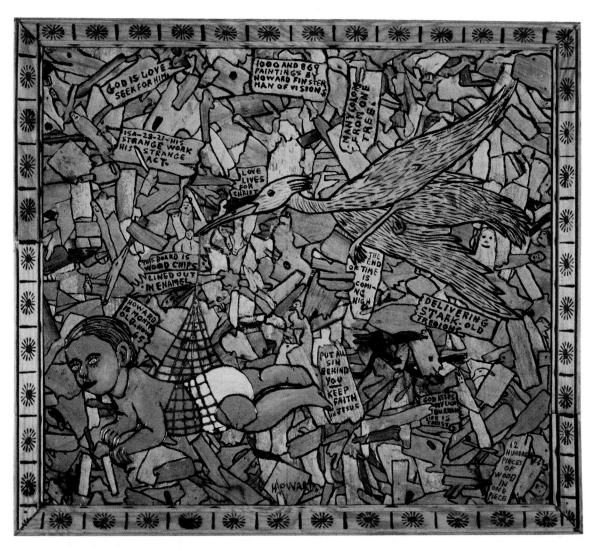

HOWARD 18 MONTHS OLD: enamel on particle board, 1981, #1000 869. (Photo: Courtesy Phyllis Kind Gallery)

slopping the hogs. Slop was dishwater and table scraps in a five-gallon lard can. I carried it in a ten-quart water bucket about one-half a block to the hog pen near the corn crib. I poured it into a long wooden V-type troft and then shucked corn and threw it in. I can hear them crushing it now.

We wasted nothing and were independent people. The only thing we really had to buy was kerosene oil, coffee, and flower. We even raised our own tobacco and made our own homebrew whisky and wine. When I was a little fellow I would take dry cornstalks and make mules out of them and play with them. The girls had corncob dolls. Us children walked two miles to our school house

TIME WAITS FOR NOTHING: enamel on wood, 23×82¹/₂″, 1980, #1000 806. (Stephanie and Stanley Sackin. Photo: Robert Spencer)

at Violet Hill. We chewed dried orange pealing for our tobacco.

Church and school were in the same building. At the school bell we lined up. Walking in, we put our lunch on the shelves just inside the door, some in brown sugar bags, some in syrup buckets, and a very few in lunch pails. Some had two baked potatoes, some had biscuts, and some had cane syrup direct in the bottom of the syrup bucket with one piece of corn bread laying in the syrup and that was all they had. I seen it with my own eyes. School started with a song called "When the Roll Is Called Up Yonder," following with a Bible verse and repeating the Lord's Prayer together.

One day when I was small I took up a song book and blowed through the end of it and it whizzed like a loud goose. I alarmed the students and the teacher called me out of the group to the rostem. As I stood frightened to death, he had a long hickry stick in his hand and said, "Son, I'm not going to make you pull off your coat this time," and he came down on the back of that old thick wool coat and the dust flew and you could hear that sound probably one half a block. That was my first whipping—and the last one.

The first year I went to school I had fun. I didn't even know I was going to get an education. I lingered in the first grade, called "prymer." I loved the group of children so much that I wanted to play instead of studying, so I stayed in the prymer two years before passing.

We had a T-model truck and Dady would let me go with him to help load and unload lumber. Oh, it was so great to me to have a job on that big high lumber stack. I felt like I was on top of the world. One day while going down the mountain with three hundred feet of green lumber, I saw a large rock laying crossways down a long fill and I said, "Dady, what is that big thing? It looks like a casket." He said, "Son, that *is* a casket." He made a big story out of it and he could get me to believe almost anything. He said that many people had tried to drag it off with grapevines and everybody that ever tried to pull it off died. No one had ever been able to move it and it might be full of treasure. We crossed another hill before reaching town. It was called Pudding Ridge. I said, "Dady, why do they call this Pudding Ridge?" He said, "Son, there's a cave down that ridge somewhere and in

them is little mushrooms growing on the ceiling and walls full of some kind of pudding and poor people come there to eat." Smoking his old pipe, Dady had me wondering and dreaming.

Later on I began to go out and cut hickry limbs the size of your finger while the sap was rising and slip off the bark and make whistles to blow. And then I decided to cut forked limbs and use inner-tube rubber for my sling-shot, used old shoe tongues to hold the small stones and roamed the creekbanks shooting at snakes and water mosquitoes. I made a wood lathe from the wheel of an old corn planter, put on a spinnel, and fastened it to a fence post. I began to turn out small eight-inch wooden oil lamps and salt and pepper shakers. Some I would fill with talcum powders for the bathroom. I built an old bicycle out of parts. It was an old wooded-rim bicycle and the tires would leak down, so I took out the valve core and took a glass of water and mixed bread flower and come up with a thin batter dough. I took a big sup of the thin batter dough and squirted it from my mouth into the valve stem of the tire until the whole glass of batter dough was inside the old tubeless tire. Then I put the valve core back in and turned the wheel till the batter dough became a inside lining and sealed all the high-pressure leaks.

I loaded up my woodwork on my bicycle and made long-range tours and stopped house-to-house selling lamp sets I made, two for twenty-five cents. Believe me, that was a lot of money then, for a one-pound can of coffee was twenty-five cents, a half side of pork bacon was one dollar and seventy-five, soda five cents, shoes two dollars and ninty eight, overalls two dollars and fifty cents and eggs were fifteen cents a dozen. Boy, those dreams are left forever. I could take my light bill I am paying now and make a full crop on it then for six months.

I was my Mother's plowboy. She showed us what to do and could even plow herself. We raised cotton, peas, peanuts, and had an apple orchard. We would feed the mules before daylight, go to school at eight in the morning, and come home and clear ground until the whip-poor-will was hollering in the evening. I thought the whip-poor-will was saying, "Whip you I will. Whip you I will."

We had dancing parties on Saturday nights with banjos and fiddles. People told jokes and stories and

would set on the front porch and argue about what the President was going to do. My Dady was a Democrat. Ever once in a while a drunk would come in. We'd have to take a broom and run him out. But most of the people didn't drink too much. People would be singing, "Five to my five is twenty-five, six to my five is thirty, seven to my five is thirty-five, eight to my five is forty." We'd sing the multiplication tables and everybody could learn 'em.

Us thirteen kids will never know how much trouble we were. My brother and I, we'd get an old car battery, a T-model coil, and we'd charge a water bucket, and people didn't know anything 'bout electricity. . . . A girl come up one night, picked the dipper up, throwed it down right quick, says, "Lord, something wrong with my arm." She got shocked—she didn't know what it was. Me and my brother just rolled with laughter.

I seen one kid one time, seen him take a knife, a sharp knife, and laying his finger on something, and he come down like he was going to cut his finger off, and he jerks his finger out you know and hit with the knife. Well, I was playing daredevil one day by myself, and I'm just a little fellow, and I came down with the butcher knife and jerked my finger out, and I came down, I didn't get my finger out, and cut it completely off, just a little skin holding it and it hanging straight down. I jumped up and ran to my older sister, she saw that my finger was cut off and she knew she would catch it for not watching me closer, so she didn't tell it but ran and got a rag and put the finger back in place real tight. She bound it up with flower-sack-cloth strings and it actually grew back together and I can still wiggle that finger. It is a little crucked but actually grew back without any medicine or anything. So you guys that's playing daredevil out there, follerin the leader, watch about what you are doing, be sure you get your finger out from under the butcher's knife before you come down, 'cause I didn't get mine out and cut it off.[1]

Back in those days they had what you call rock candy, and they would put it in whisky and shake it up and soak it, and that was our cough syrup, our medicine. There was one little baby that lived thirteen weeks on a spoonful of whisky a day and that whisky saved its life. A spoonful a day for thirteen weeks pulled that baby

through, without milk. I was attentive to things like that when I heard my Mother tell them stories.

At Christmas there was a special entertainment. My first memory is still fresh from one and one half years old. Santa Claus was sitting between the kitchen and the living room in a big chair in the corner. He was the first human being I ever saw outside of the family. When my Mother brought me in to see Santa Claus, I looked at him and he was beautiful. He was fat, his jaw stuck out, and he had whiskers. I sat on Santa Claus's lap with fear and rejoicing at the same time. He was a stranger to me. All they told me about Santa Claus was that he wouldn't hurt you and he was good to children if the children was good. He reached into his bag and brought out a little crystal glass fire wagon filled with little candy pills of all colors. You talk about striking Howard Finster's eyes, that little glass fire wagon really got my attention. When Santa handed me that little glass fire wagon, I saw right then that Santa Claus was the only God that I knew. I couldn't talk except just with my mind, but I knew Santa was a God.

He was supreme to my mother, father, brothers, and sisters. I fell in love with Santa Claus because that fire wagon was the first thing that was ever given to me that I knew was a gift. I believed in him as a supreme God and he lived in my life as a God until I was thirteen and found God through Jesus Christ. Santa Claus was a good friend to me 'cause he led me to God.

When I was three years old we had a little dog named Trixie. She had her pups under the house. We were unaware when her pups were borned she also had rabies and was going mad. Mother didn't know it at that time and she went under to get Trixie and the puppies, but

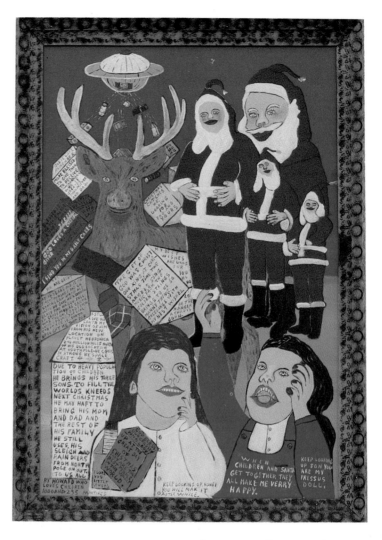

VISION OF SANTA AND HIS THREE SONS ON PLANET NEBRONICA: enamel on masonite, 21¼ × 30¾" including frame, 1978, #1000 255. (Stephanie and Stanley Sackin. Photo: Robert Spencer)

Trixie bit my Mother, and when she got Trixie out, Trixie bit my older sister Abby also, and she bit my father. When Trixie came by me, she only licked my legs. Trixie acted so strange, having a fit, my father was afraid she had rabies, so my father killed Trixie and sent her head to Montgomery, Alabama, to be tested, and they sent a telegram saying Trixie was mad and to come at once for treatment, so Dady and Mother and Abby all had to immediately catch the train to Montgomery, Alabama, about two hundred miles or more. As they left they checked me and found no bites. They left me at home, so Abby gave me a little crystal goblet which was a toy. (I have it now so you might say I have been collecting items since I was three years old.)

They were gone about twenty-two days to take rabies treatments, twenty-one daily shots. Abby was told not to eat any sweets. When they came back home, Abby had an absess from where they anockelated her and on account of her eating sweets she finally died from this absess. She didn't have rabies but died from infections.

Six weeks after Abby died, when I was three years old, one day I came in and asked my sister and brother where Mother was and they said she was at the tomato patch. We had two tomato patches, one above the road and one below the road, so Mother was above the road, and I went to the patch below the road. When I didn't find my Mother, I became afraid, and while I was crying out for my Mother, my sister Abby appeared, the one who had been dead for a good while.

I looked and saw her coming down from toward Heaven. She was coming down at an angle toward the center of the old mill road. Three steps came before her as she used them and went away behind her, and the one she was in at all times made seven steps coming and going away. When she got about three or four feet above the middle of the road, she started back up on the same angle she came down. Three steps kept disappearing behind her and when she got up as high as I saw her coming down, I called her name. I thought she would accompany me, but as she turned her head around from her right shoulder, a long white robe opened back from one side and under the robe I saw a large check skirt I had seen her in before she died.

After looking at me she disappeared, steps and all,

so all I knew to do was to run back to the house. I told my Mother that I had seen Abby and my Mother, having some Indian in her, was frightened, thinking something was going to happen to me after seeing Abby come down and go away over the middle of the old mill road. Mother wondered for years about the vision. I didn't know nothing about death. All I knew is I was in the tomato patch crying for my mother when Abby appeared. I was just a scared kid down in the tomato patch. I changed from crying to my Mama and started crying to Abby, and then I had nobody to help me and I got scared and ran home.

I spent a lot of time sitting on our front porch watching for shooting stars. Every once in a while a star with a tail, a comet, would cross over in the night. The first rockets I've ever seen was in the comic books. I think it was Roy Rogers. I believe it was some kind of Rogers [Buck Rogers]. I was interested in those rockets. It looked impossible for something to fly through the air like a bullet and no propeller on it.

I flew a lot at night when I was a child. I started having dreams about flying. At first I had dreams about falling off our two-story house. The more I would try to keep from falling off, the more I would slip and finally just fall, and when I'd fall I'd just shut my eyes waiting to die when I hit the ground. I have never hit the ground in the dream. Well, after I had that dream of falling off the house and never hitting the bottom, I finally got to dreaming I was flying, and the time I was between four and five years old I was flying all over that house. I was making swift dips like some shooting bird. I'd make a dip and come down where all my friends were and go back up. They was watching me like I was putting on an air show. I'd go over the top of the trees just like a dart.

We had a Methodist and a Baptist church in town. I was born into a Baptist church, what you call an old-fashioned Free Will Baptist Church. They washed feet and didn't have no Sunday School. My Mother wasn't saved until she was forty. I was raised up in church but I went on my own. There were church revivals in the night and I would ride six miles in a wagon with my brothers and sisters.

When I was thirteen I got saved just like my sister did, in a Methodist revival meeting. When I went to the altar, I was under conviction and I wanted something to happen

in my life. I knew I was mean, I was ill, I was disturbed, and I knew I needed to be saved. I said, "O God, save me." That's all I knew to say. Something spoke to my feeling, not the feeling of a wounded hand or a pinch of skin, but the feeling of my soul. God's spirit came into my life and made a new person out of me that night.

That night when the Holy Spirit hit me, I wanted the whole world to know what was happening to me and I walked them benches like a coon on a tree limb and I shouted till I got so horse till I couldn't shout. I walked out of that church and I looked into the sky and there were the brightest stars that I had ever seen before. It was the prettiest sky I had ever seen. When I went home that night I slept the most comfortable and most undisturbed sleep of my life.

Two years after becoming a Christian, I was hauling wood for winter heating. I had an invalid brother who fell in the fire when he was a baby and it burnt the back of his neck. His mind stopped growing, but his body kept growing and he kept a baby's mind till his death. He was in my custody to take care of. He was about twenty-one years old and I was fifteen years old. He couldn't talk but could hear and he always played with toys all his life and I had lots of fun joking with him and seeing him laugh.

He was with me, laying down in the wagon bed with his head propped up with his hands, and the two old mules started out with that old T-model Ford wheel wagon. We was going down a long ways on the side of a hill crossing over small ditches as fast as those old mules could run. I looked down at him and he was bouncing up and down about four to six inches on the bottom of the bed, laughing out loud, and I got to laughing, standing up holding the lines, and both of us was in the glory of real fun. In the middle of it all something as the voice of God said to my soul, I am calling you to preach the Gospel, and my countaince fell.

I stopped the wagon and began to pray. I became frightened and troubled real bad, and with one and one half minutes time I said, "God I don't have an education and I don't even have a suit of clothes." I said, "Lord, I can't." And the second thought I said, "Lord, put it off one year." And suddenly the feeling left me and I felt as if I hadn't never been called of God and went on as if I had it

made. And all this happened before we had even got to the wood pile. I told no one that God called me, as preachers usually was older in those days. So I didn't even keep up with the time and date I was called to preach.

But after a year of child living and fun, the very next year about the same time in the fall, the second conviction fell on me like a heavy mountain of iron. I was plowing in a corn field on the south end of our farm and there was a cave down in the ground back in some rocks. I was so desperate, I stopped the mule out in the field and climbed down in that cave to pray, and when I got down there, instead of praying I thought I would die, and I dashed back to the top, panting for breath. I was sure that this was the last chance for being a preacher but I did not want to be a preacher.

In 1932 when Herbert Hoover was President, he was faced with a drought of crop failures. The bollweavils got the cotton, and the corn dried up green in the field. That year cotton was eleven cents a pound and meat was forty cents a pound and someone made a song up and it went like this: "Eleven-cent cotton and forty-cent meat, now how in the world can a poor man eat?" We ate ear corn bread for breakfast and made a crop on blue goose peas and they had so many weavils in them Mother couldn't float them all out. Many times I would dip a bollweavil out of my plate. I set wooden rabbit traps and caught rabbits to sell. They were bringing fifteen cents each in Chattanooga. A man come by and picked them up.

Our house set facing the east and you could see about twenty miles this side of Lookout Mountain, two and one half miles away. One day Dady was sitting on the front porch in his old rocker with his feet up on the front porch post smoking his pipe reading, usually about the war just past, about old Kaiser Bill, the warmonger in Germany, and he read of John D. Rockefellow, which we all thought was the greatest businessman in the whole world and he was like America's only father of dependence. Everybody knew John D. around there.

And suddenly a far-off shower came along on the side of Lookout Mountain, raining down about two and a half miles east of our burning up crops. Dady got mad with the Lord, saying, "Look yonder at that rain coming down the side of that mountain in those trees and our

*Opposite:* ELI WHITNEY: enamel on wood with pyrography, 32 × 24¹/₄", 1978, #1000 32. (Jeff and Jane C. Camp. Photo: Hardy & Sheffield Photography)

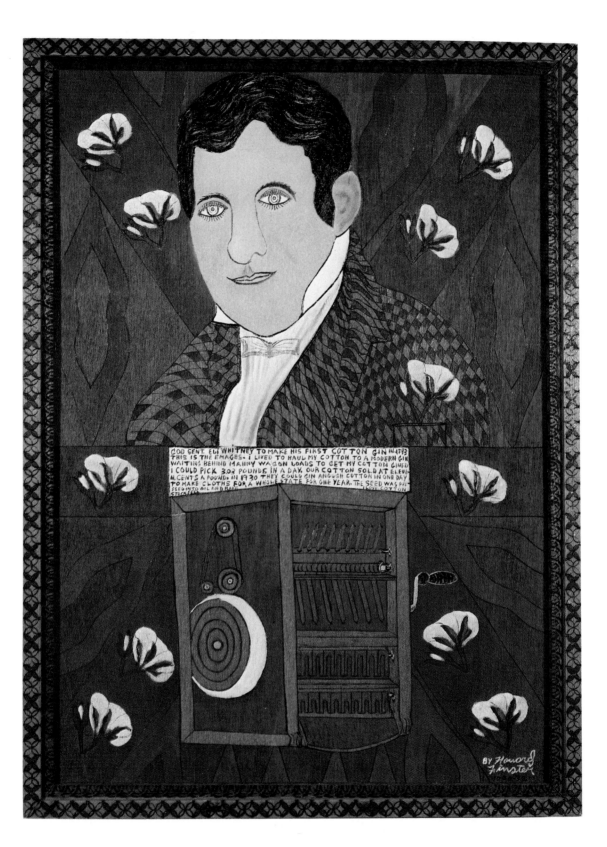

GOD SENT. ELI WHITNEY TO MAKE HIS FIRST COTTON GIN IN 1793
THIS IS THE EMAGES. I LIVED TO HAUL MY COTTON TO A MODERN GIN
WAITING BEHIND MANNY WAGON LOADS TO GET MY COTTON GINED
I COULD PICK 303 POUNDS IN A DAY. OUR COTTON SOLD AT ELEVEN
N CENTS A POUND. IN 1930 THEY COULD GIN ANOUGH COTTON IN ONE DAY
TO MAKE CLOTHS FOR A WHOLE STATE FOR ONE YEAR. THE SEED WAS PAS
SSED INTO OIL AND MANY                    LOVE COTTON

BY Howard
Finster

crops here dried up." He really quarled at the Lord about that and I was really wondering about it myself. I will never forget what Dady said. He said to me, "Son, the time will come when the nations will fight wars just pushing buttons and bomb one another all the way across the ocean."

A young lady named Pauline Freeman moved into my community. She was fair and beautiful. She lived next door and I got acquainted with her walking to church with her. I took her as a beautiful friendship that appeared as a season. I got one of her small pictures some way and placed it in my billfold. I kept her in my hip pocket and carried her for a good while.

I was with a group of my old boy friends, laughing and scuffling. We went to the stream and swimmed in the water together and enjoyed a sportship. Sometimes our old swimming place was crowded and when they wanted all of them to stay for a while, they would take up a handful of mud, and when one decided to go home, about the time he was slipping on his pants, they would dab mud on his back and he would have to go back in the water to wash off. They would do one another that way and see that no one left until we all went together. We would wet the banks with water and skate on slick clay for up to twenty or thirty feet bare-footed. We really had fun.

One day they were talking about their girlfriends. I pulled out this nice picture of my girlfriend, just having fun, and let them look at it, thinking nothing of it, and when they finished looking at it, I thought, well, I will take a peep at it, and when I looked at it my eyes kindly froze on it and something silently touched the feeling of my soul. This is your own beloved helpmate on time and in season, and I fell in deep love with her, and couldn't get away from it night or day just seeing the picture. It was really more than just sex, believe me, and I knew it.

Once the northwest wind was blowing hard and Mother was canning food on the old wood stove in the kitchen. It was hot over that old stove, but the worst part was a spark came out of the top of the flue chemny and landed on our wooden roof of shingles and caught the roof on fire, and the wind drove the fire right through that roof. I ran upstairs and the blaze was leaping about eight feet. That two-story colonial house burned to the ground

*Opposite:* 4 Beasts of Revelation: enamel on wood, 21 × 17½", n.d. (Maria Artemis. Photo: Michael Woods)

18

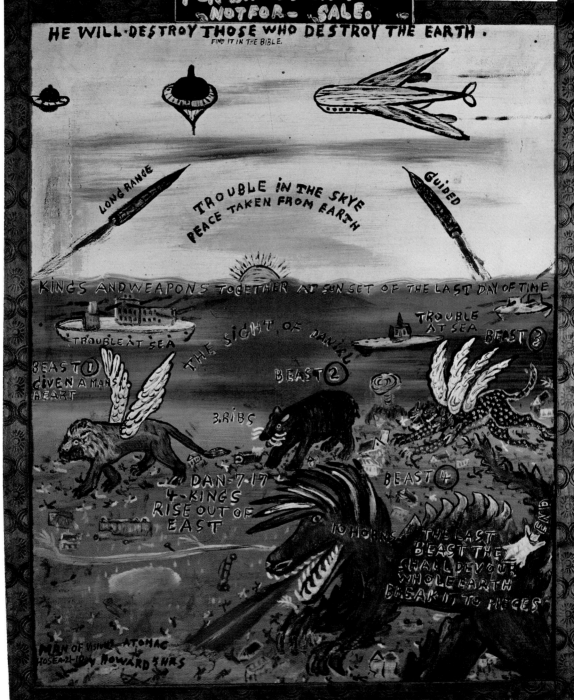

in about thirty minutes and the neighbors got there in time to move back what we got out or it would have burnt too. I can still hear the beautiful hand-painted glass doors my Mother painted cracking and falling out on the floor. It was the most desperate sound I have ever heard, that roaring blaze, popping, cracking, falling. I was left with the one pair of pants I had on, the knees of them was tore out. Dady was sitting down under an apple tree exausted, our nice home in ashes, and I thought, Dady, I heard you many times say that this old house is not built right. If I ever build another, it will be different, and I thought to myself, no one should grumble about all they have. We had to sleep on the floor in an old abandoned house which was used for a cotton house. We lived in it for many weeks. The community and the good church people helped us build back a smaller house.

Still the calling to preach the Gospel was heavy upon my soul. In all this trouble, one day I went to the Lord and said, "Lord, just let me be a field worker and help the sick," and I said to myself, "That's it," but it did not work. Finally I went to the old barn where I fed the stock and went up the ladder in the loft where I could see the gold sinking sun through the cracks of that old barn. I began to walk up and down the old loose plank floor and I began to cry and shed tears and a great spirit came upon me and I said, "I will go." The next day I thought, "No one knows this but me. How am I going to tell people and specially Dady and Mother?"

One night my Dady took the old truck and loaded us all up and drove us to Lee's Chapel Baptist Church to a big revival, but he would not go in the church. And that night Preacher Harrison, a young preacher, was there from Rome, and I looked and Richard Phillips, my schoolteacher, was in the quire, and I made my way to the quire and sat down by the teacher. He was the first one I told about my calling. I said, "Brother Phillips, I have been called to preach." He smiled and said, "You will have a chance to speak tonight," and it almost lifted me off my seat. He had an old dollar pocketwatch and he kept it in his hand a lot in school and sometimes he would fall asleep rubbing that old watch. It looked like gold but it was brass.

After the services began, they heard a voice sound out. It was my schoolteacher. He said, "Folks, I have an

announcement to make. Tonight, Howard Finster is called to preach." No one laughed about it. In fact, they took it seriously, and he said, "Howard will confess his calling tonight," and then I stood up behind that sacred desk and began to speak. From then on I felt like I was a preacher. I felt like I had begun and also finished my preaching because such a big load was gone. But really I was beginning the most greatest calling there was.

SUE MY SISTER  HOWARD

"My classmates receiving our diplomas finishing the sixth grade at Violet Hill School in 1930."

When I returned home that night I began to study. In fact, while I was plowing, I stopped the old mule and stepped out behind a stump and began to preach to a field of weeds. I thought to myself, How I wish those weeds were people. Then I found an old Oliver typewriter out of a dump. That old machine was rusty and dirty and I cleaned it up, oiled it, and worked with it a week or two, and finally got it to writing. At age sixteen I wrote my first sermon, "The Ways of Life," to publish, and took it to the Fort Payne *Journal* at Fort Payne, Alabama, a twelve-mile bike ride, and the *Journal* published my sermon.

At the end of the sixth grade, I had to help out full time on the farm. I didn't get to finish high school. I just finished through the sixth grade. I had to pick up corn stalks and work in the fields. I would have liked to go to high school and college—it hurt me real bad, but other people did the same, picked cotton and farmed. They gave blacks seventy-five cents a hundred pounds for cotton. I got twelve and a half cents an hour for cutting wood.

I kidded Pauline and told her I had fallen in love with her through her picture. She was so beautiful. (Her people were large size—they had Indian blood in them: her grandmother was half Indian.) I asked her Dady for her hand and he consented. I got my father to loan me five dollars for the wedding. I got Pauline Freeman Finster a beautiful light blue crape wedding dress for two dollars and ninety-eight cents. Doctor's exam one dollar; license one dollar. On October 23 of 1935 we went to Reverend Doc White's cotton gin and he married us in the cotton-

gin office and my wife's mother was the only witness. Pauline was sixteen and I was eighteen. Rev. White made no charge, so I gave him fifty cents by scratching up a little more change.

We went back home and our real dream began that evening. We gathered corn into the two-horse wagon made of four T-model wheels without tires and we kissed for a while and then went back to work. I was thinking about sleeping that night in my own bed that I had made good and strong, with the most beautiful blond-headed blue-eyed girl in the world.

### Is Santa Claus Real?
### (poem of my experience)

Was Santa Claus a fable?
In my youth I did not know.
I believed in him so much,
That finally it was so.

In the arms of Santa's wife,
She rocked me in her chair,
While he prepared my living
Without favor or fear.

He was instant in all seasons,
Not just on holidays.
Thirteen of us children
He helped her all to raise.

Fifty years ago, he smiled down in
     my face.
For I was only added to this human race.
He framed his arms to help me until I
     was grown.
I knew more about Santa after I left
     my home.

I look back at his mustache and the big red
     suit he wore.
He held me on his lap near the room's
     center door.

I see him different, now, in my mystery
     pointing view.
If Santa is real to me, he aught to be
     to you.

# CHAPTER 2

---

# The Goatheads

*The early years of their marriage were no easier for Pauline and Howard than they were for any other young couple in the 1930s. To provide for both his preaching and his growing family, Howard, always ready to try his hand at anything, worked at a wide variety of jobs. He developed numerous skills that he would later use in his career as an artist. Putting his preaching career first at all times, Howard accepted the challenge of "stepping out on faith."*

Howard: "After about four weeks, my wife and I started feeling like real married people. We began to raise children and the first child born was Earline. She weighed six pounds. Doctor Richey delivered our baby and I was right by Pauline's side while the baby was borned. That was my first miracle sight to see. I remember the colored lady, our neighbor, who came in to wash our new baby and clean it up after birth in our bedroom. The doctor charged twenty-five dollars for the delivery and the good old colored sister and neighbor would not charge a dime.

"We lived on my parents' farm. I was first a farmer. I could plow, cultivate, plant, and sow, all it took to be a farmer. I done blacksmith work and hammered out shoes for them old mules."

Pauline: "Before I even met Howard he had decided to become a preacher.

Back in those days some preachers only went once a month to their churches because it was hard to get transportation. Preachers used to drive their mules and buggies for miles to get to their churches."

Howard: "I was slow getting started out because we had only one service a month and all the old preachers were dying to preach. It was hard for a young preacher to get any preaching. All he got to do was to testify, because them old preachers didn't want you stealing their flock. I'd get up and make my testimony and that's about all the preaching I done for a while.

"I have a heart's picture of my grandfather, Mose Henegar, who was a minister. He traveled by horse and buggy from Valley Head, Alabama, to Dirtseller Mountain west of Gaylesville to a little church. I can't remember him, but I met some old people who were personally acquainted with him, and I was personally amazed to hear of my grandfather. I see him looking down a narrow, one-tract road where the tree limbs covered over the top. A little one-horse buggy slowly travels. The narrow wheels sink down into the deep muddy tracks bringing up mud and water spilling it out over the road. The horse is walking in the middle of the roadbed between the two roots, his feet popping up and down in the slick mud. The old minister weaves from one side of the buggy to the other over the rough muddy road, holding the lines firmly in his hand. Hours and hours go by and finally he

THEY THAT PLOW: enamel on wood, 17¹/₂ × 48", ca. 1978, #1000 360. (Janet Fleisher Gallery. Photo: Norinne Betjemann)

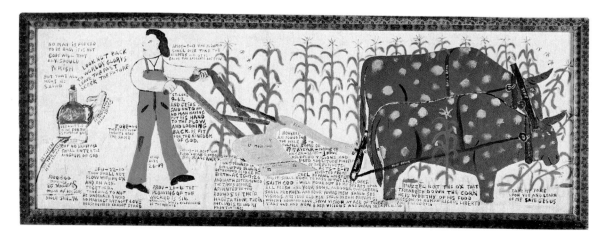

reaches his church. His round trip to the church takes Saturday, Sunday, and part of Monday. In these days he usually preaches two times, his services about once a month.

"After two years doing farm work, we moved to Trion, Georgia. I became a textile employee at the Riegel Textile Mill, and learned to wind thread on the loom. I worked several mill jobs over the next few years. I became a machine fixer at the Chime Glove Mill. I walked around with a pocketful of screw drivers bukled around me. I never took no training on fixin' machines. I worked in a dyehouse too, dying cloth, and later became a cloth inspector.

"I was a cloth inspector at Riegel Dye Plant. Setting upon peacock blue was a hard job, so I wrote a poem about it, "Dyehouse Blues":

> Ten thousand steps on the Dyehouse floor
> carrying up patches and you still want more
> Yes a patch on the Grey, the Blue and the
>   Green
> and many patches for Walter Kind.
> Sometimes three patches on the straight
> and two out of three you think I am late.
> Right up the aisle with a patch in my hand,
> Watching the cloth from the Pad to Cans
> Fuller cries out, "Where is my clips?
> Did you pull out the places where the leader
>   was ripped?"
> Your tag is not ready to give me time,
> Your cloth is O.K., don't worry your mind.
> When I leave old Fuller, take a step or two
>   more, I meet Old Gaylor
> at the office door.
> I hear him say, "Why bring so many machine
>   patches, there's no use . . .
> Your chasing the floor like an Old Wild
>   Goose."
> Let me check my chemicals and make my
>   mix,
> Don't crowd me so and get me in such a fix.
> I take a big step in the office door,
> Manual cries out, "Preacher, bring me some
>   more."

Tell Cleve to make a five cent add . . .
Where is Carl, I need him so bad.
Clean up your floor and push the rags down
in the cans
We are looking for company and some of the
Big Men
Watch that cloth don't leave it too long,
You may get spots while you are gone . . .
I call for Dan, "Come fix my machine."
They reply, "You'll just tear it up again."
My box is full of cloth, I holler for help,
I soon learn to push out myself.
Carl comes along saying "Preacher, come
with me,
Let's go to the Frame Room, I want you to
see . . .
You ran this bad cloth, and what a shame,
It will give us Dye Men a bad name."
Like a sheep-killing dog I stagger home
Wondering if they will send me home

For the Dye House Blues is not easy made

I take blame for bad cloth defect I have not
seen
Like a back-stabbed man or an innocent
queen.
I am responsible for cloth that fall while I
take a patch
Just as though I had a pair of eyes in the
middle of my back.
Bad cloth that falls while I am gone
Is just the same as if I had of known.
I like tobacco, but have no time to take.
I watch the other men's jobs and give them a
break.
All through the night people ask me for
change
Like I was a clerk of a money-making brain.
Some ask me to loan them money just like I
was Dan McWhorter
even without a receipt or even a mutter.
Sometimes the bell rings
and I can't hear

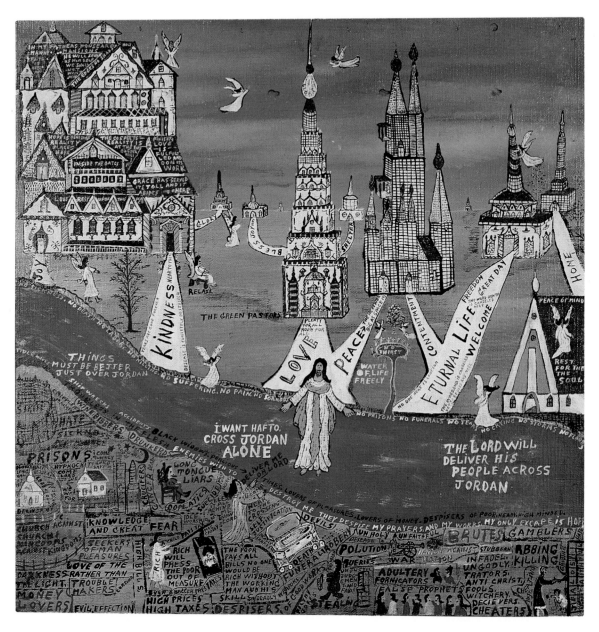

for the No. 1 can's gear.
Oh, how Fuller and Gaylor thinks
I should clean out me ears
I step to the water fountain to get a drink.
They ring the bell to make me think—
A clip is on the way or a salvage tore.
You better pull it out, there may be more.
Along about nine when I think I have time,

THE LORD WILL DELIVER HIS PEOPLE
ACROSS JORDAN: enamel on masonite,
30½ × 29½", n.d. (Herbert W.
Hemphill, Jr. Photo: Stuart Rome)

I run to the vending machine
and if it fails I have no bond
Just a little white refund.
If I happen to get milk—
I hold it in my hand
and drink it like a baby.
As I walk along a slosh on my lips
and some on my cloth
and milk on my nose.
The "Super" comes by and looks at the cloth
It seems he is worried about the time we have
lost.
The Bleach House ahead,
The Dye House full of empty boxes
scarse like Jersey bulls.
Here comes Houston with a splinter in his
hand
Hey, get this out man.
Let me go smoke
Give me a break
Just a little time
It will only take.
Yes my job is so occupied, when I go to the
water-house
I have to appoint a man in my place.

Yes, this is the Dye House Blues.

Look out a hole through the window panels
painted like a bear
Peeping through the bars of his cage
The birds flying and singing where they
please,
and Old Preacher in a Dye House squeeze.
The kids are out playing on the sand
Me fastened as a Dye House man.
Engineers passing right by the door—
Me carring patches up and down these Dye
House floors.
Even little fishes out there in the creek
Part of the time me in here to sweep
Hey fellows, excuse me I am out of paper
THE DYE HOUSE BLUES TO BE FINISHED
LATER . . .

28

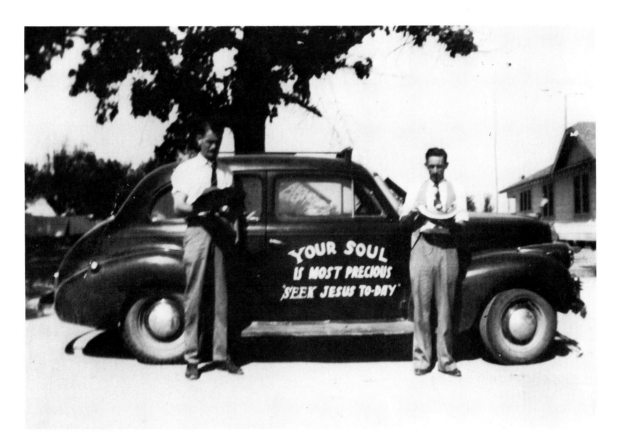

"But what was most important to me was my preaching. I did my preaching sometimes inside the plant walls, but most of it on my time-off period. Because I didn't get many opportunities to preach in church, I started my own revivals and my own tent services.

"Floyd Crow and I were halfer and halfers [partners]. We would preach at dance halls. We got a car and painted a verse on the door and would drive up with a speaker on the car and preach to whoever assembled. Later on we decided we needed a tent. We framed pictures in a basement till we got enough money to buy that tent. We saved some two hundred people.

"I love all people. I communicate with people. Sinners are my favorite people because they are the people I would like to win for God. I wasn't called to the righteous. I was called to the sinners. I like to preach to the sinner world. Since I don't condemn no kind of religion, I have all kinds of people to talk to."

"This is me going from city to city preaching in 1937. I was also pastoring three churches at this time and preaching on WGTA Radio."

## [REVIVAL NOTICE]

Now listen, an old-fashioned revival is in view now. First Sunday night in July, continuing through two weeks. If you are a Methodist we want you. If you are a Church of God we want you. If you are a Baptist we want you, regardless of your beliefs we want you. Come on and let's have one more good revival together before Jesus comes back. And listen, drunkards, we want you to come. If you know any thieves and robbers, bring them. And you women who are unsaved and lost bring all the gamblers and streetwalkers you can. We love your soul and will try to preach you the truth, God being our helper. This revival is at the Happy Valley Baptist Church, South Rossville, beginning Sunday night, July 25, through two weeks. Sinners come, we are praying for you. Services each evening. *By the Evangelist Howard Finster, Trion GA Route 1.*

"In 1944, Floyd and I ran a revival. He was a Methodist and I was a Baptist. We both worked in the plant in the daytime and did the revivals in the evenings after getting off work. We went all around Georgia with our portable tent and portable chairs. Some nights we got two hundred and fifty to one thousand and five hundred people. One night we got forty converts. We made handbills to get exposure for our revivals. We had special singers, quartets, and duets, and I played the piano and the organ. We'd start the service at seven and go till midnight and at one old mill town we started a second service at midnight when they came off shift.

"Regular churches would take offerings on Sunday mornings for the pastor. They didn't pay enough to live on, maybe seven or twenty-five dollars a service. On our revivals we took offerings every night. We'd get two hundred and fifty to three hundred people at a revival and that would cover expenses.

"I'm just kinda an independent-like fellow. I'm a Baptist but I believe in all the religions. The only kind of religion I'm against is infidelity. I don't condemn nobody for nothing. You don't fall out with people because they

*Opposite page:*

*Above:* "Baptizing every other one with my preacher friend Floyd Crow. These were the first members of the Moon Lake Baptist Church in Little Rock at Mentone, Alabama, in the early 1940s."

*Below:* SATAN UNION PAINTING: enamel on wood, 12 × 40", n.d. (Cavin Morris. Photo: Stuart Rome)

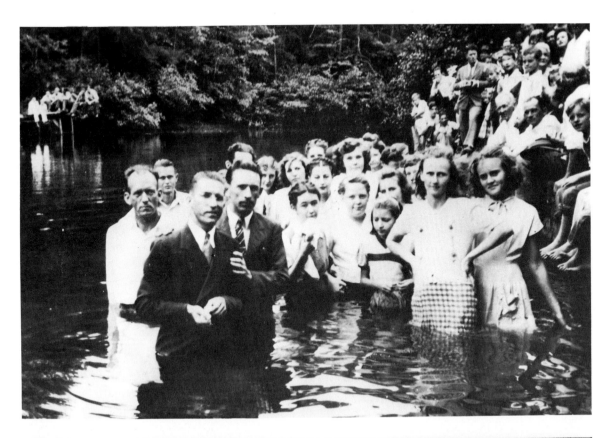

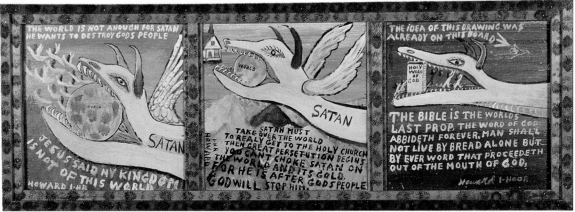

believe different than you do. If you criticize them, you're making them worse. If you condemn them, you're making them worse. If they condemn themselves, it helps them and they will come out of it.

"I remember my first revival at Chapel Hill Community Building. I'll never forget the little house and the many people who gathered. God richly blessed us, and

# Tent Revival

*Howard puts on Bible shows* **AT BERRYTON**

## BEGINS MONDAY NIGHT, MAY 30, 7:30

### BIBLE PICTURES WILL BE SHOWN EACH EVENING—FROM THE BIRTH OF CHRIST TO THE RESURRECTION.

### ALL DENOMINATIONS ARE WELCOME

Conducted by Rev. Howard Finister and Rev. Fred Tucker.

Rev. L. H. Newson, of Attalla, Ala. will do the Preaching.

## COME HEAR THE MAN OF GOD PREACH

The Pastor of the Shady Grove Baptist Church in Attalla, Ala.

*Above:* To spread the word about his revival meetings, Howard used handbills, pamphlets, and newspaper advertisements like this one. (Photo: M. Lee Fatherree)

*Opposite page:*

*Above:* "This is me, my wife, and three children, Roy Gene, Gladys, and Earline, at my birthplace in Valley Head, Alabama, 1942."

*Below:* "This is our grocery store in Trion, 1946. I made the blocks and the machine that made the blocks for this building."

there were about fifty converts. Another revival was the one held at Fort Payne, Alabama. Brother Crow and I used our tent on Gault Avenue near the Davis Hosiery Mill. It was estimated there were more than two hundred conversions. People crowded the tent from various places and God blessed us in a mighty way. There were sinners begging for mercy. They were at the altars by numbers and fell on their knees outside the tent, even near the sidewalk."

Pauline: "After he got his own tent, he would be gone for a week at a time. He'd preach two or three revivals a summer and be gone all summer. He was gone so much our daughter Thelma forgot him. He really studied the Bible as best he could. He studied every night. He would mark the pages for his sermons. A sermon would come out of anything that would cross his mind. If something would come along that was so wrong, he would just start quoting the Bible. I used to tell him I got a sermon every day. Sometimes I would listen, then again I'd say, 'Howard, just be quiet.'"

Howard: "It was difficult for her to live with me because we raised five kids and I was on the road constantly running revivals, and sometimes I'd run sixteen weeks of revivals while she was home doctoring the babies. If she hadn't done that then I couldn't have done what I done. She is responsible for my minister work.

"I have walked as far as four miles to church. I have rode a wagon as far as six miles to revival meetings. I have been deprived of going to church when my tennis shoes were threadbare. I have stood out in winter's open weather and conducted funeral services when I was not able to afford an overcoat. People around me stood in their warm overcoats while I thought I would almost freeze. I have baptized in December in the open streams when my legs would cramp. My first automobile was a T model and I never was able to get it to run. I have spent

thousands of dollars for transportation, but I can't remember a mile that I ever drove for the Devil."

I have buried them in water
I have buried them in the snow
I have seen them come into the world
I have seen them last when they go
I have shared my tears with thousands
My heart was broken days and nights
I've rejoiced with the angels
What a beautiful glorious sight
I was part of those I met
I am now part of you
I'm in the middle of your sorrows
I must see you make it through

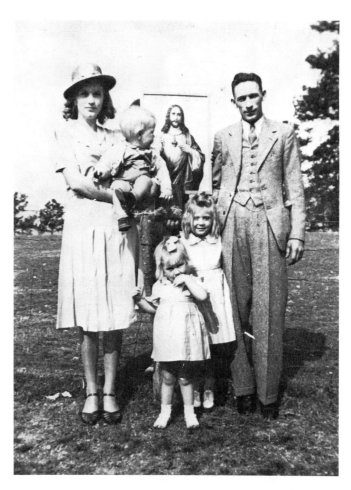

"In Trion, Georgia, 1941, I built my first blockhouse. It was a grocery store on the first floor, with living quarters on the second floor. I made the block molds and molded the blocks with creek gravel that I hauled. I flattened out oil cans and used them for shingles. Pauline ran the store for around ten years. We sold kerosene, groceries, and cold drinks. People would come by and would always quote cheaper grocery prices from another store and get down on our merchandise till we could hardly make it. They would pay weekly till they moved away and on the last bill they would stick us, so I finally went broke.

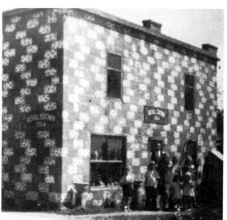

"Then I began to sell clothes and one day a little ragged boy came in and he was pitiful. I was so touched by his old ragged clothes that I said to him, 'What size pants do you wear?' I gave him two or three pairs of pants and other clothes and I said, 'Don't tell no one who gave you those clothes,' and he ran happily away. But he didn't keep the secret, and the next day it seemed just about half of his family was down to see me. They were looking for the free clothing giveaway. So you see it is hard to help others.

"I pastored one church for fifteen years and three

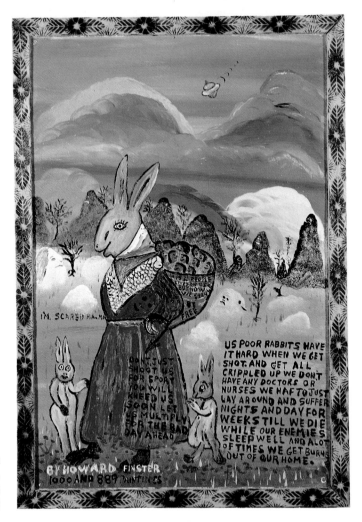

*Right:* Us Poor Rabbits: enamel on metal mounted on wood, 19⁵/₈ × 13⁵/₈", 1981, #1000 889. (Jane Braddock & John Baeder. Photo: Larry Dixon)

*Opposite:* Vision of a Great Gulf on Planet Hell: enamel on wood, 14³/₄ × 21¹/₂", ca. 1980, #1000 712. (Herbert W. Hemphill, Jr. Photo: Stuart Rome)

months in hearing distance of a man who dealt in wildcat whisky. The law caught him several times, but they never stopped him. He could hear me preaching from his two-story mansion. The way I handled him was not to meddle in his business, nor did he meddle in mine. I visited him when he was sick and loved him and gave him the same care I gave my church members. After eight years hearing me preach from his all-around porch, one night I looked back in the congregation and there he sat. When I preached, large tears rolled down his cheeks. He surrendered to God and joined the church. After many years he was laying on his deathbed and he drawed me in his arms and said, 'Brother Finster, I love you too. You were the cause of me being saved.'

"I saw a man who run into a burning house to save his little girl. He brought her out in his arms but she was dead in a short time. He stood with big fire blisters

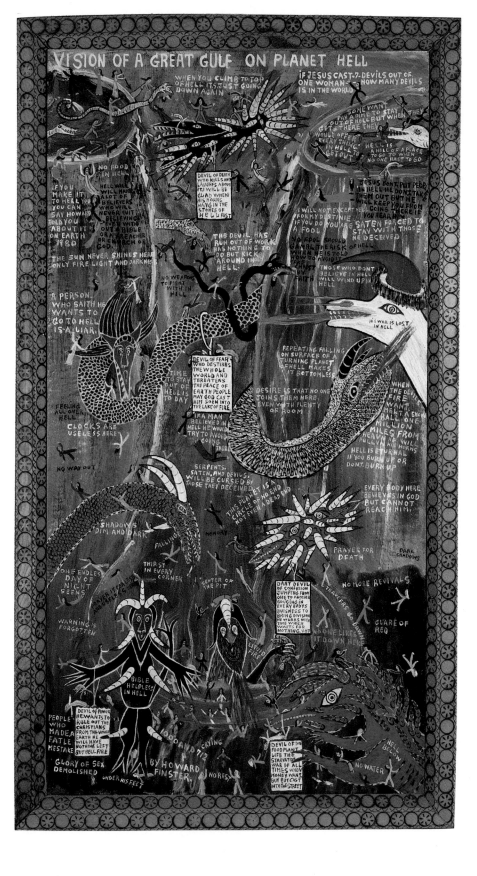

One of the hundreds of sermons that Howard published in local papers at his expense. (Photo: M. Lee Fatherree)

hanging over his eyes and face by the side of his little daughter who was dead. It was more than a man knew how to bear. I tried to comfort him by speaking of the patience of Job but in a time like that nothing seem to help. If fathers and mothers were on the job for the souls of their children to be saved like this poor man was about his little girl, surely more young people would be saved.

"I believe that it is important to tell all that we know about Hell. If people don't believe in a Hell, how can they escape Hell? You love your little baby you teach it the danger of fire, so if you love the souls of others you should teach them the danger of Hell.

"Back in the forties I had a newspaper column of my sermons. I counted almost five hundred clippings from the Summerville *News* which I published through the years at the rate of seventy-five cents a column inch. This adds up to about five thousand inches, which would amount to three thousand seven hundred and fifty dollars. I don't remember one single dollar that has been sent to me to help publish my writings. It costs to burn a candle or shine a light, but it is worth the expense. I pay the price from my earnings to try to shine a light for others. If others would donate for my talent of writing, it would lengthen the beam to shine farther. It costs on an average of about ten dollars per week to write a short sermon or poem, but it is an effort to help all mankind.

"The Riegel Mill, where I worked, told me I would have to work on Sundays. I told them I had two community appointments on Sunday at Chapel Hill and Sunday nights at Hanson Church and that the young people depended on me to speak regular so that I couldn't work in the plant on Sunday. They said if I didn't come in on Sunday not to come in on Monday. So I didn't go in on Sunday. I served my churches and the mill fired me and put on my separation papers, 'This employee would not work on Sundays.' That's all they had against me. Mr. Cook, the personnel man, as he handed me my separation papers, said, 'You have the highest calling and that's preaching the Gospel.' So I was throwed out of a job and in debt.

"I went home and set up a woodshop in my yard and began to build screen windows and doors. Before long I was making more money than I did in the mill and still preaching. So God took care of me. Then I took up

carpenter work and built and remodeled houses. I done interior finishing, molding floors, and tiling. I began plumbing and pipework, too. I could plumb a whole house. Then I became an upholsterer and made hand-built furniture. I made doll furniture and later we moved to Chattanooga and I worked at Cavalier Corporation building furniture on an assembly line. I made cedar chests and bedroom suites.

"During all this public work, I was also preaching the Gospel, writing poems and sermons. I compose some songs in poetry but my gift is preaching the Gospel. I don't read books because I'm only sent to preach one book, the Bible. I believe in the facts of the truth. I've taught facts, I've preached facts, and I don't listen to contradictions against me because I know I'm right. I don't fall out with people who condemn me. I also went on the radio to preach, was on WGWD for years and also on WROM Saturday mornings at nine-fifteen. I'd preach and then the choral group would sing a song or two.

"I was voted in to pastor a church away down in southeast Alabama. I felt like I was drifting into a paradise opportunity to work for God, but really I was headed for the jaws of a vice on the Devil's workbench. What I didn't know was that the young people outvoted some of the old-time goatheads which was trying to bring in an older minister. They had future trouble up their sleeves. Well, I begun a revival and the attendance swelled to about ninety people in the church. About seventeen people were saved and I baptized a number of new members. Of course when things began prospering, these old head members, who was laying low to see the church lay down and die, really seen the church get up and walk.

"They raised up a carload of old men and drove up in front of my house one day and called me out to the car and said, 'Finster, we want to see your preaching license. We also come to tell you that your men who have been going down in the old cemetery before church services start, that has to be stopped for we built the church to have services in and not to hold prayer in the cemetery. And those women who go in the back Sunday School rooms before services and start praying and shouting with all that noise, that has got to stop. And on the second Sunday we are going to bring our minister to church and he is going to take the pulpit.'

HOWARD FINSTER IN GREEN SUIT: enamel on wood, 76 × 21", ca. 1978, #1000 390. (Marion Stroud Swingle. Photo: Norinne Betjemann)

## Places Where I Preached:

Lee's Chapel Baptist Church, Valley Head, Violet Hill Baptist, Second Baptist Fort Payne, Presbyterian near Gaylesville, Methodist Church Watson Chapel, Frog Pond Baptist Church near Blanche, Alabama, Berea Baptist Church near Menlo, Georgia; Methodist Church east of Chesterfield, Alabama; Baptist Church west of Lyerly, Georgia; Free Holiness at Lyerly, Harmony Grove, Sulphur Springs, Methodist Mentone, Alabama; Baptist Sulphur Springs, Ga.; New Lookout near Mentone, Rock Bridge Baptist, Riber Park on Lookout Mountain, New Union, Lookout Mountain; Little River, Lookout Mountain; Tent Meeting, Valley Head, near City Hall; South Summerville Baptist, Pennville Gospel Tabernacle, Old Dry Valley School, Trion, Ga.; First Baptist Church, Trion, Ga.; Mountain View Baptist, Trion; Spring Creek Baptist, Trion; Chapel Hill Community Building, Trion; Wayside Chapel, Summerville; New Prospect, Trion; Happy Valley Baptist, Rossville, Ga.; Mission on Main Street, Chattanooga, TN; on streets of Summerville; streets of Valley Head; streets of Chattanooga; Cavalier Plant, Chattanooga; streets of Menlo; Blanche Sawmill; Ebenezer Baptist, Sandmountain, near Mt. Olive; Four Mile Baptist, Friendship Baptist, Sandmountain Bittle Cross Roads, Streets of Mentone; Baptist Church, Dutton, Ala.; Brush Arbor near Dutton; Baptist Church on Little Sand Mountain near Gore; Screamersville; Baptist West Summerville; Head Springs Community Church; Rock Hill Baptist Church, southwest of Lyerly; Harrisburg Nazarene in Dry Valley; Made Talk at Mill Creek; Black Oak Baptist, southeast of Fort Payne; Lookout Mountain, Liberty Hill Baptist, Adamsburg, Lookout Mountain; Mount Harmon, west of Fort Payne; Delma Baptist, east of Fort Payne on Lookout Mountain, and many other places.

## Estimate Report, 15 years of service at Chelsea Baptist Church

called January 1950 resigned April 1965
Salary $14,000 and forty dollars
Sermons—1501.00
Training union—135
Visiting sermons—70
70 different ministers visit
1 automobile donated
suits—8; tires—75; Christmas gifts—75
other gifts—45
Donations (on radio broadcasts)—884.00
Messages published
in Summerville *News*—489
Songs—500.50; prayers—243
Funeral 10 at church
Special Dinners—88
Visits 608
Prayer in homes 65
Lessons taught 1000.00
Total Baptisings 14
Revivals 17
Converts 80
Marriages 60
Other funerals 55
Christmas programs and plays 16
Played piano 58 times; accordion 16 times
Directed choir 7 times
Scripture reading 16060.00
Special songs 9
Building new church 2
2 Gear cars used 4; miles driven 168,000
Personal donation to church—402.00
Traveling exp—5000.00
Services held—11,300.00
Total churching 453,000.00
Deacons ordained 3
New members from other churches—45
Special song by group—1,108
Dismissed by letter—19
Death of members—9
Baptized about 40

**MY FIRST BOOK OF MY OWN**
**COMPOUSERING**
*Sample of Life's Story*
*and Poem Book*

### No. 1
— BY —

*God*

*is*

*Love*

*Be*

*Not*

*Afraid*

**REV. W. HOWARD FINSTER**
**EVANGELIST**

**WITHIN THE GATE**

Within the gate of Heaven,
A peaceful Rest inside;
With golden streets and friends
To meet, where there is no sin
and pride.

We have our war and trouble,
At present time we wait;
There's peaceful rest for everyone
Just within the gates.

ach h is straight and narrow
for ls from worldly cares to
ur feet to Heaven's streets
ere's no sin and snare. **(3)**

**JESUS NEVER FAILS**

On the sea of Galilee,
The ships were set to sail,
Tho storms were hard and waves
were high,
But Jesus never fails.
The powerful word, Peace be Still,
Calm out over the sea,
His saving hands, Now as then,
Can set our nation free.
No victory found in faithless men,
Who gnash their teeth and wail,
When they can put their faith in
Christ,
ne that never fails.

*Left:* Title page from Howard's first self-published book of poems, 1945. (Photo: M. Lee Fatherree)

*Above:* Howard's drawing skills were used early on when he worked as a carpenter, sketching designs for custom furniture, 1952. (Photo: M. Lee Fatherree)

"When the other people at the church heard this, they were ready for a fight. One rough sinner-man came to me and said, 'Finster, I have a real sharp knife and I ate peas and corn bread in prison before and I can do it again. Don't worry, no one is going to take your pulpit. My knife is sharp and I've been in trouble before.' So I woke up in a vice between a prospering church and a blood-shedding fight. The young were on my side and the goatheads were ready to strike. I wanted to preserve peace but that wasn't easy, because the Devil had got me in that vice time after time.

"I hate back-stabbers and snipers. Even dogs come

out for a fair fight face to face. Dogs are not back-stabbers. Birds fight fair. Skunks and rattlesnakes warn before they attack. The only thing I know that don't fight fair is a back-stabbing coward that don't give the other party a chance. I had a man once who came to me and threatened me for a fight. I said to him, 'You pick out the way you want to settle this matter, by law or fists.' Fighting is not my game. I never raised a fight in my life, but I been in fights. I admire a fair fighter. If you really want to find out about fighting, read the whole Bible through for it has more murder stories in it than any book I have read.

"Kidnappers can be stopped. I have posted my wife that if for any reason I should be kidnapped, for her to tell them I wasn't worth a dime to her and to do with me whatever they wish and be sure she didn't pay them a dime. I want her to hang up every time they called. For a man's worth more in dollars and cents dead than he is alive. If a few people would sacrifice their lives and the lives of their loved ones, they might stand a chance to put kidnappers out of business. The man that is kidnapped is the only man that can stop kidnapping.

"If every person was a real Christian there would be no killing, so we could close all weapon factories and save millions of lives and dollars. The world doesn't know the worth of a Christian. If everybody on earth were Christians, there would be no more stealing or robbing or rape. The lock and key company could go out of business. All vaults could stand open twenty-four hours daily. We could close all prisons, lay off all F.B.I.'s and police, and we would save millions of lives and dollars. Yet the government, Satanists, and infidels know not the worth of real Christians and they'd rather set them aside because of the writings of the Constitution that all men are equal. They build nice prisons and operate recreation centers and finally turn loose killers and robbers who go back in business the second time to give the old-aged business-man the second time to watch out for the same killer to strike again. And this is what's wrong with our world, we need more Christians.

"Preachers think they got power just by preaching and that sinners will get saved. You can't run sinners out of church. You have to run them into church and make it a soul-saving station for God. The preachers, that's what's the matter with the churches today.

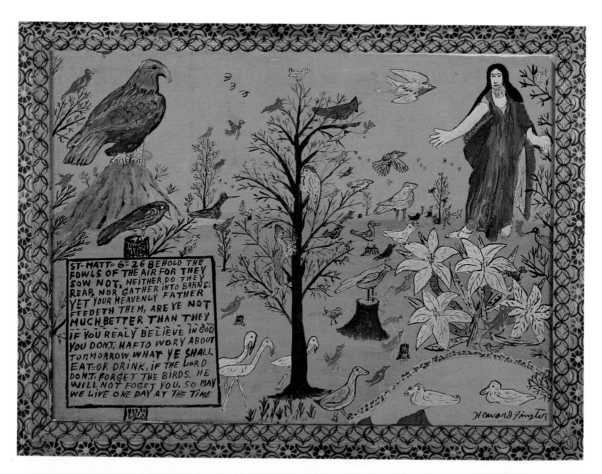

ST. MATT= 6= 26 BEHOLD THE
FOWLS OF THE AIR FOR THEY
SOW NOT, NEITHER DO THEY
REAP NOR GATHER INTO BARNS;
YET YOUR HEAVENLY FATHER
FEEDETH THEM, ARE YE NOT
MUCH BETTER THAN THEY
IF YOU REALY BELIEVE IN GOD
YOU DONT, HAFTO WORY ABOUT
TOMMORROW, WHAT YE SHALL
EAT=OR DRINK, IF THE LORD
DON,T. FORGET THE BIRDS. HE
WILL NOT FOGET YOU, SO MAY
WE LIVE ONE DAY AT THE TIME

Howard Finster

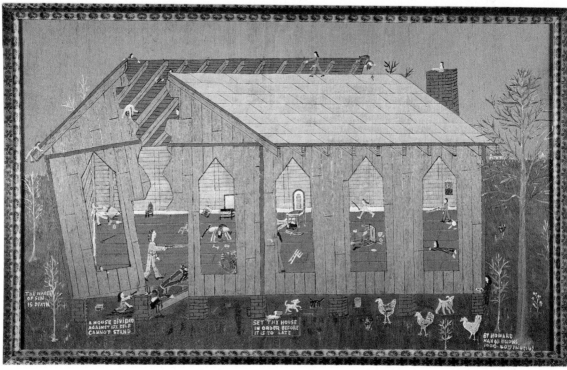

THE WAGES
OF SIN
IS DEATH

A HOUSE DIVIDED
AGAINST ITS SELF
CANNOT STAND

SET THY HOUSE
IN ORDER BEFORE
IT IS TO LATE

BY HOWARD
MAN OF VISIONS
1000- 603 PAINTING

"I was preaching in a little Holiness church here a while back and I told them, 'You people shout and holler and have a good time. What are you shouting about?' In another sense of the word, I said, 'The only things I know of that will make an angel in Heaven shout is for a soul to come to God. That's the only place where I've ever found where anybody ever shouts. Y'all need to be crying and weeping for your family, your loved ones and your country. There's people who think I ain't having a good service if I ain't shouting and hollering and running all over the place and rolling on the floor. People going to Hell all around me, up and down the streets there where I'm preaching. I couldn't go in there and have a good time with them while the world is dying. You couldn't go in there and have a good time with them while the world is dying. You couldn't go in a room where your father is dying and start having a party and rolling and shouting. It's not a time for that.' God says, 'Those that laugh now shall cry and mourn later and those that cry now shall laugh later.' He says, 'The first shall be last and the last shall be first.'

"I remember traveling on a street that headed off into a small boat dock. There was a red light hanging over the middle of the street going off and on constantly so I stopped, but another man went on through and plunged over the boat dock into the Tennessee River and lost his life. The thought came to me, 'Safety is on one side of the red light and danger is on the other side of the red light.' I hope that I can be a red light for God and warn people from danger and destruction.

"If alcohol could speak the truth, I believe it would say: 'When I am matured from the earth I am a little grain stored in the barns and grainerys. Some of me is worked into bread in which I feed the hungry. Some of me is made into alcohol used to preserve drugs in which I visit the hospitals and homes to help the sick. But you moonshiners and still-punchers mix me with sugar and put me in a filthy vat and heat me with old car batteries and let me sour and stink, then boil me into steam and run me through a warm and cool water and drip me into a jug and bootleg me out over the country. I poison people and destroy the innocent, shorten the life of thousands, and fill the hospitals and graveyards. I become so wicked you can track me with blood and hunger and find me all up

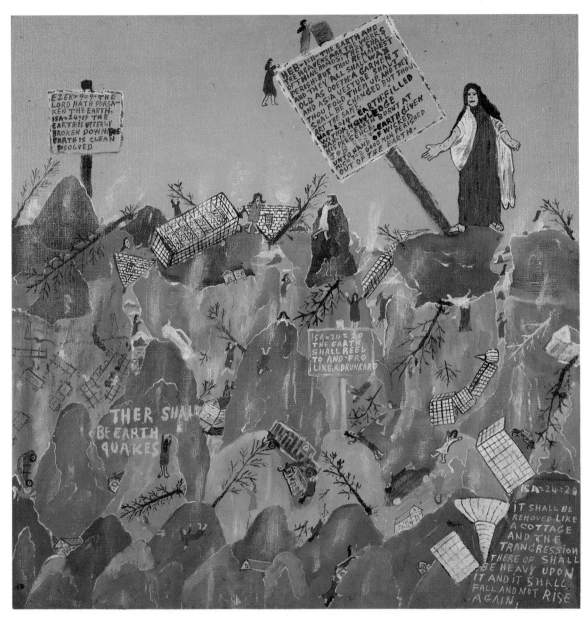

and down the road, from the finest homes to the federal prison. I am the way to the electric chair. Death and Hell is the end of my trail. Yet it is not my fault for you could have made me into a nice pone of bread. But the way you have used me, you may go to Hell.' Alcohol appears like a beautiful dream and explodes like the atomic bomb.

"I was called to a city church as pastor which paid a fair salary. I organized a midweek Bible class for the children and taught them myself. I used to teach on a blackboard. I called it 'chalkwork.' If I was telling a story

THERE SHALL BE EARTHQUAKES: enamel on masonite, 30 × 29¹/₂", ca. 1976. (Herbert W. Hemphill, Jr. Photo: Stuart Rome)

43

on faith, I would draw a little wheat seed and stalk and maybe a little grave. I had to teach the kids about the Bible and this is how I did it. I'd draw different things like maybe I'd draw a cross and put a fence around it saying, 'You can't get to Hell without getting over this cross,' or, 'No way to get to Hell without going over this cross.' Or I'd write, 'No way to get to Hell without going over Mother's prayers.' I would write the word 'prayer' on the blackboard and then draw somebody stepping over Mother's prayers. My chalk art was just images and discussions."

Howard's daughter, Virginia Brown, remembers: "He'd write on the blackboard and then he'd draw the pictures and explain it. Anyone could understand it that way. His drawings would always refer to the Bible, and he would draw humans, animals, and trees. He had some little drawings at church to give out as souvenirs. If anyone wanted to buy one, he would sell it to them."

Floyd Crow's sister, Haynie Lou, adds: "I knew him when he was in his early twenties. He kept us laughing a lot and the young people of the church loved him dearly. He was a good preacher. He came up with odd subjects, but he got his messages across. He used to draw with chalk for the service. He would bring out his point with his chalk."

Howard getting his point across with "chalkwork," Calhoun High School, Waynesboro, Georgia. (Photo: Bob Linn)

The genesis of Howard's art is this chalkwork. He may also have been influenced by earlier exposure to Baptist "preaching diagrams." Artist Eleanor Dickinson has documented rural southern preachers, including Howard Finster, for over twenty years.

Eleanor Dickinson: "This lithograph from 1895 is very much the Pilgrim's Progress idea of the path of the soul through earth to end up in Heaven or Hell. It's a pathway-to-salvation diagram. It's didactic, entirely for teaching, and not meant as some work of art. I've seen earlier ones that are more ornate. I've seen them in the South in tent revivals and churches. They're not common, but they are not unknown. Most of them are done by the preacher. They use materials that don't last too long, such as chalk, enamel, or colored pencils. Most are cruder, but have the same themes. They usually make them bigger, brighter, and they'll do it to scream to the

people, to attract their attention. They might put it on the side of the tent as the theme for the revival and use a different topic every night.

"This drawing is very symmetrical, as are many of Howard Finster's paintings. The design, format, and use of words are also similar to Howard's art. As a Baptist preacher, he certainly would have seen diagrams like this one. He also would have used Sunday School materials in which there is a lot of this interaction of image and lettering. It's very common on Sunday School cards, posters, as well as fans, and any of that could have influenced him."

Photographer Margo Rosenbaum: "I think that his art comes out of the rural Georgia tradition of roadside sign painting, such as the *Jesus Saves* signs and the painted advertisements for fruits and vegetables."

Howard: "In the forties I built a little garden museum out of wood behind the grocery store in Trion. It had several buildings, including a copy of the church at Silver Hill. People would stop by and enjoy themselves. It was for everyone. I had a donation box and all the money I collected went to the crippled children's hospital in Hapeville, Georgia. I had an exhibit house and inside I had a chicken that I had stuffed and I put a pan of corn in front of him, and it was real life-like."

This backyard museum became Howard Finster's lure to the world. It was a place for "fellowship," where children from the Chelsea Baptist Church could picnic on a Sunday afternoon while its caretaker got in a little extra preaching time. It attracted believers and non-believers alike, both curious about the wooden flowers, fourteen-foot castles, and displays of antiques and oddities. It was in this combination—a fantasyland and a park—that Howard realized he had not only the gift but also the means to reach people outside the church walls, a realization that served as the impetus for the creation of his

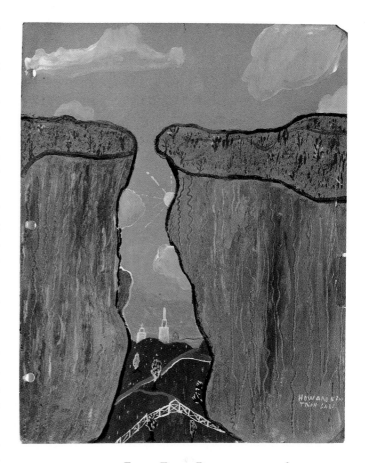

EARLY TRION PAINTING: enamel on cardboard, 13¹/₂ × 10". (J. F. Turner. Photo: M. Lee Fatherree)

45

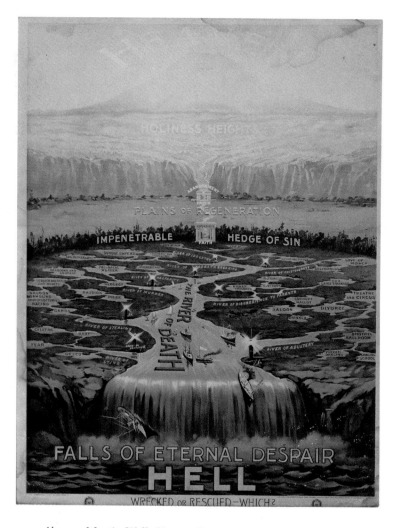

*Above:* Martin Wells Knapp, FALLS OF
ETERNAL DISPAIR (PREACHING DIAGRAM):
lithograph, 26 × 32", 1895. (Eleanor
Dickinson. Photo: M. Lee Fatherree)

Roadside sign, Cobden, Illinois, 1977.
(Photo: Eleanor Dickinson)

major artistic attraction, Para-
dise Garden.

Howard: "I made covered
bowls, dressers, mugs, cannon
guns, and doll furniture at my
woodshop in Trion. Later I
started making wooden clock
cases. Sometimes I would buy
nine hundred dollars wholesale
of G.E. clocks and cut a place in
the frame I made to put a pic-
ture. I called them family picture
clocks. One time I made a sale of
one hundred and fifteen clocks
for one thousand dollars to Bill
Thornburg of Anderson, Indi-
ana. I would cut the clocks out
with a jigsaw and shape them on
a router and trimming machine.
I started forty to fifty clocks a
day and even got the kids to cut
a few."

His daughter, Beverly, re-
members her dad working on
crafts and clocks in the basement
of the house. "I did some of the
trim work on the clocks. I would
burn the designs on the edge. He
paid us kids by the piece."

These clocks were important to Howard for several
reasons. First of all, he was now able, without enlisting
help outside the family, to mass-produce an item he could
turn out quickly. Production techniques, picked up in
factory work, could be translated in time- and money-
saving efforts. "I built family picture clocks by the truck-
load. I made my own printing heads and made all kinds
of designs, and my clocks sold beyond demand for fifteen
dollars."

These clock cases were utilitarian, handcrafted, and
in the folk tradition of the cottage industry crafts. What
Howard learned from his woodworking was that with
hard work, control, and a unique product, he could sup-
port his family independent of the local factory and still
have time to preach the Gospel. In addition, Howard

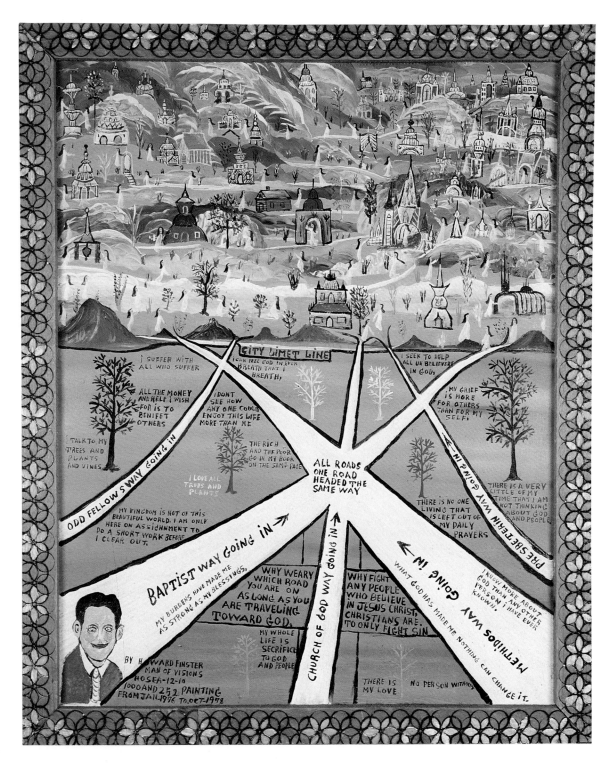

ALL ROADS ONE ROAD HEADED THE SAME WAY: enamel on wood, 1978, #1000 252.
(Cavin Morris. Photo: Barry Pribula)

*Right:* "My kids in my first garden," Trion, Georgia.

*Right below:* "This is a fourteen-foot wooden structure and my wife and a small child in the Garden."

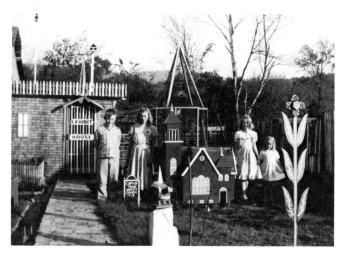

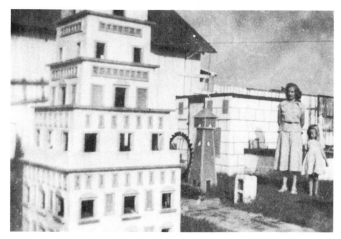

*Above:* "This is a model of the First Baptist Church at Trion."

honed his talent at selling to the public what the public wanted—something unique and inexpensive.

Howard: "I made seventeen hundred dollars' worth of grandfather picture clocks and one night I set one of these clocks on the television and this song came to me and I wrote it before the clock":

### *You're My Clock That Hangs Upon the Plastic Wall*

1) You're my clock up on the wall
You will tell me when you call
You will tell me when to come and go
I will read your dial by day
while you count my time away
As your hands will point the number of them all.

*Chorus: repeat between verses:*
You are my little master's king
You point my time to many things
You're the clock that hangs upon my plastic wall

2) I will follow by your time
I will wake up when you chime your golden hands
that point me through the day

3) You can send me out this morning
You can bring me back to night
I will follow by your numbers
for I know you always count them right.

4) You're copied more than a million times.
The world looks on your face.
You time the greatest warships
and orbits through the space.

5) You follow the sun by day.
You follow the moon by night.
You lose no time by sleeping
I know your time is right.

6) Nothing more to take your place
to cause the perfect time.
Without your service we would drift
the space of unknown time.

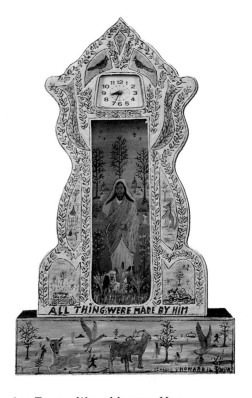

ALL THINGS WERE MADE BY HIM:
clockcase: enamel, wood, glass, and
clock, $27^1/_2 \times 17 \times 4^1/_2$", n.d., 12 hours.
(Herbert W. Hemphill, Jr. Photo: Stuart
Rome)

"I began machine work on cars and could rebuild a motor. I worked on lawn mowers and repaired bicycles for years. The reason I worked on bicycles was that at Christmas time you would see kids with new bicycles, and a little poor ragged boy would be out there crying for one and couldn't get it. I started making bicycles they could afford, ten or twelve dollars for a bicycle. I fixed 'em over and over."

Summerville resident Alfred Henderson: "If a tire blew on your bicycle, he'd fix it. Maybe at the end of the week he'd let you mow the yard for him. If you didn't have a bicycle, he'd let you work it out and sell you one. He'd seen that there wasn't a kid in the world that didn't have a bicycle."[2]

Howard: "I wanted to enlarge my museum due to the fact that the highway was missing me and I'd run out of land. The church I was pastoring, Chelsea Baptist, had a

"Selling my woodcraft at a flea market in Scotchborow [Scottsboro], Alabama. Sold five hundred dollars worth of things I made at one parking," 1960.

beautiful hillside and big pine trees as well. I wanted to build a garden on church property for church work. I wasn't able to get any backing from the church officials. . . . They never did bring it up before the church. They wasn't interested enough in it, so I left that church. Well, over in Pennville, off Highway 27 next to Summerville, there was this abandoned lake where doctors used to come in rowboats and kill ducks. I found this lady who begged me to buy it for a thousand dollars. It was a wasteland."

### RECORD OF HOWARD BEGIN WITH SCRAPS AND WOUND UP WITH PROFIT

I bought a junk bicycle from Mr. Gowers for three dollars and added my skill and a few new parts to it and it became a nice bike worth fifteen dollars. So I sold it for fifteen dollars. From a wholesale catalogue I bought seven wall clocks. By adding seventy-five cents and my skill, I designed a mantle clock case with a few pieces of wood. I built seven beautiful mantle clocks that wholesaled at ten dollars each, which totaled seventy dollars. I sent one hundred dollars to the World's Mission Rice Fund for the hungry, I sent another hundred to A. A. Tanner, the radio pastor, and twenty-five cents to the Flower Fund, ten dollars to my pastor, ten dollars to my church, one hundred to a sick patient in Trion Hospital, one hundred to Frank Rosser, my favorite missionary, which left me a balance of forty-five seventy-five, which would buy 456 scrap pieces of plywood from Bryce Evins wood shop and from these scrap pieces I could build two hundred fifty clock cabinets at four-fifty each, which amounted to eleven hundred twenty-five dollars, which I did, taking three seventy-five and turning it over four times and coming out with eleven hundred twenty-five. How did this happen? By using my gift of talent and tools and labor.                    —1949

## The Truth of the Trade

I was a farmer. I could plow, cultivate, plant, sow, gather, and preserve, all it took to be a farmer. But I finally quit. I done hammer out blacksmith irons with white heat and shoed mules, but I finally quit. I begin preaching as a pastor and pastored churches for many years, but finally quit. I mounted animals, stuffed them, treated them with formality-hide, and even skinned a chicken so small its skin was almost thin as tissue paper. I stuffed him, sew him up and mounted him on a board, standing up and eating corn from a little pan, and had corn in the pan. But I finally quit. I told a few fortunes as a mind reader but I finally quit. I begin woodcraft and could do top work as a finisher and was finally employed at a furniture factory, but quit. I became a textile employee and learned to wind thread and work with cotton fabrics, but quit. I became a machine fixer in a glove mill and could fix machines, but I quit. I worked in a dye house dyeing cloth, became a cloth inspector, and quit. I took up carpenter work, built houses, remodeled flooring, tiling, plumbing, and pipe work, but I quit. I begin plumbing and pipe cutting but I quit. I even made bricks and blocks with my own mold and build my first home, but I quit. I begin lawn mower and bicycle repair for years but I quit. I begin making clocks by the hundreds and hundreds but I quit. I begin machine work on cars and could rebuild a motor but I quit. I used to contract cutting logs from the forest but I quit. I owned and operated a grocery store for years but I quit. I begin marrying people and preaching funerals for years and still do. In 1976 I begin folk art painting and I don't think I will ever quit because I can do all these things together in folk art painting. I find no end to folk art painting, and I don't think no artist on earth found the end of art.                    —*1976*

CLOCK CASE: wood, pyrography, glass, and collage, 12$^1/_2$ × 13″, ca. 1969. (J. F. Turner. Photo: M. Lee Fatherree)

# CHAPTER 3

# The Inventions of Mankind

*Originally intended to be simply a larger-scale version of his backyard museum in Trion, Paradise Garden is Howard Finster's major statement in art. It is his purest, largest, and most complicated work, encompassing over three acres and hundreds of individual creations in several media. Starting with cement walkways to exhibit houses, the Garden began taking on a Surrealist air when Howard built a cement wall inlaid with castoffs and family mementos. This wall was not built to keep out visitors, but to draw them in. And it did. Embedded in the wall, in addition to a vial containing a neighbor boy's tonsils, visitors discover bits of cast-off jewelry, watches, plaster statues, and all manner of oddities. Verses from the Bible, painted on masonite, were attached or placed next to many of the exhibits. For example, an eight-foot concrete shoe was inspired by Ephesians 6:15, "And your feet shod with the preparation of the gospel of peace." The combination of the word and an image, usually of an eye-catching fantasy nature, was reminiscent of the preaching diagrams that Howard used in his children's Bible classes. The key to this instruction was getting the children's attention and then getting the biblical message across in the simplest of terms. This teaching technique, used in what was now becoming his "Bible Park," was successful on several levels. It offered the visitor an entertaining experience and gave Howard an opportunity to spark a conversation that eventually led to a sermon on any of a multitude of topics. The park was built as a labor of love and devotion, and stands as a testament to the drive and dedication of the visionary able to materialize his vision.*

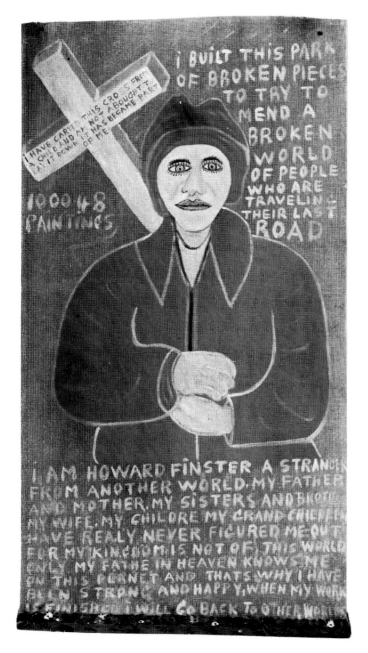

In the image, the following text appears as part of the artwork:

I BUILT THIS PARK OF BROKEN PIECES TO TRY TO MEND A BROKEN WORLD OF PEOPLE WHO ARE TRAVELING THEIR LAST ROAD

I HAVE CARVED THIS CROSS FROM A CHILD AND AM NOT ABOUGHT IT SAY IT DOWN OF ME HAS BECAME PART

100048 PAINTINGS

I AM HOWARD FINSTER A STRANGER FROM ANOTHER WORLD. MY FATHER AND MOTHER, MY SISTERS AND BROTHERS MY WIFE, MY CHILDRE MY GRAND CHILDREN HAVE REALLY NEVER FIGURED ME OUT FOR MY KINGDOM IS NOT OF THIS WORLD ONLY MY FATHE IN HEAVEN KNOWS ME ON THIS PLANET AND THATS WHY I HAVE BEEN STRONG AND HAPPY, WHEN MY WORK IS FINISHED I WILL GO BACK TO OTHER WORLDS

Paradise Garden Banner, enamel on military cloth, 44¹/₂ × 24¹/₂", 1978. (J. F. Turner. Photo: M. Lee Fatherree)

Howard: "I always wanted to build something like a city. When I was a small boy I'd take rocks and line 'em up and have streets and a little town. When the Lord called me to preach, I was on a creek bank on our farm making mud steps up the side of the creek. When he called me to preach, I had to lay that all down."[3]

"At the last church I pastored before I retired, I wanted to build a garden on church property and have a

park for the church and the children. I couldn't get any backing on it, so I come home and give the church up. I preached about forty years. All the time I was preaching my mind was on building something. I know I was going to build this garden because it was on me to build it. 'Just something,' I told the Lord. 'Is there anything else you want me to do besides pastoring?' So it came to me to build a Paradise and decorate it with the Bible.

"God spoke to my soul that there was something for me in Pennville. We moved there from Trion in October 1961.

"The two and a half acres I bought were nothing but wasteland. A lot of people used it as a dump for their garbage. It took me seven years to fill in that swamp of rich muck that went three to four feet in depth. I took my wheelbarrow, shovel, garden tiller, and mow blade, and began to clear away the underbrush. I located three springs on the land, routed them in the direction I desired, built the low areas, and leveled the land. Snakes, I never saw so many, I killed about one hundred while working here, but was bitten only once. I drained the bite by sucking it, and when the pain went away, I went back to work.

"The mire was so bad that at times I had to pull my boots out by hand. One day I looked up from where I stood in that swamp and suddenly I was tired. I felt that I had taken on too big of a job, what with only myself, my wheelbarrow, and my shovel, and I said, 'Lord, give me the strength to build this park.'[4]

"I had to have a shop, so I started digging out a basement from under our house and taking that dirt out back by wheelbarrows every day. I built up my muscles that way. A year later, after putting about eighteen inches of fill dirt on that lake, I began to plant a few trees and flowers and put some beds with dirt in them in the branches of the springs, so I could grow things year round: they always had water. I started going to the dump and collecting old broken dishes and molding bricks. I'd go to the dump and find some of the prettiest things you've ever seen. Sometimes twenty-two-carat gold dishes would be broke and thrown in there.

"I built the park because I was commissioned by God. I started the Garden in 1970 about one hundred feet

*Opposite:* Paradise Garden, 1977. (Photo: Willem Volkersz)

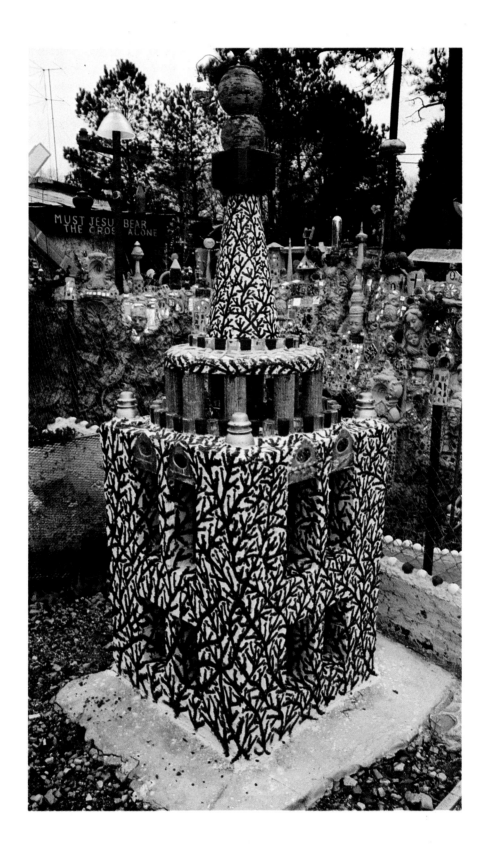

**HISTORY** OF PLANT FARM MUSEUM — IT TOOK ME ABOUT SEVEN YEARS TO CLEAR OUT THIS JUNGLE KILLING OVER ONE HUNDRED SNAKES, AND CUTTING THOUSANDS OF TREES, BUSHES, VINES AND THORNS. FILLING DITCHE. LEVELING CLEANING OUT GARBAGE THROUGHOUT. LABOR ALL BY HAND TOOLS. STANDING ON MUD PALETS RAKING OUT WATER WAYS FOR THREE SPRING BRANCHES. IT WAS SAID BY MRS. C L LOWERY THAT THIS PLACE ONCE WAS A LAKE WHERE MEN HUNTED DUCKS FROM SMALL ROWE BOATS. MR. C L LOWERY FORMER OWNER OF THIS LAND DUG INTO A CLAY POT OF INDIAN ARROW HEADS. IF HE FOUND OTHER THINGS ITS UNKNOWN. SINCE THAT TIME I FOUND ONE SMALL PIECE OF YELLOW GOLD SHINING FROM THE MUD WHERE I WAS DIGGING. NOT TOO FAR FROM THE CLAY POT MR. LOWERY WAS A MUSIC TEACHER WROTE THE WORDS TO THE SONG LIFES EVENING SUN ALLSO STUDIED AND WORKED ON PREPITUAL MACHINE 40 YEARS. I NOW HAVE REMAINS OF HIS MACHINE. MANY YEARS AGO I KNOW GOD SPOKE TO MY SOUL THAT THERE WAS SOMETHING FOR ME IN PENNVILLE AFTER 40 YEARS PREACHING THE GOSPEL WITH OUT CHARGE. I THEN FELT LED TO BUILD A PARADISE GARDEN IN WHICH I WILL OPEN PRINT THE HOLY BIBLE VERSE BY VERSE. THROUGHOUT. PLEASE RESPECT FOR CHRIST SAKE W H F

HISTORY OF PLANT FARM MUSEUM (Sign): housepaint on wood, 47 × 54½", ca. 1974. (Robert Greenberg. Photo: Frank Maresca)

into the backyard, built a cement walk, and put up a haul shed and started to display the inventions of mankind. My park is a memorial to inventors. The inventors don't get recognition. They don't have an Inventor's Day. To represent them, I'm trying to collect at least one of every invention in the world.

"An unknown number of probably thousands of people has visited my park of exhibits of antiques. After the tour, as they come out the gate, I can hear these words: 'Finster, you are in the wrong location. You need this park on the highway. It would be a gold mine.' You would be surprised how long it would take to tell each person why I am not located on the highway, even as I wish myself. The answer is it took nine years with the Trion Mills as a hand, and sixteen years of self-employment, to raise and school five children, and raise enough money to buy the cheapest location in Pennville, even a swamp of mud and water. I am fortuned by the help of God just to have this location.

"What would it take to put fourteen hundred exhibits on display across the highway from the Penn Drive-in Theater? It would take a pardner of one quarter of a million dollars, and three acres of land. One acre for front parking, two acres for sidewalks, pools, exhibits, artificial rocks, and animals. Cages for fowls, and animals. Fish ponds, pools, skating rinks, swings, play areas, and equipment, castles, and midget cities, waterwheels, gaslights, registering gates to one of the greatest excitements of Chattooga County with a reasonable charge to enter the park with activity to all privileges of seen [scene] and entertainments.

"I have seen this picture for many years and started it. But I cannot paint it by myself. I need a quarter-of-a-million-dollar man to help me make this picture come true. I am sure it would pay back and be educational to the general public and tourist. Give me three acres of land and three good work hands and a living salary until this park is completed and tell me when to start.

"I've saved everything but money. It is said in

Proverbs 18.9: 'He also that is slothful in his work is brother to him that is a great waster.' It was said by my grandfather who was a minister many years ago that it was a sin to waste things. If a man at retiring age had the full value of what he and his family had wasted, it would probably be enough to furnish him the rest of his life.

"You name any valuable thing that is of benefit to the human race and you are naming something that is being wasted every day in our country. Skidding rubber off your tires just to hear them scream; running the gas tank over, spilling fuel on the ground; making unnecessary trips; turning on the TV; leaving the room for an hour with no one watching, burning lights that are not needed; dripping water by not cutting it off good. Twenty or thirty pounds of food each week dumped in the waste can; disposing of clothing that could be mended; taking two or three draws from a king-size cigarette, mashing the rest of it in the ground with your foot; heating rooms that are not necessary; building large additions to God's church and not even using them all; building new schools and not even using them ten years until they are closed and consolidated to another school.

"My wife said, 'Don't build that garden, get that junk

HENRY FORD AT 2¹/₂: enamel on masonite, 31 × 50", ca. 1977, #1000 36. (Liz Blackman. Photo: Lannen/Kelly)

57

The first haul shed built in Paradise
Garden to display the "Inventions of
Mankind." (Photo: Greg Blasdel)

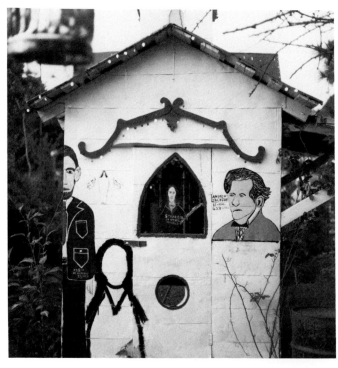

WASTE CAN: enamel on metal, 20 × 29",
1979. (Collection of Andy Nasisse.
Photo: Walker Montgomery)

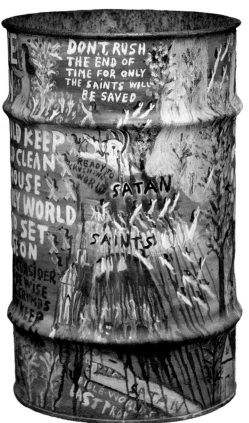

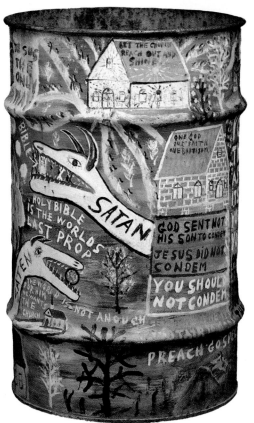

out of there,' but the Lord gave me a picture in the night what to do the following day. I wasn't expecting to excite the whole world. I just wanted to put every verse of the Bible in there. I wrote what I felt God's word says. If I had to write it on a refrigerator or down on the sidewalk out of marbles, I wrote it. People were saying, 'What's that fool doing, breaking up the Bible and putting it in his garden when everybody has a complete Bible?'

"My family didn't like what I was doing, especially my wife. I told her, 'I'll make an agreement with you, since I ain't got nowhere to build this garden. I'll give you the front of the house and everything. I'll take the back-yard and back porch.' I said, 'I'll have more visitors in my backyard and porch than you'll ever have come up your front steps.' So I made a deal with her, you know."

Pauline: "Howard's life has always been to build and make something that people would want to see. That's just Howard. The park was something for the people to see. He has always been a very busy person. I used to tell him I wished I had half his energy. He was working in the

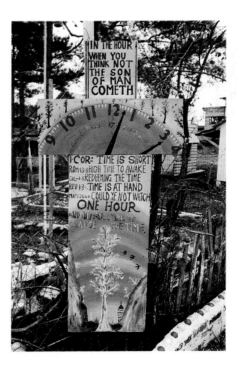

Paradise Garden, 1977. (Photo: Willem Volkersz)

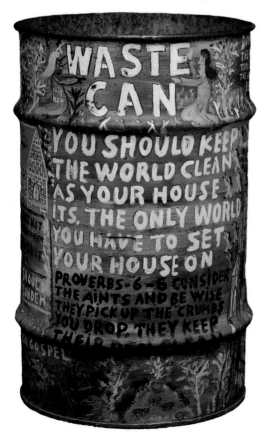

These are two of the twenty-one trades Howard used to support his family and ministry. (Photo: M. Lee Fatherree)

park in all his spare time. He liked to put out a little bit of everything. He liked to mix, because he thinks that's the way the Garden of Eden was—fruits and flowers and everything mixed together. I helped him plant flowers once in a while. We had corn, tomatoes, sweet grapes, sunflowers, cucumbers, plums, grapes, apples, blueberries, septadine, and crepe myrtle."

Howard: "I made the walkway day by day. I started molding in just gold watches and gold rings, jewelry, diamonds, anything that shined. I got ahold of some old purple milk bottles and I began to mold them in. Later they passed a law to keep people out of the dump and I couldn't get nothing there, and the people found out and started coming by here and letting me pick out what I wanted before they went to the dump. Everything you can think of that people throw away is in this park. I got to molding fragments of mirrors and I got to buying mirrors. I was the only fellow that anybody known of that would buy a broken mirror. They would break a mirror and come to Howard Finster's and I'd give them a dollar and a half or two and I would cut them in diamond shapes and start molding them in."

Pauline: "Sometimes they would just bring junk and he'd always pay them whatever he thought it was worth and I'd get aggravated."

Howard: "Most of the stuff here in the Garden is junk and not worth anything, and if it is worth anything, I damage it to where it ain't worth anything."

Pauline: "Some of the townspeople would laugh at Howard, but it didn't seem to bother him. He just went on his way, working like he wanted regardless of what people thought. He never did seem to mind."

Howard: "My only son Roy Gene runs a TV repairshop, and me displaying the inventions of mankind, like old junk in my park, and him repairing TVs, well I found out that people around were calling me and Roy 'Sanders and Son' [*Sanford & Son*, 1970s television series about a junk collector and his son, starring Redd Foxx]. Well, it fits pretty good. I like Sanders and Son programs. I also like Lucille Ball and Red Skelton. They never make fun of God or the Bible."

Howard's youngest daughter, Beverly, remembers her father repairing and selling bicycles: "Everybody

wanted to come here and get their bikes, because they could get them cheaper and they would last longer. He was always popular among people. He said there was an adult world and a teenage world and a kids' world. He always talked to us about our lives, and he'd preach to us individually. My dad had a museum and he was doing different things than anybody else. Nobody else was building a park. I realized that I was going to have a different life than my friends. My nephews, Andy and Alan, would haul bricks and carry stuff in the garden under the direction of Papa. He also would hire people who came by and needed work. He built that garden in three or four years."

*Right:* Pauline Finster tending her vegetable patch next to Paradise Garden. (Photo: J. F. Turner)

*Below:* The main trail, Paradise Garden. (Photo: Cement Products)

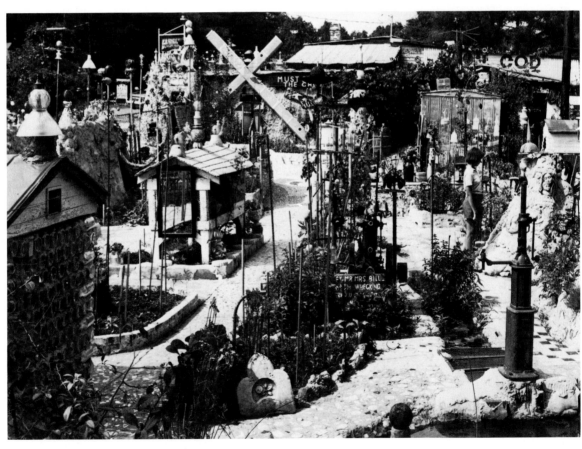

61

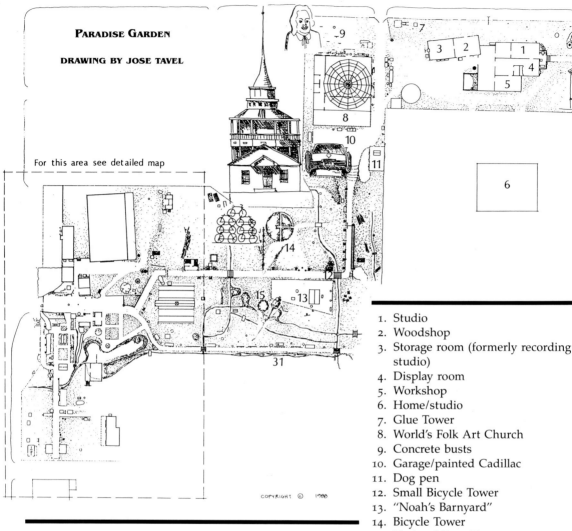

## Paradise Garden

### DRAWING BY JOSE TAVEL

For this area see detailed map

COPYRIGHT © 1988

1. Studio
2. Woodshop
3. Storage room (formerly recording studio)
4. Display room
5. Workshop
6. Home/studio
7. Glue Tower
8. World's Folk Art Church
9. Concrete busts
10. Garage/painted Cadillac
11. Dog pen
12. Small Bicycle Tower
13. "Noah's Barnyard"
14. Bicycle Tower
15. National Rose Tower
16. Bunk House
17. Concrete "Giant's Shoe"
18. Angel
19. Tomb of the "Unknown Body"
20. Shoe Room
21. Exhibition Gallery
22. Painted refrigerator
23. Location where Howard had the vision to "paint sacred art"
24. Display building (formerly bike shop and television repair shop)
25. First concrete wall (embedded with artifacts)
26. Bible House

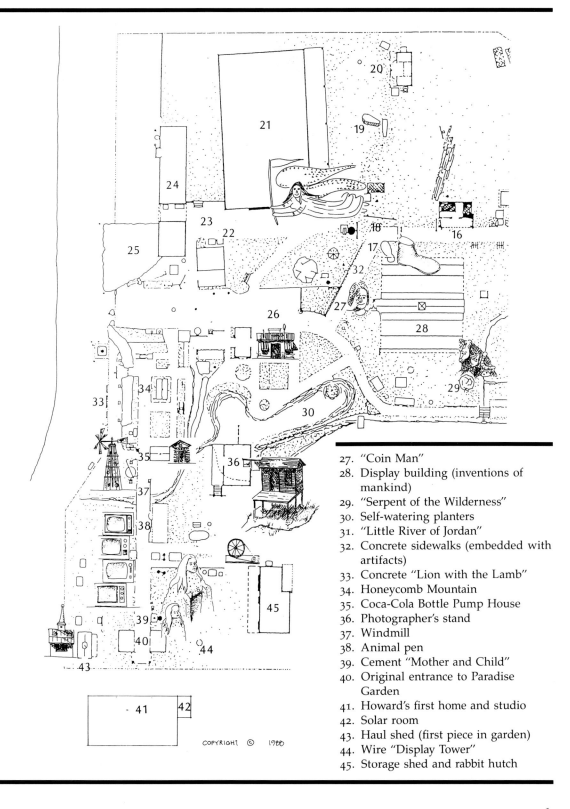

27. "Coin Man"
28. Display building (inventions of mankind)
29. "Serpent of the Wilderness"
30. Self-watering planters
31. "Little River of Jordan"
32. Concrete sidewalks (embedded with artifacts)
33. Concrete "Lion with the Lamb"
34. Honeycomb Mountain
35. Coca-Cola Bottle Pump House
36. Photographer's stand
37. Windmill
38. Animal pen
39. Cement "Mother and Child"
40. Original entrance to Paradise Garden
41. Howard's first home and studio
42. Solar room
43. Haul shed (first piece in garden)
44. Wire "Display Tower"
45. Storage shed and rabbit hutch

COPYRIGHT © 1980

Bible House, Paradise Garden. (Photo: J. F. Turner)

When I visited Howard in the summer of 1987, he offered to be my guide on a tour of the Garden. He told me: "I got to studying about doing some art in the cement and I cut bars of mirrors and molded mansions in the walk. I begun to do art in the walks. This wall here is the first big cement I done. I have family names in here and friends and all kinds of things molded in it. A doctor gave me a little boy's tonsils in a jar and I molded them in here. One fellow brought his birth certificate in, and this lady who died, she wanted her plates preserved, so I put them in the wall. Over here is part of a walk about a yard square, paved with old keys. I wrote here, 'Prayer is the key.' And on that wall is a big old yoke and it's got a message from the Bible that says, 'Take my yoke upon you.' And yonder is the Bible house. It's got the story on it about the Last Days. 'In the last days perilous times shall come and there shall be famines and pestilence and earthquakes. The men leaving the natural use of women burned in their lust one toward another. Men with men working that which is unseemly.'

"This is the Bicycle Tower. I had tons of bicycle parts and I sold a lot of them for scrap iron.

"I'd take trade-ins and pile 'em up. It got into boxcar loads, tons of metal. I sold one load and it didn't bring enough to fool with. I made a tower out of steel, thirty feet across the bottom and about twenty feet high. It's a real tower now and has a loft in it, you can walk along the bottom of it and get bicycle things, lawn mowers, televisions. It's a fancy place for birds, and the bottom is a den for the field snakes.[5]

"I couldn't get enough for [the bikes] and I had a vision of making this tower and growing fruit and stuff on it. It took me about two weeks to wire it up. I built it around growing trees. I raise artichokes, butterbeans, and natural wild roses around it.

"Pauline says this junk ruins the Garden. If she had her way, it would go. . . . There are fifteen watches molded in that walkway. It also has shells, jewelry, coins, antique bottles, anything that shines and is pretty. This here is a giant cement shoe. I molded that from one of my

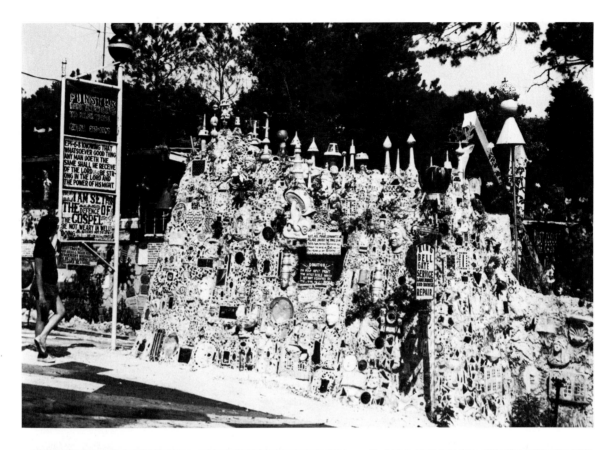

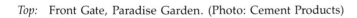

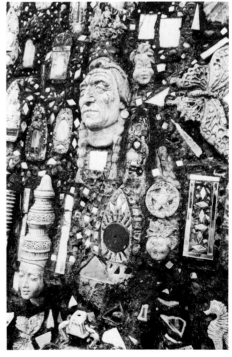

*Top:* Front Gate, Paradise Garden. (Photo: Cement Products)

*Right:* Detail, Front Gate. (Photo: J. F. Turner)

*Left:* Mirror- and tile-inlaid walkway, Paradise Garden.
(Photo: J. F. Turner)

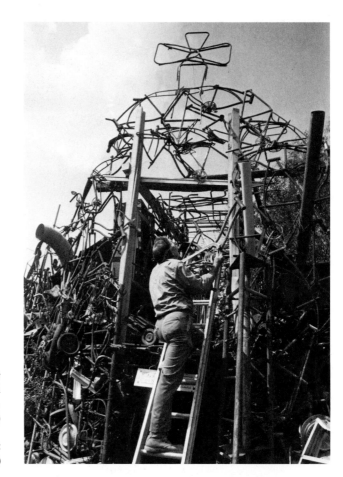

*Right:* "The Tower reminds me of the many years I worked on bicycles and that's the reason I built it." (Photo: J. F. Turner)

*Below:* Inside the Bicycle Tower. (Photo: © 1986 Marianne Barcellona)

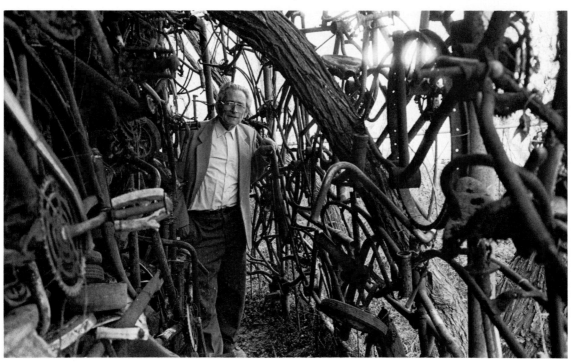

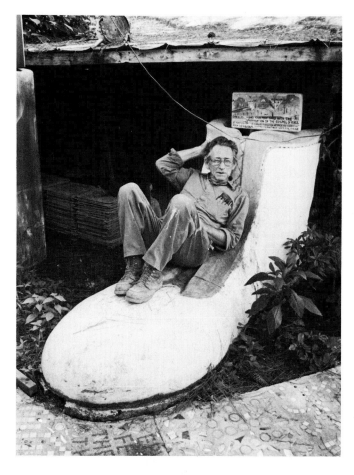

The "Giant's Shoe" in Paradise Garden, modeled after Howard's own work boot. (Photo: J. F. Turner)

old work shoes. It weighs about two tons and took me about ten hours to make. It's filled in with bricks and old rocks and is covered with cement. That shoe represents being shod and it saves your feet from all the sharp rocks and it protects you, just like Jesus. . . .

"I keep a record of everything. I welcome visitors to my park during the day hours with the exception of from two to six each Sunday. There is no admission charge. I started registering all my visitors in July of 1975. I write some of their names on the wall. I got people from all over the States.

"I seen kids out of their mothers' arms pick their first fruit here. I get to see them pick their first fruit. Their eyes will dance at a plum tree with a thousand red plums and wonder why in the world he hasn't seen them before. And he'd get ahold of it and the limb wouldn't give and he'd think he couldn't get it and I'd say, 'Keep comin on out, yank on it.' And directly he'd pull it off and look at it. For the first time in his life, he sees where such as that comes from, and laugh seeing where it come from. And

he'd never seen it but from a paper bag. That's what this Garden's about. This Garden's a contribution.[6]

"Over here is a pigeon sanctuary. I raised them and angory rabbits for a while. That's an electric stove I poured cement over and made into a mountain. The animals go in there and hibernate. The scorpions have taught me things. I have watched the spiders. They even weave their web within four feet of my porch. I learned how they measure and make the perfect pattern. The spider has learned me art.

"Things grow wild and unbelievable in my Garden. I just weighed an eight-pound pota pumkin that was plucked hanging from overhead. Zenas, old maids, marigolds, and touch-me-nots all grow far above my head in my Garden. Westera vine grows about one hundred feet. My roses grow from twenty-five feet to fifty! I picked one rose; it measured ten inches across the top. My grapes grow over forty feet out and some have second-crop bunches. Butterbeans grow thirty feet. I also had goldfish, geese, guineas, peacocks, goats, and a three-legged rooster in the Garden.

"I wrote God's messages on that lawn mower and it's preaching for me. I put things to work for the Lord. That mirror house on the platform, I built it for photographers to take aerial pictures of the Garden. The inside is all mirrors too. I like going up there with just a few people because they reflect all over that room and I feel like I'm preaching to a whole congregation of people. I can also stand with my back to the neighbors and look into the

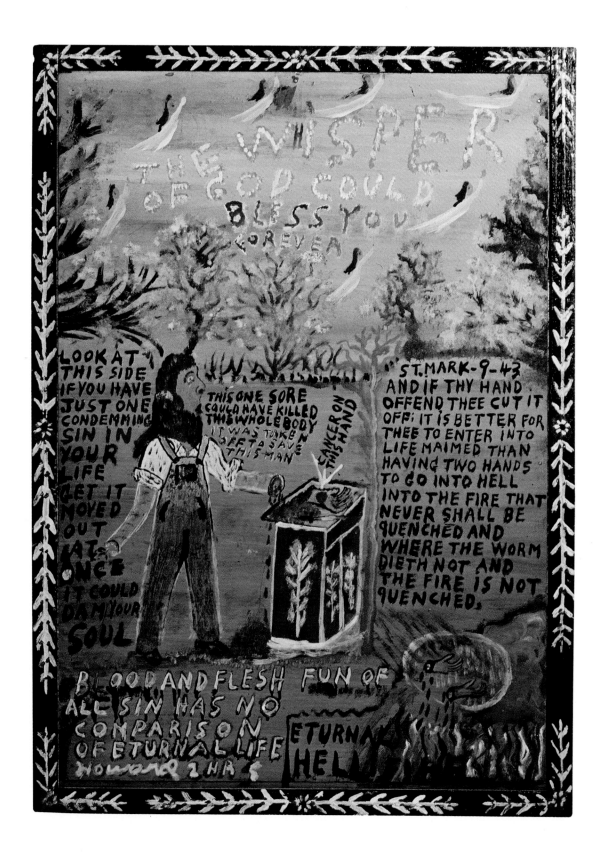

*Below:* Paradise Garden, 1977. (Photo: Willem Volkersz)

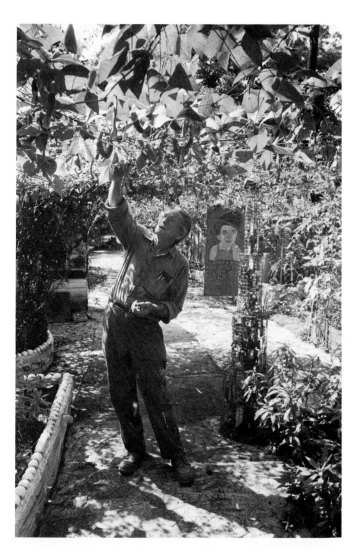

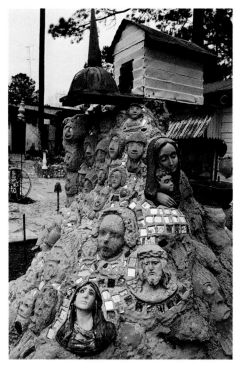

*Top right:* Howard picking beans in Paradise Garden. (Photo: J. F. Turner)

*Bottom right:* "Noah's Barnyard," Paradise Garden. (Photo: J. F. Turner)

*Opposite page, top:* SOME OF THE MOST BEAUTIFUL FLOWERS: enamel on wood, 24 × 36", ca. 1977, #1000 11. (Herbert W. Hemphill, Jr. Photo: Stuart Rome)

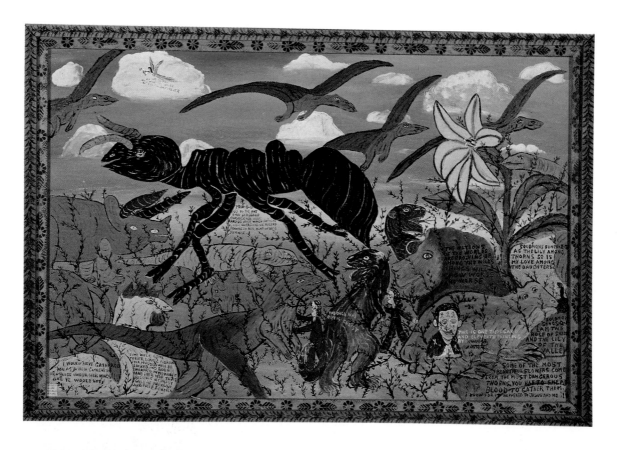

*Left:* SNAPPING TURTLE LAWNMOWER: Paradise Garden, 1979. (Photo: Jeff Camp)

*Right:* Photographers' platform, Paradise Garden. (Photo: J. F. Turner)

mirrors and see what they are doing without them knowing it.

"God wanted me to take this junk and make something out of it and show people who got things that they could do something where they stand. You see, I'm an example from God and the world to the principles of God. God didn't just call the many wise people or prudent people, he called the little people like the fisherman and everything and made something out of them. And that's the way I am.

"Now, I was pastoring churches and I couldn't reach very many people. There was only about fifty to seventy-five people that I could reach, unless I was in a revival. The same people came every Sunday. One night when I was pastoring, I asked the congregation what I had preached on that morning. They had forgot what I preached on that morning from one service to another. I figured if I done my art enamel and put it out on paintings, if they forgot today, they could remember it tomorrow. Like the Bible says, 'Without a vision the people perish.' When they read a line they forget it, but when they see a line and see a picture, that reminds them of it. It presses it deeper into the brain cells.

"I built clocks, I done woodwork, and I fixed lawn mowers. I fixed about anything that came along if people wanted it fixed. I fixed bicycles and when I was through, I would paint a bike up like new. Sometimes I would paint a bike up and it would fall over and get a scrimp place on it. Well, I hated to go over the whole thing, so I started out patching it with a little brush, but it would always leave marks, you know, so I took my finger and dipped it in paint and found it so much smoother than the brush.

"One day I dipped my finger in some white paint and picked it up, and when I picked it up, it formed a face before I ever seen the face, and I turned it around to look and see if I had too much paint and there were two eyes, a mouth, a nose, and everything. A whole face. My finger looked like a face. All it lacked was a little hair around it. And there was a feeling that come over me, a divine feeling just came over me and said, 'Paint sacred art.' I said, 'Lord, I can't paint. I don't have no education in that.' So then I took a dollar bill out of my wallet and started posing on [copying] the picture of George Wash-

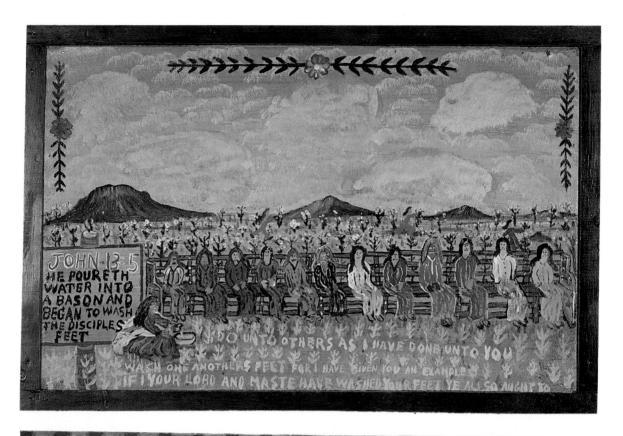

JOHN 13.5

HE POURETH
WATER INTO
A BASON AND
BEGAN TO WASH
THE DISCIPLES
FEET

DO UNTO OTHERS AS I HAVE DONE UNTO YOU

WASH ONE ANOTHERS FEET FOR I HAVE GIVEN YOU AN EXAMPLE

IF I YOUR LORD AND MASTER HAVE WASHED YOUR FEET YE ALSO AUGHT TO

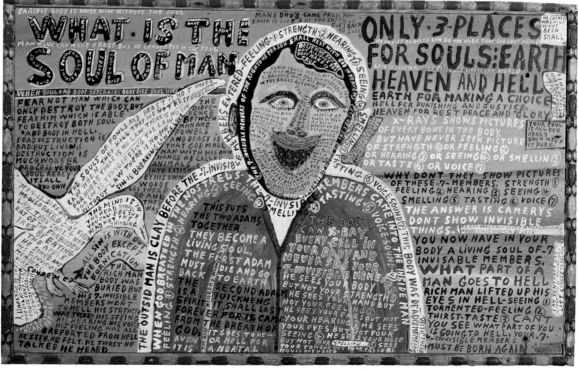

WHAT·IS·THE
SOUL OF MAN

ONLY·3·PLACES
FOR SOULS:EARTH
HEAVEN AND HELL

EARTH FOR MAKING A CHOICE
HELL FOR PUNISHING AND JUSTICE
HEAVEN FOR REST PEACE AND GLORY

ington. Some kids were around watching me work and that was the first time I felt I was an artist.

"After I drawed George Washington off a dollar bill I painted him three times as he growed: first, best, and greatest. This was in January of 1976 and I got shut in by the cold weather and didn't work on the Garden, and these pictures came on my mind and I began to paint them and I just painted a sluice of them.

"I have inner-ear trouble. I chew tobacco to clean out the fluids. When it hits you, you have to shut your eyes and lay still. Sometimes I'd wake up in the morning, turn my head over, and when I did, the ceiling would just go in a million miles. I'd have to lay back down and just keep messing around till I got to where I could get up. I found out after I had a few of those inner-ear spells that I wasn't going to be depending on pastoring at the church. I might get up and fall right in front of them.

"I used to remodel houses, but I've always wanted to build just real castles, you know, a big castle. I decided I'd start painting, and I found out I could just build castles and everything sitting in a chair, you know, just with a little old brush. Now that's the reason I got interested in it, and I never have loved nothing as much as I've loved painting."

Although people were stopping by to see what was going on in the Garden as early as the mid-1960s, Howard's creations didn't receive major attention until 1975.

Howard: "I was first published by the Summerville *News* and the Trion *Facts*. One day in 1975 my friend Edith Wilson came by. She wanted to call Channel 5 in Atlanta and have them to come down and put my Garden on TV. But I told her that I lacked five years yet before I would have the Garden finished. So she took it on her own and notified Bill Flenn, the newsman on Channel 5, and he came down and they ran it three times. From Channel 5 it went to Miss Anna Wadsworth of American Art [Georgia Council for the Arts]. Then the Atlanta *Journal* put the Garden on the cover, including eight pictures through the magazine [January 1976]. *Esquire* magazine [December 1975] to Herbert Waide Hemphill, Jr., book writer and of the art and craft museum of Massachusetts [co-author of *Twentieth Century American Folk Art and Artists;* board member of the Museum of American Folk Art],

*Opposite page:*

*Top:* Howard re-creates the "face" that first inspired him to paint sacred art. (Photo: J. F. Turner)

*Left:* Howard's second painting as an "artist," "posed" from a dollar bill. Paradise Garden. (Photo: J. F. Turner)

*Right:* An early architectural sketch. (Photo: M. Lee Fatherree)

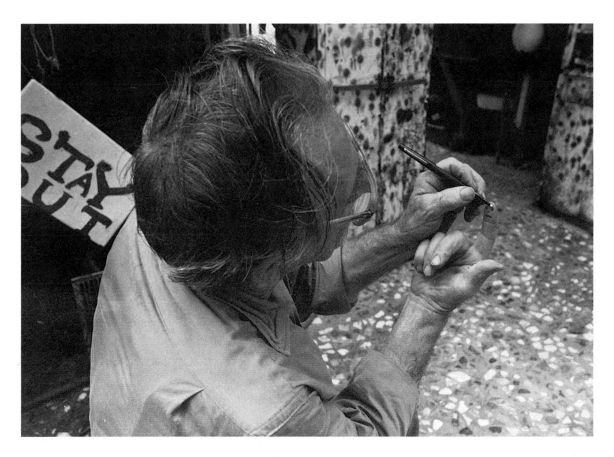

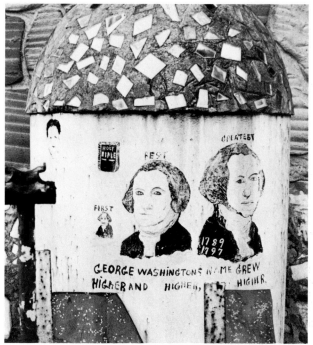

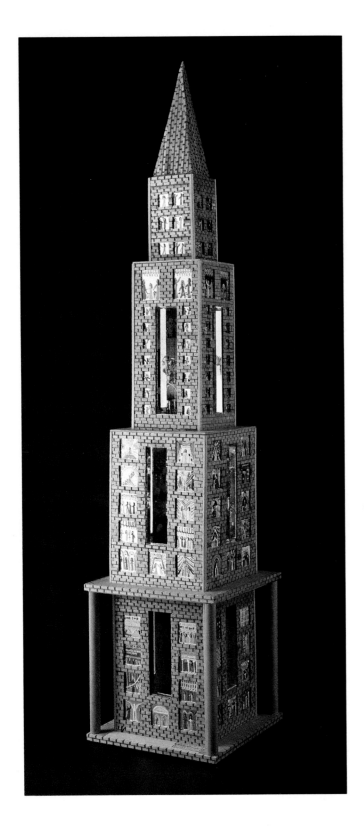

*Left:* Tower: wood with pyrography, enamel on mirror, $81^{3}/_{8} \times 17^{7}/_{8} \times 17^{7}/_{8}''$, 1981, #2000 241. (Jane Braddock & John Baeder. Photo: Larry Dixon)

*Opposite:* detail

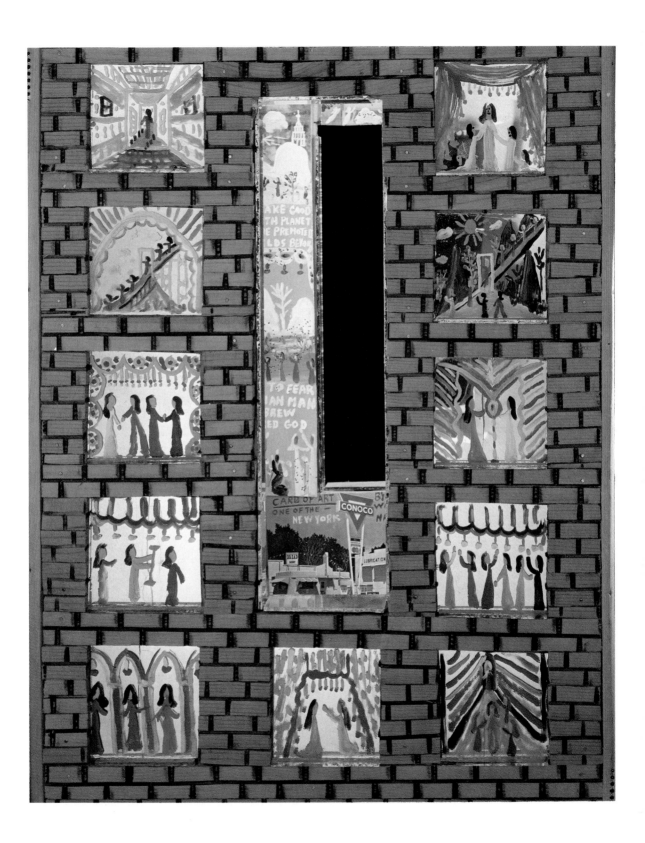

HEB~11: BY FAITH NOAH BEING WARNED OF GOD OF THINGS NOT SEEN AS YET MOVED WITH FEAR, PREPARED AN ARK TO THE SAVING OF HIS HOUSE

THE HIGHEST MOUNTAINS
BECAME SO LOW THEY COULD NOT
SAVE ANY UNBELIEVER
ONLY THE ARK COULD SAVE MAN
IN THAT DAY,

AS IN THE DAYS OF NOAH " SO SHALL IT BE
AS IN THE DAYS OF THE COMING OF THE SON OF
ONLY JESUS CAN SAVE IN THESE LAST DAYS, "

Noah Being Warned: enamel on panel, 17¾ × 36", ca. 1976. (Cynthia Carlson. Photo: Norinne Betjemann)

then to the new Bradley Wing of Columbus, Georgia.

"Then an art teacher [Cynthia Carlson] called me wanting to know how to get from New York to my place. I told her and she drove through, bringing her father, who was eighty-five years old. Well, she wanted a painting. I told her I hadn't sold any one for less than twenty-five dollars. I hate to sell anything less than that so I could always have a name that I have never sold one less than twenty-five, even if it's just a little one no bigger than your hand. She said okay, and for twenty-five dollars she bought a small painting of Noah's Ark. Also she made picture slides of the Garden to show her students. Then to Robert Bishop of the Henry Ford Museum of Dearborn, Michigan [Greenfield Village].

"Then the state of Colorado [Georgia, for a show entitled "Missing Pieces," curated by Anna Wadsworth] appropriated the funds to make a movie of the park and called me, saying, 'We will pay you one hundred dollars a day to be star of the show to explain the paintings and sermons and statues and Bible verses all over the park and to play your five-string banjo and your harmonica for background music.'

"On Sunday, July 11, the big truck from the TV network with all the equipment drove up with five employees to shoot the film. They worked me all day long, sweating and playing the instruments. It was all new to me. Visitors were setting all around, and the staff telling

78

them all the time, 'Don't make any racket, don't talk, don't walk, don't even breathe hard.' The sound doctor man kept a sound test on his ears all the time. A plane went over and they stopped shooting instantly. I would have to go over the act again. One time I was playing the harmonica and an old black dog outside the gate begin to howl to the music, so they had to cut again.

"So, film shooting is hard work and tedious. When they left I was ready to go back repairing lawn mowers. No more shooting for me. But the visitors looked happy to see the first movie of Pennville, Georgia. Some of my grandchildren were in the picture and some of my neighbors' children were in the picture.

"Then to the Georgia state art building in Atlanta. It was a special show and had three full pages of my work in the 1976 catalogue of the *Missing Pieces* book, selling at five dollars each. What a great fire Edith Wilson started with her little match!

1976 REPORT:
Donation: 695.53
Film Shooting: 100.00
Painting Sale: 580
Total: 1375.53

—*from a Finster painting*

"I wanted to keep my paintings to start with. See, when I started painting I had no intention to sell one picture. I was nailing them to the cement with cement nails. Visitors come here and kept going up on·them [in price] till I got my crowbar and I took them off. I even started painting the pictures on the ground so they couldn't take 'em. I had no intention whatsoever of selling any of the pictures when I put them out in the Garden. But I got to studying about God wanting me to sell them. He didn't want me to get concerned for the money I got out of them, but He wanted me to take the money I got out of them and put it back [in the Garden]. And another thing He wanted me to do, He wanted one of my pictures to speak to a million people instead of preaching to three or four thousand.

"When I sold them, I would draw them back [copy them]. They offered me one hundred dollars and then I painted another one back. Every one I paint is a little

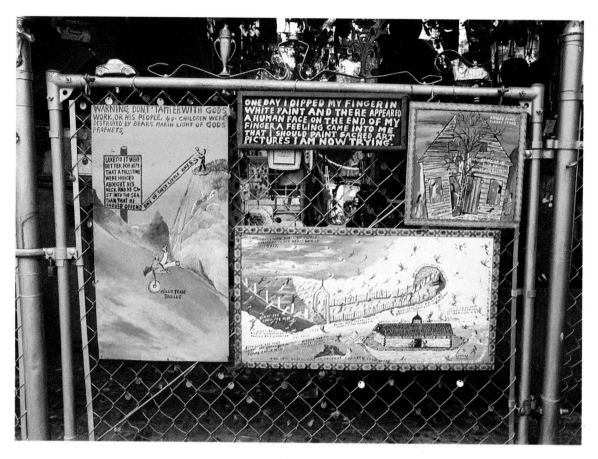

*Above:* Paintings on gate to Finster's Paradise Garden, 1976. (Photo: Willem Volkersz)

*Right:* The back of Howard's home in Paradise Garden, which housed his first studio, July 1977. (Photo: Greg Blasdel)

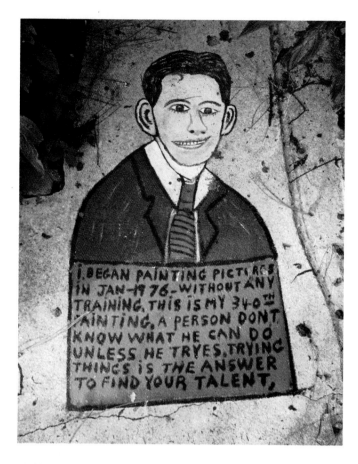

Howard Finster on Paradise Garden walkway. (Photo: Greg Blasdel)

different, never none alike. When a picture sorta makes a hit, I keep painting it and painting new ones. I got some drawn back as good if not better than the one I had.

"Not too many people know about this vision of 1976. It is just as real as if it actually happened. In fact, part of this vision is joined in personal contact. The first of the vision was seen. The last part of the vision was carried out by my own eyes and hands. It was a vision half seen and half done by me myself. I heard a voice calling at my garden gate where a lot of people blow their car horns and holler out, 'Howard, are you home?' I went to the door looking out over my back porch and at my gate a man was standing on the outside. He was about fifteen feet tall. I knew him, but couldn't think of his name. I was shocked at his size. His face was as wide as a Frigidaire. I said to him, 'What could I do for you?' He answered to me, 'Howard, get on the altar.' I thought to myself, I've been preaching for years. What does he mean, 'Get on the altar'? So I said to him, 'Did you say get

on the altar?' The second time he answered, 'Get on the altar.' After this he reduced to a normal-size man in the same image and disappeared.

"I was left to wonder for four days. After four days a man called, saying, 'Howard, my Dady died and the family wants you to conduct the funeral. Our name is Hughes. Do you remember us?' I said on the phone to him, 'I know so many Hugheses, you will have to drop by and show me his picture so that I can tell which Hughes he is.' So the man came by bringing his father's picture for me to look at and recognize.

"He handed the picture to me standing on my front porch and soon as I saw it, I knew he was the man who four days earlier stood as a giant at my gate. I looked up at Mr. Hughes and said, 'This man stood at my gate as a giant four days ago.' Mr. Hughes looked at me as if he thought I was insane. His father was an old friend of mine years before, who was a minister. So I told this vision in the funeral and all the people looked surprised, but after the funeral the vision came out clear to me. 'Howard, if you want to go out big in the world, you must quit working on bicycles and lawn mowers. *Getting on the altar* means putting yourself into one thing and that was art.'

"So I was for sure in this vision that I must close down my shop and begin painting sacred art. Five days later I closed down my repairshop and called people in to pick up their machines that was tagged for repair. I had sold two hundred and sixty-seven paintings of my own imagination that year, and I thought with a thousand dollars in money, that God is trying to tell me something, that I don't need to be fooling with bicycles. Of course, a thousand dollars ain't much now, when you are trying to live. If I had an income to where I could buy my food, just me and my wife, I'd just do nothing but paint. And I'd just take a break every few minutes and go back and paint. Take a break, walk around, and go back and paint a little.

"I didn't want to fix bicycles. So when I found out for sure that God called me to do sacred art, I molded my tools in the walkway as evidence. I'm not fixing bicycles anymore. I'm going to be a full-time artist.

"What I needed was a buddy, someone like Lucille Ball, that got seventy-six million dollars, who could pay me a living salary. I got a contract from the Library of

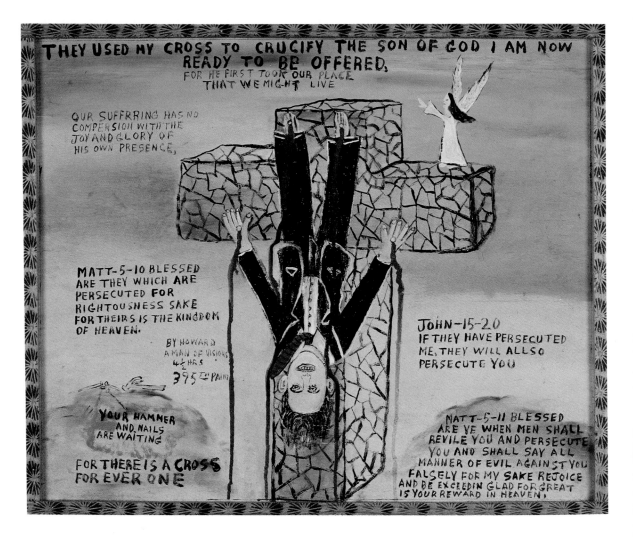

Congress to do two paintings and two signs. I didn't do signs much anymore, except for neighborhood businesses, but they said they would pay two hundred dollars for the paintings. They said they wanted two paintings of just my own idea of folk art."

Beverly: "In 1976 he started talking about his paintings. He'd always talked about doing art for God. I remember him painting in the basement. The painting had a big fence and a gate. As soon as he started painting, he was selling them within weeks at the Garden. When he began his art, he told us about his first vision. He also told us about the man at the gate. My mother said if he didn't quit telling people about those visions, they were going to think he was crazy, but she had a vision twice. She was sitting at her sewing machine and she heard someone call

THEY USED MY CROSS TO CRUCIFY: enamel on board, 15¼ × 18½", 1977, #395. (Private Collection. Photo: Norinne Betjemann)

her by her childhood name, Betsy. It was her mother who had passed years before. Dad said that's why she had the visions, because she didn't believe in his visions. He talked about them with the family regular because he was painting them on a daily basis. I believe he was getting visions because of his work and because of the Bible. In 1976 he became more fanatic in art because the message was getting out to the people. He became more driven."

Howard: "How could I expect anybody not to think I was crazy when they don't know nothing about what I'm talking about? My family didn't understand me because they didn't want me putting garbage up in the Garden. My father used to think I was goin' mental when I was asking him man-sized questions, and me just a kid. I had assurances from God, not my family, state, country, or grandkids, and if I hadn't had the assurance of God, my family would absolutely discourage me and I wouldn't have gotten nowhere except done what they wanted. Nobody is crazy that communicates with God Almighty, the engineer of earth's planet. Nobody is crazy that God Almighty would employ and use as an instrument. Nobody is crazy that tells the world what I'm telling 'em. There is nothing mental about me. You know, I've been a laughingstock in the county for forty years. People around here say, 'That old Howard, he's crazy.'"

I asked a handful of Summerville residents what they and the community thought about Howard and his Paradise Garden.

Bobby Lee Cook: "This is a mountain region and mountain people are rigidly independent. They are imbued with many eccentricities."

John Turner (no relation to the author): "Howard was thought of as the village eccentric. To some he was a nut, but the community was tolerant."

Sue Hurley: "Howard is rural America, from the working class."

John Turner: "Summerville is a mill town. Seventy-five percent of the people work in the mill and five percent are white collar. What Summerville is all about, it's a car town. They are interested in cars and riding up and down the street and it's always been that way. Of the five percent white collar, only half are interested in art and appreciate Howard. The rest of the townspeople couldn't care one way or another. People are not into art around here.

Very few people from Summerville have been to Paradise Garden. Summerville, Georgia, has more characters per square inch than you can imagine. Most everybody here is an individual and they do their own thing and everybody has their own eccentricities. There is so much that goes on in this community. If you went out and killed somebody or something like that, you'd get a little notoriety."

A. J. Strickland: "People mind their own business in this town. It's fundamentalist, conservative, but basically tolerant, and that allows Howard the freedom to create. He was free. He didn't have anybody to tell him what to do. They didn't encourage him, but they didn't discourage him. We don't have a building inspector to inspect what he was doing. He was free."

Sadie Strickland: "I used to take my first-grade students to Paradise Garden and the children would love it. He had the only peacock in Summerville."

A. J. Strickland: "He's got a lot of the town's history in that Garden. It's Summerville's first museum. He wants people to come to the park to enjoy themselves and

Wire train display, Paradise Garden. (Photo: Jeff Camp)

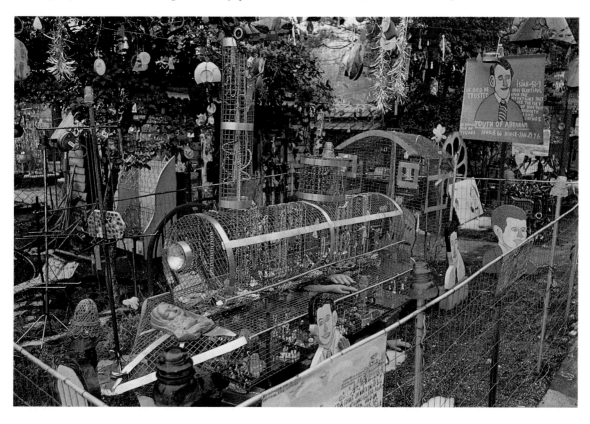

85

be educated. He's got a printing press, farm implements, and even a wooden bicycle rim."

Sue Hurley: "If you go back to the Bible days, you know, even Christ, his very own knew him not. So I think Howard is one of our own and our very own people knew him not until the *Wall Street Journal* came out with his picture on the front page and he was on the Johnny Carson Show [August 1983]."

John Turner: "The idea that somebody from Summerville could get on the Johnny Carson Show and go head to head with Johnny was something. Howard was just himself."

Sue Hurley: "I think he is a very Godly man. He gives out love to anybody that will stop five minutes and let himself be loved. He is a person that reaches out to every human that he comes in contact with."

Sadie Strickland: "I admire him because he is doing what he wants to do and can do and does it. He gives his art not only to the community but to the world. He had an idea and he didn't care whether anybody liked it or not. I learned from him that if you have a goal, pursue it, just go ahead and do it."

John Turner: "He talks like he paints—it flows, unpredictable. He doesn't think things through, it just flows. He goes in flows. Every time I come here I get energized and motivated. I see a lot of wit and wisdom in what he writes. It has an innocence and a charm. The energy and the obsession in the World's Folk Art Church is like a Michelangelo, a modern-day folk Picasso. He is not a folk artist anymore. He's an artist. I see Howard as a latter-day prophet."

Karen Cook: "I go to the Garden when I get depressed. It makes me feel better. I like it especially on a rainy day. It's a religious experience. I do believe Howard has visions. There is no way possible that he would have been able to create all this in such a short amount of time if he did not have visions and he did not have help from someone."

Bobby Lee Cook, Sr.: "He is a kind, compassionate, humanistic, decent, and understanding man who makes the world a little more decent as he passes through."

Howard: "The Garden was first called the Pine Springs Museum and then the Plant Farm Museum. People

would stop by on occasion and think they could buy plants here. A reporter called it Paradise Garden in a newspaper article, and that name kinda stayed.

"Unknown Body" tomb, Paradise Garden. (Photo: Cement Products)

"Right here there's the remains of an unknown body found in the county and killed during the Civil War. A doctor found it on his property and gave it to me. I made this Egyptian tomb, put the remains of the body in, and gave her a service. The autopsy thought it was a young girl about seventeen years old. I took her bones and put them in this nice tomb. It has a glass top over it where you can see her teeth and all.

"These here are display towers that you can put anything in, broken glass, and older relics of yesterday — plates, saucers, bottles, and little lamps. It's twenty-two-carat gold I think on that plate. All these are the inventions of mankind. Women can use these mirrors to dress their hair. I can't put a very big mirror in the sidewalk on account of it sort of exposes the women who wear dresses. You have to watch about that.

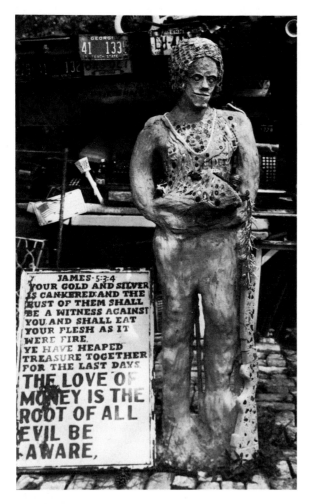

JAMES·5:3:4
YOUR GOLD AND SILVER
IS CANKERED AND THE
RUST OF THEM SHALL
BE A WITNESS AGAINST
YOU AND SHALL EAT
YOUR FLESH AS IT
WERE FIRE.
YE HAVE HEAPED
TREASURE TOGETHER
FOR THE LAST DAYS
THE LOVE OF
MONEY IS THE
ROOT OF ALL
EVIL BE
AWARE,

*Above:* "Coin Man," Paradise Garden. (Photo: Cement Products)

*Opposite page:*

*Top:* This concrete sculpture is called "The Serpent of the Wilderness." Howard says that real snakes hibernate inside it. (Photo: © 1986 Marianne Barcellona)

*Bottom:* "When I drive this Cadillac it gathers much attention. It is the best driving car I have ever driven." Paradise Garden. (Photo: Ann F. Oppenhimer)

"You can't bring nothing here that I can't find a use for it. It don't make no difference. That man there is made of cement and I call him the Coin Man. That money molded in his chest is money that I found in the sand in Florida with my money detector. I spent four days on it. The serpent in the wilderness, it's my third piece of sculpture. Somebody seen a live snake on it. They hibernate in that thing. I just made it by hand on the rock where you see it.

"I wired that Rose Tower up in two or three days. It has a sign on it about Proverbs and Revelations. It's like the paintings in that you get the people to come over and take a look at it and then read the message.

"A woman called me on the phone one day and said, 'Don't you know it is a sin to sell the Bible?' I said, 'Lady, do you have a Bible?' She said yes. I said, 'Where did you get it?' She said she bought it. Don't you see how groggy some people can be? They can buy every verse in the Bible themselves. But it is a sin for a sixty-year-old minister to sell two verses, with a full description explaining it. I call that gagging at a gnat and swallowing a camel. You can criticize a man for building a park, but you can't destroy the smiles and joy of children looking at the fowls and goldfish and flowers.

"This is Honeycomb Mountain. It's made out of air-pack packing paper. I use anything for molds—paper horns, bicycle tires, and Pringle's potato chip cans. This is a Valentine box turned into a beautiful piece of art. I built the park because I was commissioned by God. I spent one hundred and fifty thousand dollars and twenty-four years of work. I've collected less than three hundred dollars in the donation box, and I used it to buy food for the animals in the park.

"When I grew up, I found out what the world wanted. They wanted free service. They wanted whatever was cheap or whatever you would give them free. I preached about forty years ago from one church to another. I never made any charges for my ministry, but I accept free donations. My whole life has been given as a

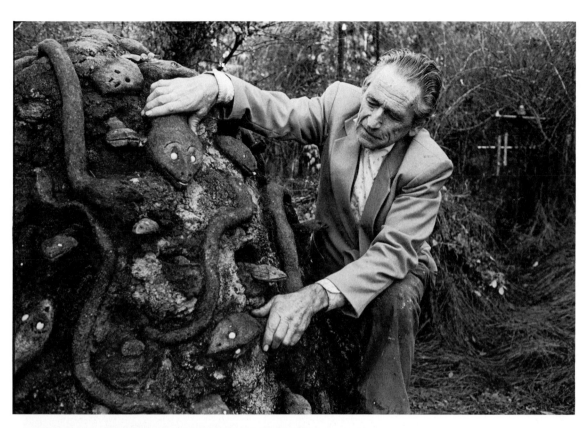

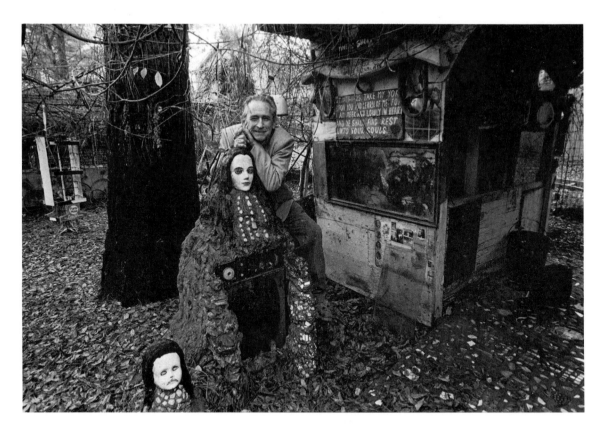

The cement "Mother and Child,"
Paradise Garden. (Photo: © 1986
Marianne Barcellona)

public service. My poems, my songs, my park, and all
has been free to schools, to churches, to Boy Scouts, and
to strangers who walk through my Garden of work and
flowers. The world wanted what I had free so that is what
they got and this is what I gave.

"This is a woman whose hair was supposed to go to
the ground on each side. I molded her face in a shoebox.
This is her kid with a suitcase and they're fixing to go
somewhere. This sign says, 'If you meet Howard Finster
and forget him, you have lost nothing. But if you meet
Jesus and forget him, you have lost everything.'

"I marry people here in the park all the time. They
have come from as far away as Canada. I tell them to call a
day before and I tell them, 'If you want me to marry you
just like I am in my paint clothes, I'll do it.' I married them
on a couch. I've married them sitting in cars. Marriage is
love, it is not a sermon. Marriage is when two people love
another as they love themselves.

"We have three stands of wild bees. This is a tower
full of mirrors that you walk up to and see yourself in

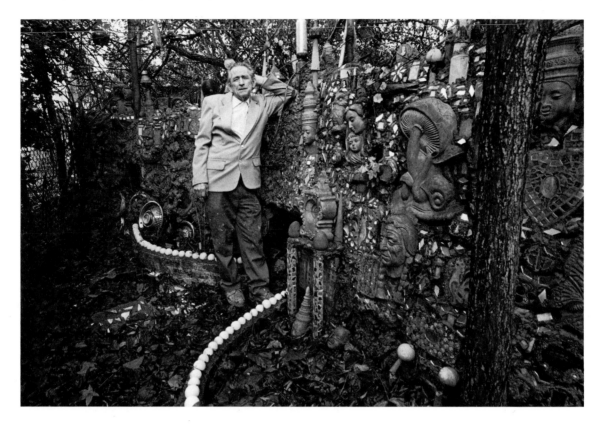

Molded cement wall, Paradise Garden.
(Photo: © 1986 Marianne Barcellona)

there and it's sorta like looking at a spirit floating in the air. The mirrors give you a view of the Garden. This monument has mirrors and from a distance it looks like it has holes through it. I like it."

Architect Jose Tavel, who has made fifteen trips to Paradise Garden, comments: "I think his use of mirrors is very much to put you, the observer, in the piece itself. His artwork is not just something that sits out there. It's something that becomes part of you. I don't think it is something you can fully appreciate in one visit or five visits. It's something that really grows on you. It's something you have to interact with. It's something that's out there that talks to us. It talks with us through all his writings and constructions. It's something you really have to look at and think about.

"That sidewalk becomes the history of the Garden itself. It's not just artifacts, but particular artifacts. It includes not only the tool that Howard used when he repaired bicycles, but the names of people who were special to him. They were the tools of the making and the

A visitor in Paradise Garden. (Photo: Cement Products)

people that made it. . . . When you go to the Garden for the first time, you see the big pieces like the Bicycle Tower. After you go back, you see the individual bicycles and how they are held together. You will even find a lawn mower wired in. In the spring the vines climb up the wire towers and the grass grows up. The spatial aspects change; it's different from winter, and what was a very harsh environment—rusted metal—becomes very soft and sensual.

"I think the whole vocabulary that speaks about his Garden and chapel and studio is vernacular. It's very common. I mean, there is nothing special about the building materials and that's what makes it special. You can drive around town and see them used the way we are used to seeing them used, so they are nothing special. But at Paradise Garden, where a column should usually

be vertical, he turns it horizontal or diagonal and uses it in a completely different way, divorced from all the meaning and previous uses it ever had, and represented in a way that is something completely different."

Howard: "I bought that church from Billy Wright, on the back end of my property. I had a vision to put a dome on which would hide the sway on the roof. I made it thirty feet through the first layer and moved it three feet in for the second level. For the third level I moved it in two more feet. Each level has sixteen sides. I learned to cut every angle in there with just two measuring sticks, without a rule or anything. The only thing I had to square was the top of the studs. The columns were my own design. I took two by fours and rolled roofing paper around them. Everything in there is cut at odd angles. I made all of them angles and just followed that vision out as I seen it and made a stacked steeple.

"The Folk Art Church was a vision that was like a camera. You make a negative in your camera and it is not developed. When you get your negative developed, then everybody sees it. Before nobody in the world would see it but me. My brain cells are full of things nobody can see till I bring them out. I see it before I done it.

"A couple of them fellows that teach at Georgia Tech came out here and asked to see my blueprints and I had to tell them my blueprints was in my head—a vision. They couldn't believe it, but that's okay, 'cause I couldn't believe it when they told me they have to draw everything before they build it. I figured most of them had visions like me.[7]

"I've seen the domes on the mansions in Russia. It's wonderful work, but it ain't my type. I like American-type buildings like the Empire State Building and the big cathedrals in England. I like them, except they are way behind of the ones I see. I have visions of different buildings I don't find none of them on this earth."

Jose Tavel: "He has been able to do something that I as an architect surely wouldn't attempt. He works out angles as far as triangulation with very simplistic, primitive tools. The way he has that church standing up, theoretically, it shouldn't be standing up. I've been up there when the wind has been blowing. The whole thing moves, but it's holding fast."

*Top:* World's Folk Art Church, Paradise Garden, 1982. (Photo: J. F. Turner)

*Bottom:* World's Folk Art Church, Paradise Garden, October 1987. (Photo: J. F. Turner)

Howard: "I just think to myself, Well, if it blows over, I'll just let it lay there and it will be like the Leaning Tower."

Jose: "I think he is an incredible architect. As a trained architect I learned things that we were supposed to do, methods that we're supposed to use, materials we're supposed to use. Because of my exposure to Howard, I've tried very much to get away from that to see what the alternatives are. There are no bounds to his creativity. He doesn't know what things are supposed to be, so there are no limits. It would be helpful to have a vision—not a goal, but a guiding thread or reason that drives you on. He does the same with his paintings, taking familiar images and showing them a different way. It's that twist on the very common that makes it so special. I can look at his paintings but later look again and discover something new, just like the Garden. Most of Howard's earlier paintings are about architecture or have architectural elements that are related to the Garden. The early paintings were accents to the architecture of the Garden. They were ornaments, not paintings."

Howard left his last official church in 1980, when controversy arose over bringing movie cameras into the church and filming his service. He says, "I have so many interviewers. The last church I was pastoring, they were coming there and making movies of me in the pulpit preaching, taking my whole services on tape and in pictures to the universities. And some of them grumbled about it—the Lord's house being a show house. I got up and told them that I thought this was the mission of this church. I thought the Gospel spoke to all the world. I said to these fellows that come in there, 'Do you watch your TV? The TV ain't nothing but a camera. A camera comes into our church taking the service out to publish the Gospel all over the world, and you kick up about it.'"[8]

On February 14, 1981, Howard had a vision of a church, the only church system of its kind, a church of living facts, of truth and justice, a church without pastor or trustees or deacon or stewards or ushers, or even without membership. He described his vision: "It is a setting near Paradise Garden and its contents will be the truth of God, the truth of mankind and his discoveries, the truth of the present, and the truth of the future. These

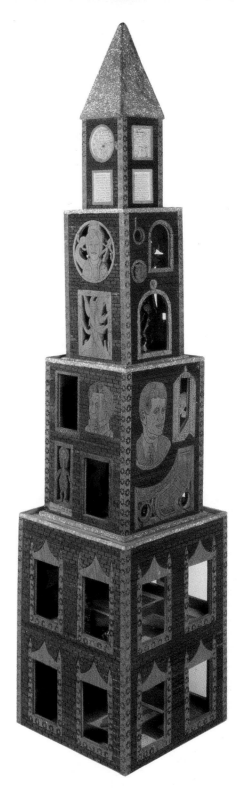

THE CASTLE OF WORDS: wood with pyrography, glitter, metal, glass, briar root, ink on paper, $16^{5}/_{8} \times 16^{5}/_{8} \times 72^{1}/_{2}$", 1979, #1000 492. (The Turner Collection. Photo: Norinne Betjemann)

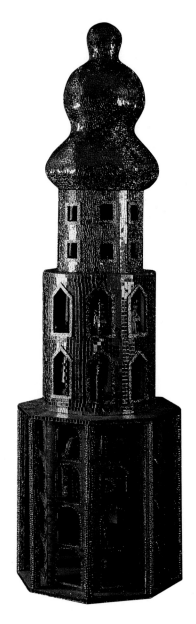

MIRROR CASTLE: mixed media: glass, wood, cement; 78" tall, 1977. (Janet Fleisher Gallery. Photo: Norinne Betjemann)

facts shall be in beautiful enamel color pictures all over the walls inside. Pictures will include verse and sermons and poems. Songs and music will all be present, twenty-four hours a day. People can go to church in numbers or alone and get the messages by reading from the walls or shooting photos with their cameras. They can carry the messages with them when they leave the church and give them to people all over the world. It will belong to the whole population of earth planet. People all over the world can see and read it from wherever they may be. Even angels will look upon it."

In July 1987, Howard placed a mirror-encrusted spire, capped by a copper toilet-bowl cock, on top of the church, completing his basic design. He has plans to build an aerial tramway from the church that will wind through the park.

Howard: "The Garden is hardly half finished. Every sculpture I've built is not even finished. I don't know of one thing in this world that I've done that was actually ever finished. I never made my best clock. I never fixed

"Y'know, a man has to have a lot of patience to preach and make it plain. And I believe one of the writers said, 'It's so plain that even if a man be a wayfaring man, or a hobo, or a fool, he shouldn't miss heaven. Heaven's out there, not only heaven, H-E-A-V-E-N-S, Heavens out there."

"I have a vision of God. He said in the last days old men shall have visions, young men shall dream dreams."

"Beloved friends, I can preach with my shirt tail out, like I have right here now. I've become a stranger in the world, and I'm traveling through. And I will believe what God shows me, I will preach it and I will tell it. If nobody on earth believes it but me, I'll be believing it when Jesus comes back."

—from a sermon given at Silver Hill Baptist Church, September 21, 1980. (Photos: Margo Newmark Rosenbaum)

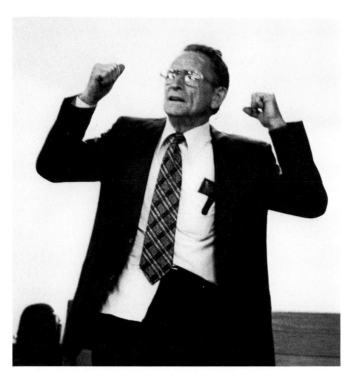

*Right:* Five stories directly below the steeple of the World's Folk Art Church is the Mirror Room. Partially inspired by the Civil War Cyclorama in Atlanta, everything placed inside reflects several times. (Photo: J. F. Turner)

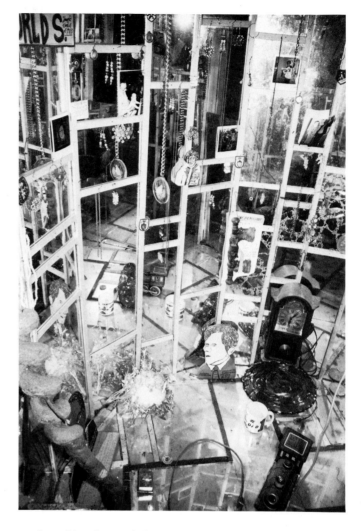

*Above:* Interior, World's Folk Art Church, second floor, Paradise Garden. (Photo: J. F. Turner)

my best bicycle, and that's one thing I couldn't tell you, what things would look like if I ever finished something.

"Paradise Garden is a workshop for pastors and lay members to meet people from nations across the world and every state in the Union and to welcome them to this country and invite them to your church. Some of them stay here for days. When you see cars parked around the Garden, it is a good time to come in and meet the people and talk to them. People from all over this land meet here and get acquainted with one another and talk for hours.

"Many times when I was pastoring churches, I looked over my crowd and there was no sinners there. That's when you go to the wayside and compel them to come in. Our Garden is the wayside. Sinners are here

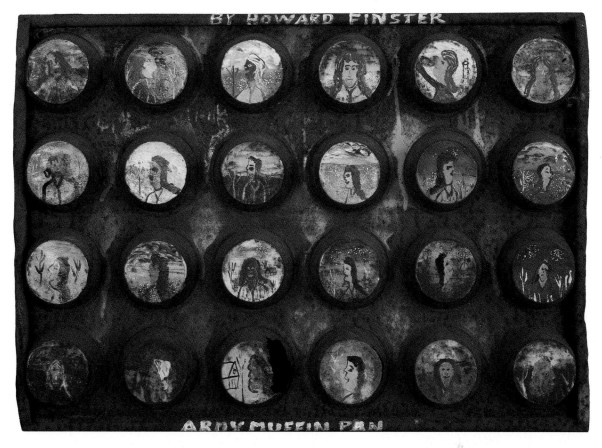

ARMY MUFFIN PAN: enamel on metal, 20 × 14", n.d. (Dan Prince/Prince Art Consultants. Photo: Nathien Roberts)

about every day. Sometimes I preach here two hours a day. How can you reach your sinner friends unless you meet them? I pray for my enemies. I bought a city block from selling my artwork and gave it to the people all over the world. They can read my messages and other people's in the Garden. My Garden and work goes out daily in home photos, slide shows, movies, magazines, TV news, press, and radio—flowing out like a running spring from a mountain.

"Thousands of people don't listen to the religious programs but they come to Paradise Garden and buy my sacred art. . . . I also represent artists and their work, from three years old on up to Grandma Moses [in the World's Folk Art Church]. It don't cost nobody to exhibit here. I tell them to fix their own displays. It's a headquarters for artists. Like in the old days when the first travelers would mark their initials on an old tree at a crossroads. First thing you know, the tree is covered up

99

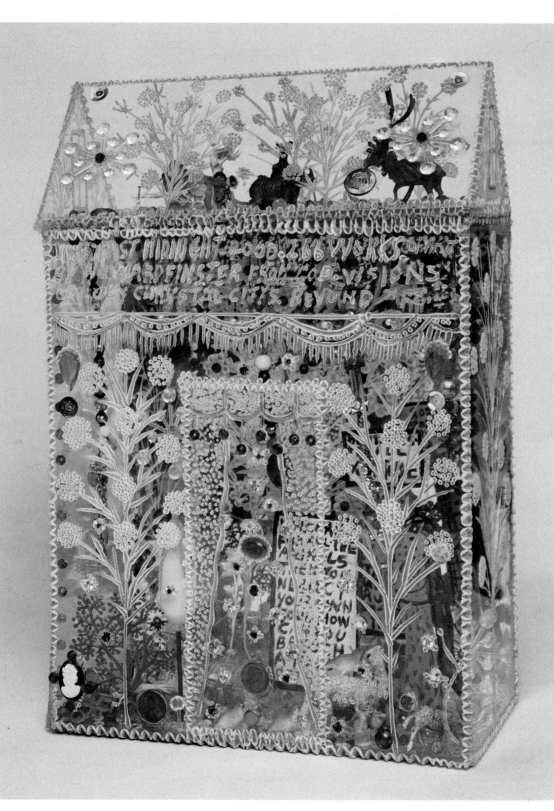

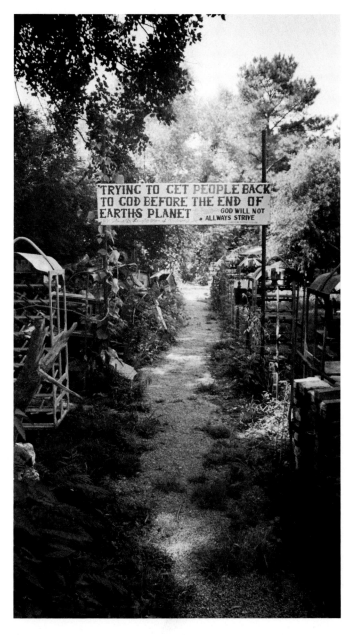

*Left:* The back gate to Paradise Garden.
(Photo: J. F. Turner)

by names. You can see who's been there and where they went. That's how it is at my place.[9]

"Since life began with a beautiful garden it should end with a beautiful garden. I am called from another world. I try to live perfect. I built this park of broken pieces to try to mend a broken world of people who are traveling their last road. I took the pieces you threw away and put them together by night and day. Washed by rain, dried by sun, a million pieces, all in one."

*Opposite:* VISIONS OF HOLY CRYSTAL CITIES BEYOND: plexiglass and mixed media, $15^{1}/_{2} \times 10^{1}/_{2} \times 5^{1}/_{4}$", 1985, #4000 266. (Robert Bishop. Photo: Barry Pribula)

# CHAPTER 4

---

# You've Got to Be a Starlet Before You're a Star

*Howard Finster is a unique artist, not only because of his style but because of the marketing of his art. Represented in over a dozen galleries from coast to coast, his work is also in several museums as well as in the homes of hundreds of collectors of twentieth-century folk art. How it got there is a mystery to some and a point of contention to others.*

*Thus the marketing of Howard Finster is a tale worth telling for several reasons. First, it lays bare the myth that Howard—like many self-taught artists—was unable to cope or adjust to the demands of an "art marketplace" and a curious public. The fact that he has an outgoing personality, a promoter's sense, and a burning desire to "get the messages out" (at a more than reasonable price), has put Finster on top of almost all of his transactions. As an evangelist he learned how to captivate an audience; as an artist he learned how to manipulate one. Making art in all shapes, sizes, and prices, he was able to "send the message" from Paradise Garden to a wide range of patrons.*

*His first encounter with an agent willing to represent and promote his art resulted in a three-year odyssey that took his work through the citadels of the art establishment and into the American consciousness with exposure in national magazines. This relationship—like some marriages—had a long honeymoon, extended periods of individual growth, and, unfortunately, a loud and bitter divorce.*

*But it was as a result of this experience that Finster decided he was his own best agent. Eliminating the middleman led to an even bigger audience, more money to support his*

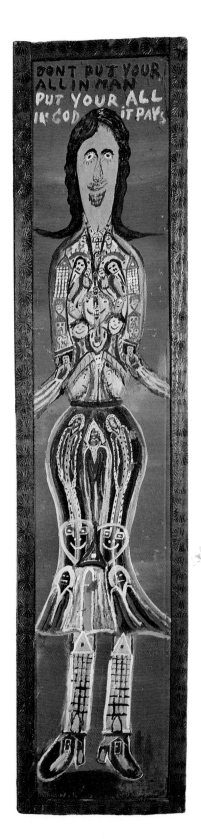

*Right:* Don't put Your All in Man: enamel on wood, 10½ × 7″, n.d. (Cavin Morris. Photo: Stuart Rome)

*Far right:* Man is Man: enamel on wood, 10½ × 7″, n. d. (Cavin Morris. Photo: Stuart Rome)

*"cause," and access to galleries anxious to show his work "without strings attached." Howard was now in control of his artistic destiny. This is extremely rare in today's high-powered art circles, and not only acts as an example but also serves notice on a business that has been affected by a true outsider.*

Relationships between artists and the dealers who represent them are often inharmonious and of relatively brief duration, particularly if the dealer has more than a modicum of success promoting the client's work. This is true in the world of conventional art as well as in outsider art. Many a struggling artist has virtually given away his or her early work in return for little more than subsistence payment from a dealer who volunteers to promote the artist's career. But this is not to say that dealers are essentially devious, determined to prey upon innocent, "unworldly," struggling artists. There is both an investment (of time and of money) and a risk involved in sponsoring an unknown artist.

Although seemingly naive and unsophisticated in his artistic expression, Howard Finster has demonstrated himself to be far from unworldly when it comes to business dealings. In his childhood he had used scrounged wood scraps, turning them into salt and pepper shakers which he sold for 25 cents a set. Now, however, he was creating works of art to spread the message of the Lord. To accomplish his purpose he needed to sell as many of his works as possible. He devised his own method of direct merchandising, gradually gaining acceptance by collectors of folk art and a number of university communities. But although many visitors to the Garden left with paintings tucked under their arms, Howard was not yet able to support himself through his art at the time of his first encounter with Jeff Camp in 1977.

Camp's chosen profession was to scour the flea markets, auctions, and estate sales for antiques which he could wholesale. He, along with a handful of others, was instrumental in the early promotion and exposure of twentieth-century American folk art. Although he had been successful at scouting out great pieces of early American oak furniture, he decided around this time to focus his entrepreneurial talents not on antiques, but on the task of representing self-taught artists.

Camp comments: "I set out to find as many artists as

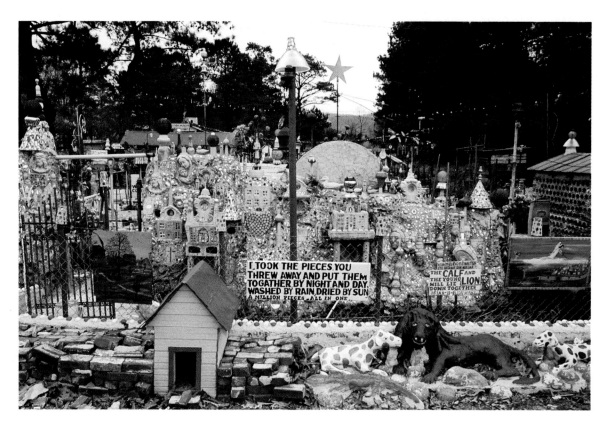

The Calf and the Lion in front of Paradise Garden, 1976. (Photo: Willem Volkersz)

I could. I can't say I ever discovered one. I always heard about them from someone else. I call myself an agent. I never would qualify myself as a skilled and competent art dealer. I was, however, a brilliant publicist for the people I handled. That was my genius and my skill. I first saw a Finster painting in an acquaintance's living room in May of 1977, and I knew then that I wanted to visit the man who had painted that picture. I left for Pennville the next month."

What Camp saw at Pennville astounded and thrilled him: "I'll never forget when I pulled up in front of the Garden the first time. It was the grandest experience I ever had in my life. I cannot recall ever going anywhere or seeing anything I was so moved by. Everything I had ever looked for or seen earlier, like a garden environment or a painting or a sculpture, it was all there in one place. The front of his son's TV repair shop [next door to the Garden] was nothing but paintings (around two hundred fifty of them) for seventy-five feet. It generated enormous power. I really loved the Garden.

"It was absolutely astonishing because of the way the sunlight altered what you saw. No matter what it was, you saw it differently moments later. Howard worked

with glass throughout the Garden and commented how he loved the way the light caught the glass and the color in the glass at different angles at different times of the day. Howard's work was strongly religious and primal from a biblical point of view, but it was always an extremely personal interpretation of the Bible. The paintings were actually extensions of the Garden, and were completely representative of what he was doing and continued to do later in his two-dimensional work. There were pictures that were solely words; there were pictures that were a mixture of imagery and words; and there were just plain images with almost no words at all. Secular, religious, fantasy themes, even Elvis was already there. The man was complete. The quintessential, complete Howard Finster was there the first day I met him.

"I considered Howard to be a genius proprietor [of the Garden]. You could see a joy about him when he worked in it. It was as if he had a higgledy-piggledy house with lots of little spaces and there were always a number of special places he seemed to go off to. Howard told me the paintings were the sermons in the Garden, and that since he couldn't always be there, he figured visitors could get the word of God without having to hear it from Howard."

The business relationship between the two men began with that first encounter. Jeff Camp had been told that Howard sold paintings for cash only and was anxious to sell his work. "That day I bought twenty-seven paintings, including three signs from the Garden, for twelve hundred dollars. It was the largest sale Howard had ever made, and he later made a plaque to commemorate the event. [It reads: "I, Howard, sold 36 paintings for one thousand dollars."] The paintings were the weirdest, most unpleasant, and totally unmarketable paintings I had ever seen. Although I sold one within a week, I didn't sell another for nine months."

Finster expands on his relationship with Camp, both as a friend and as his agent, in his "Poem to Camp Co.":

A plaque, given to Jeff Camp by Howard, commemorating Howard's biggest sale to date as an artist. (Photo: Archives of American Art, Smithsonian Institution)

The night of excitement
with Jeffrey and Jane
beyond my troubles will
always remain

Jeffrey recording Jane
shooting films me playing
the banjo just for them

Pauline fixed supper we
were stuffed to the brim
A few apples left but
I'll eat them

It is so nice to have good
friends I hope they will
come back and visit again . . .

104 paintings they are
fixing to load and just a few
hours they will be back
on the road

A MAN LIVES IN HIS SHOES: enamel on metal, 13³/₄ × 19¹/₂", ca. 1977, #1000 10. (Photo: Courtesy of Phyllis Kind Gallery)

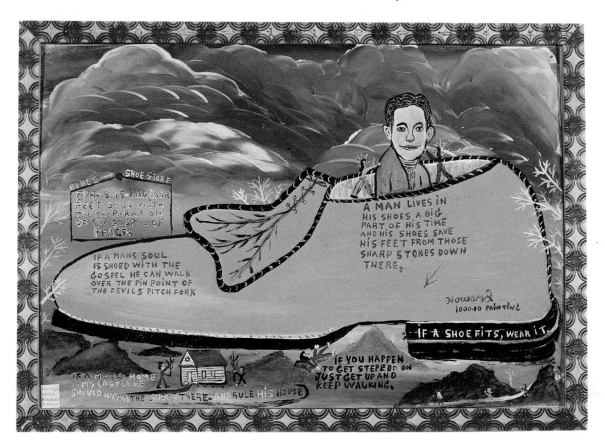

107

They have what it takes
to display my seens. To move
out my paintings and all of my dreams

They have broadened my trail
into a street. And all of
my dreams

I will spend it wisely
and multiply it big
and return it as a lamb and
not as a pig . . .

I hope I will bless in
visions of mind for you to
enjoy without wasting time

Camp: "At the time of my second visit in September,
I bought everything he had except for some small items
he was painting for the tourist trade at the Garden. From
the time early in life that he sold his clocks, he'd been a

Howard and his "souvenir art," Paradise
Garden, 1980. (Photo: Jeff Camp)

peddler. Howard made art for every conceivable market.
He viewed his art in the same way he viewed his clocks—
as something to sell. I noticed on this visit that he had
started numbering things in the Garden too, even the
rocks—anything his brush had touched was given a num-
ber. He used to keep track of the numbers by registering
them on the door jamb of his studio. His first drawings
were crayon drawings that were done in a school tablet
notebook from 1935. The drawings were of airplanes in

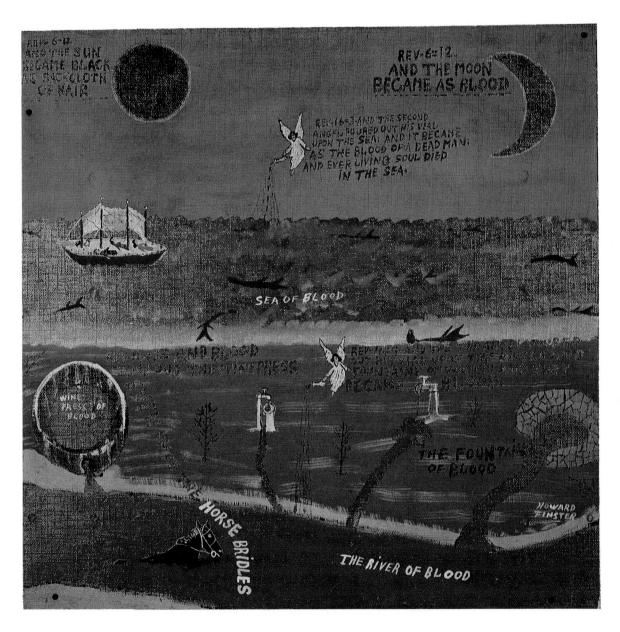

the sky and of landscapes. It was Howard, all right. There
was a little bit of everything in those drawings.

"I wanted all of Howard's work for all the money I
could afford to give him, and I told him that it wouldn't be
a lot to start with. I said, 'I want to be your main man, and
that means we must work together. You've got to be a
starlet before you're a star.' I knew what the marketplace
was, and I knew he wasn't going to be hot for a while. I
repeated my simple message over and over, in essence,

AND THE MOON BECAME AS BLOOD:
enamel on masonite, 29¹/₂ × 30", ca.
1976. (Herbert W. Hemphill, Jr. Photo:
Stuart Rome)

ELVIS: enamel on wood, $49^{1}/_{4} \times 41^{1}/_{4}$", 1979. (Jeff and Jane C. Camp. Photo: Ellen Page Wilson)

'You make great art and I'll make you famous.' He wanted to be as famous as Elvis, and I told him, 'My job is to make you well known, a respected artist. The fame is secondary. Howard,' I said, 'paint what you want, but don't paint it over and over. Take your time and make sure things are put together well.' I was very careful to let the man paint what he wanted to paint. I let him be.

"On one occasion, though, I bought him a hundred pounds of glass. Howard had gone to the University of Georgia to talk about his art, and he saw how the students melted metal and fired ceramics. When he came home, he took an old washtub, some coal, put a vacuum cleaner on reverse, and started tossing TV parts and bottles and metal into the fire. That became his 'pot mettle' art. He also began painting on panes of glass and stacking them two and three deep in front of finished paintings to box them in, calling them 'double divisions.' Later he called them 'dimension boxes.'

"He'd work in one medium for about six weeks, then jump from one area of involvement to another and become proficient at it. The guy could shift with the ease of a Picasso. He also went through a wood-burning period, then to painting spaceships, other planets, and trips to the other side of the sun. He later invented 'crater' painting [captured visions] and did a lot of that type because it was quick and easy. As he progressed, his images became tighter.

"I was Howard's agent from June of 1977 to February of 1981. I never had a written contract with him. He was my friend. He used to brag about my being his mailman, spreading his messages all over the country."

There is little doubt that Howard was initially as thrilled with Camp's large-scale purchases of his art and predictions of a rosy artistic future as Camp was at the prospect of representing Howard and acting as his sole agent. In retrospect, however, Howard tends to downplay considerably the significance of Camp's role in his career: "All he does is just help me minister. You know you can take a darn tin can and put a pot of gold in it and send it to somebody. Well, that's the way it is with my messages and things. He is just a mailman for me.[10] I was getting my art out. I was selling it everywhere before I ever fooled

with Jeff Camp, and it would have gone on without Jeff Camp. What got the art out is the technique of art and the kind of art it is. I was selling everything I made before he fooled with it. I didn't know nothing about the price of art. I sold them because I needed money for the Garden. I didn't sell them because I wanted to. I never did want to sell any of my art. I wanted to put it all in the Garden, or at least a sample of it. He begged me for a year to sign a contract with him. Pauline and my daughter Thelma told me not to sign a contract with him, but if I had, it would have ruined my whole career. I made only one exclusive contract, and that was with God. What I said [to Camp] is, 'What I want to do is go full time as an artist. If you pay me enough for all my groceries and overhead and everything, then you can get my art.' Well, that was just a talk deal. He didn't pay me enough. Four thousand dollars a year wouldn't run me. It wouldn't even pay my coffee. You can't do nothing without money."

Camp, however, says he was completely aboveboard with Howard at all times in their dealings, and that he delivered fairly on his promises to advance Finster's career as an artist. "I used to pay Howard in sums of one thousand dollars or more per load in cash. The loads used to be fifty pieces of all sizes. That averages out to forty dollars an item [$20 per item]. I warned Howard that his income would be erratic, but I tried to keep a steady flow of cash coming as best I could. No one wanted his work. They thought it was too strange and weird and bright and gaudy and ugly. After the giant appeared at the gate and told Howard to go full time on sacred art, he assumed someone would provide, and that was me.

"I talked straight with Howard from the first day. I exposed his work to as many people as I could. The first big show I arranged was a one-man exhibit [1978] at the Phyllis Kind Gallery in Chicago. I then arranged a show at the Anderson Gallery at Virginia Commonwealth, a wonderful space in which to exhibit his work. Then I got him in *Life* magazine, a feat that took me eight months to arrange. Next [in 1979] came a show at Wake Forest. I also arranged for documentation of Howard's Garden, did a newspaper of Howard's drawings, and helped him record his sermons and songs. Every one of those shows produced another page on his résumé, which made the starlet a star."

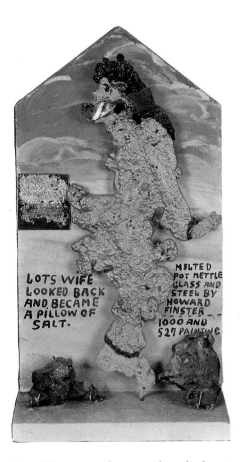

LOTS WIFE: enamel on wood, melted pot metal, glass, and steel, $15 \times 8 \times 4$", ca. 1979, #1000 527. (Cavin Morris. Photo: Stuart Rome)

In a letter to *Folk Art Finder* in June 1980, Jeff Camp wrote:

> I exhibit and sell the works of Miles B. Carpenter, Rev. Howard Finster, and S. L. Jones. I believe in a far broader sense that these three men are modern artists and that they deserve fair and ethical representation and the same consideration that fine artists enjoy. In Europe, most of the folk or naïve artists arrive at a dealer-artist relationship, and it is accepted by most. Here the art form is hardly recognized by museums, collectors, critics, etc. I hope your publication makes an effort to show that these gifted people don't live in another dimension, as many seem to believe, but are twentieth-century citizens just as you and I. They have access to the same food, roads, magazines, airplanes, and television that you and I do. They have access to the same art supplies and discarded artifacts that you and I do. But you and I do not have access to that special dimension that they help us to see in their work.

The chief bone of contention between Camp and his client appears to have been that Camp had little or no control over the marketing of Howard's work.

Camp: "I told Howard that there was one thing he had to do, and that was, he couldn't sell paintings to people out the back door to meet the needs of his wallet on a given day, because it would undermine the work that I did. I said, 'I'm going to make you nationally known and famous, and if you do this, it is going to totally undo everything I do. This is all I ask of you, and I will make you famous. I can and will do it.' I never promised him a commission, but I fully intended that Howard would share in the income from the sale of the paintings. Yet at openings Howard was known to tell people that if they came down and visited him at his Garden, they could buy the art cheaper. He did what he wanted to do. He was uncontrollable, and I needed control to do my job."

Howard, on the other hand, feels he was justified in withholding that control, contending that Camp reneged

*Opposite:* Vision of a Space City: enamel on glass and board, 31 × 23 × 3", 1978, #1000 206. (Ann and Monty Blanchard. Photo: Barry Pribula)

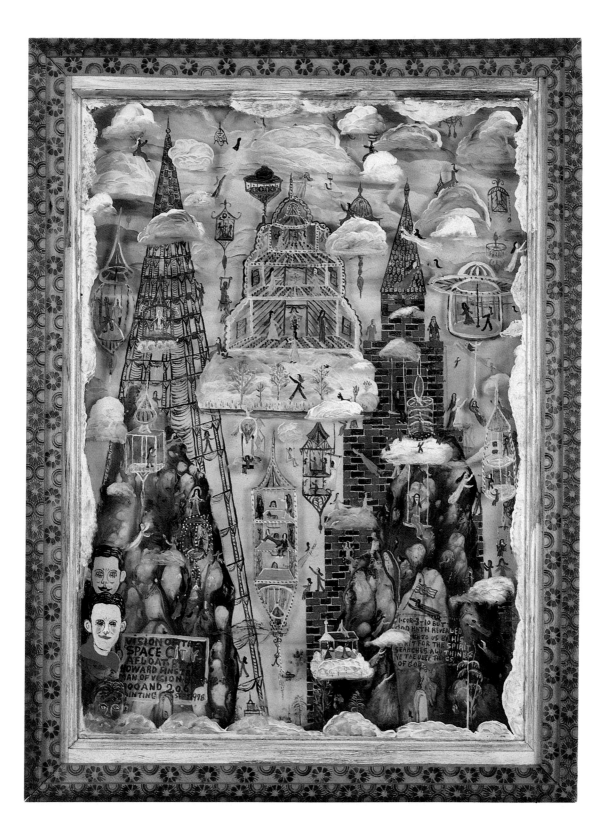

on his promise of adequate financial support and publicity: "Camp said that within four years I'd be a star of art and I'd be getting more money, yet he paid me only three to four thousand a year, and he would take a whole load of stuff, all he could haul on that van, and the last time he came here he told me, 'Howard, it [the pile of money] will be higher and higher.' But instead, what he paid me was even less than usual. He was supposed to pay me about a thousand dollars, but he came down with seven hundred dollars. He didn't have nothing to pay me. He was ruining me. I had to sell the TV shop to my son to get back on my feet. It took me four years to find out where he was going to get me, and he didn't get much of anywhere. He got me in a magazine or something a time or two, and that's it. But what did I care about being in a magazine? I needed money. When I went to his house, he had my artwork stacked in closets. He was just hoarding it up, thinking I'd be dead in a little while because my health wasn't good then. But I wanted to get my messages out."

Camp responded to Howard's criticism of his stewardship: "He is correct in that he said that to me, 'You're hoarding my work and not getting my messages out.' I told him early on, 'I will always buy and keep some of your art.' It was good to have show-quality material around so that it could be loaned to a museum or a private institution at a moment's notice. I also needed the art for myself. I loved having it as much as he did making it. I bought six hundred and fifty objects and paintings from Howard, but I never signed a contract with him. I never made any money when I knew Howard Finster. Not a dime of profit."

The rift between Camp and Finster widened and deepened when, in Camp's words, "Phyllis Kind told me that Howard had been working on her for six months to get her to represent him. In March of 1981 I saw some of his work at her gallery. Admittedly, I had not been paying him well prior to the show, but it was because there were no buyers for his work." Adding insult to injury, in Camp's view, "Howard subsequently sent me a letter saying he had torn his shoulder lifting asphalt in the Garden and couldn't paint. I went to visit him just before Christmas and he had three pieces. Later I found out that Phyllis Kind had provided U.S.I.S. [the U.S. Information

*Opposite:* 144 Thousand the Tribes of Isriel: enamel on glass and wood, 30 × 19¹/₂", 1978, #1000 265. (Herbert W. Hemphill, Jr. Photo: Stuart Rome)

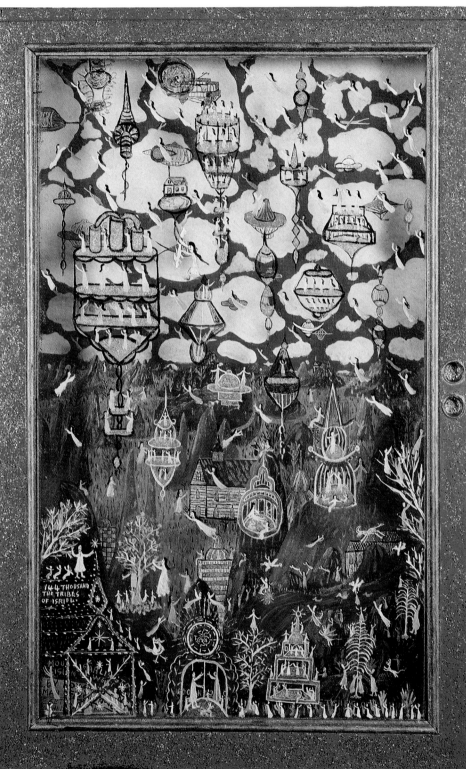

Service] with photographs of paintings I had never seen. It was for a government show. The art was Howard's cutout clocks. While Howard was being paid by me, Phyllis was putting his art on the market."

What transpired next was crucial to the direction of Finster's career. Andy Nasisse, a friend and supporter in the art department at the University of Georgia, encouraged Howard not to stick with one agent. Victor Faccinto, director of the Fine Arts Gallery at Wake Forest University, wanted Howard to have Phyllis Kind represent him. The break with Camp came over a one-man show at the Braunstein Gallery in San Francisco in 1981. Jeff Camp thought the show would be too expensive to mount, but Phyllis Kind disagreed and chose the paintings to be sent. She made sure Howard got paid from the sales of that show, and started him on a monthly stipend of $400. There was no contract.

Andy Nasisse expressed his reservations about Finster's relationship with Camp. "Howard thought he had arrived when he had an agent [Camp]. I told Howard he should be careful about that. My impression was that Camp was taking large quantities of art and giving Howard subsistence money that was paid against sales. At first I thought it was a good deal. Later I told him he shouldn't give it all [the art] to one person, and that he would be better off at a gallery. I didn't think Camp could get the work in the right places.

"In 1980 I talked with Victor [Faccinto]. At that point things had gone bad for Finster [with Camp] and Howard was really upset. He was threatening to quit painting. It became obvious that something needed to be done, so Victor and I decided to solicit Phyllis. Victor did the initial groundwork with Phyllis because he was showing with her. It was my job to get the paintings packed and up to Phyllis. I sent her paintings for two months, and then the preacher started doing it himself." Phyllis Kind acknowledges a debt to Jeff Camp for his role in acquainting her with Howard's work. "Jeff Camp first brought Howard's work into the gallery in 1977. I was already taking on consignment the work of another artist he was representing, Miles Carpenter. I fell in love with Howard's work instantly. The immediate impact of his work was that it all held together perfectly. I liked show-

ing a Finster next to a Roger Brown. I just looked at it as art."

Howard feels justified in harboring bitterness toward Jeff Camp. He sees himself as one unschooled in the ways of the world, of whose innocence Camp took unfair advantage: "If he would have paid me, he would have been the big man in my art. Andy Nasisse done more for me than Jeff Camp done. He helped me get a show in Colorado and he turned me loose and I was publicized. Andy was the man to get me in the first university. Camp got me in *Life* magazine, but he just took me. That's what he done. So I told him I wasn't giving him nothing else. I said take what you got. At the time he must have had thirty or forty thousand dollars' worth of my art at his house."

Camp attempted to mend their relationship, but Howard refused to be mollified. "I called up Howard and he just said over and over again, 'I just want to be free. I don't want to be represented. I just want to be free to sell my art.' That was the last time I talked to him." Phyllis Kind appears to reinforce Howard's view of the Finster-Camp relationship: "Jeff had three years of a nice income, and it really wasn't fair for Howard. I started getting the art directly from Howard on a monthly basis. He sends it up by bus. He sells to other people, although I wouldn't let any of my other artists get away with that. You can't discipline him. He doesn't complain, and he appreciates everything the gallery does for him."

Howard, breaking new ground with the control and sales in the marketplace, observes wryly: "She can't get on me about selling to other people, because I can do without her. She doesn't tell me nothing. We never have correspondence. We have no contract. She took me on without one. I just put the paintings in a package and send them to her on the Greyhound."

In all, despite their differences, Jeff Camp and Howard Finster now express a positive attitude about their early years together. Writing in his 1988 self-published book, *The Scrap Book of All Times,* Howard states: "Jeff began to break the ice for [my] first art work. Unknown to most of the world, it was like driving the first nails in a house. Jeff and Jane Camp had my art put in *Look* [*Life*] magazine and he took me to Phyllis Kind

Gallery for our first show in New York. [There is a second Phyllis Kind Gallery in Chicago.] He and Jane will never know how much we enjoyed the wonderful good times together."

Jeff, giving his first interview (in 1987) on his relationship with Howard, fondly recalled: "I was given the rare opportunity to view what may well be the artistic birth and the creative growth to his zenith of one of the greatest artists this country has produced. Howard's genius is in his ability to take anything that is in front of him and make something out of it, and it's done with no effort at all. He can't not make art."

HE IS THE LILY OF THE VALLEY: enamel on wood with pyrography, 63 × 25¼", ca. 1977, #1000 29. (Jeff Gold. Photo: Norinne Betjemann)

# CHAPTER 5

---

# Chairman of Sacred Art

*Unlike some artists, Howard is more than willing to discuss the inspiration, meaning, and methods of his art. People are in awe of his abundant output (in 1989 he was numbering works in the ten thousands); they wonder how any artist could produce so much in such a short time. In order to place this tremendous output in perspective, I talked with Howard about how he works.*

Howard: "I was born a baby when I came onto art. I'll be four years old in painting this coming January [in 1980].

"For thirty-five years I've used Fixal tractor enamel. I got a bargain on a truckload of Red Devil paint, and I'm using that up now. Most of my paintings are done on pine plywood. It soaks down in the wood and will never come out. When I paint a painting, you can hang it out in the front yard and it will last three years, right out in the rain, freezing and everything. They fade but they hardly ever crack."

Over the years Howard has also used crayons, ballpoint pens (full and empty), pencils, glue, ink, oils (including linseed), watercolors, and whatever else was at hand. He never bought what he called "art paint" (although he was given a tube or two by artists who stopped by), preferring instead overstocks and close-outs from the hardware store, blending them into what he calls "invention

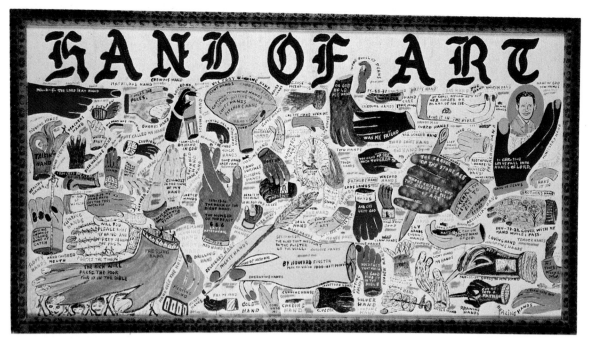

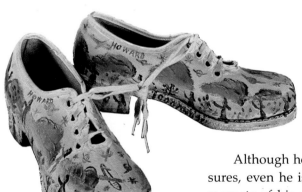

*Top:* HAND OF ART: enamel on panel, 26½ × 48" including frame, 1978, #1000 41. (Collection of Willa and Joseph Rosenberg. Photo: Barry Pribula)

GREEN HEELS A PAIR: enamel on leather. (Janet Fleisher Gallery. Photo: Norinne Betjemann)

colors." In addition to pine, he has painted on masonite, porcelain, fiberglass, metal, cement, and on rare occasion, canvas. He doesn't paint on just anything; he paints on practically *everything:* TV sets, tennis shoes, Spam cans, candle wax. Anything that will hold paint.

Although he is a master of painting trash into treasures, even he is amazed and delighted at the unusual requests of his studio visitors to do paintings on such things as their cameras, bolos, glasses, and mailboxes. His fans buy his easels, paint-smeared palettes, and wipe-rags. Howard thinks they have to be a little "touched" to do that, but then he will go out and buy another easel, using it a few months until somebody "begs him off" of that one.

Howard usually starts his paintings by applying a primer and then a background coat of paint with his finger. "After painting one thousand and six paintings, I learned that the skin would wear thin so sometimes I have to let up a few days and make framework to give the skin time to grow thicker. When a small piece of skin turns up on this finger, it scratches marks in the painting,

so I learned to take a fine sandpaper and gently rub over this finger. It would smooth off the dead skin and I could paint smoothly again. I have found nothing on earth that will paint as smooth as my finger. You can double your strokes and feel if the paint is too thick or too thin. If you pick up more paint than will hang on, dot it over the surface of your painting and reach back to the dots and pick up the right amount.

"When you use a brush, after dipping it in paint, before you rub it on, look at your brush. If it is overloaded, rub off a little lightly before rubbing it on. If you are doing a pinpoint stripe, take the other hand and push it down on board and brace your painting hand from your stationary hand.

"It means a lot to know how to thin your paint on your brush. First, keep thinner in dipping distance and first dip into thick paint, rub it on oilcloth, and then barely touch the end of your brush in thinner. Reach back to the oilcloth, dip back in the thick paint, and rub on the oilcloth till the paint is exactly the right thickness, then apply. There will be no running drips or thick slugs. You can put a perfect application smooth as flaxseed. In thirty minutes return, dip finger in linseed oil, rub on real thin coat of oil over first coat, then follow immediately with a second coat of paint over the oil and smooth it by continual rubbing till it begins to rub stiff."

If Howard is painting on plywood, he will have several precut pieces to choose from. The size of the board (from seven inches or twelve inches square to four feet by four feet) determines the price of the completed painting. One day I saw him flipping through a stack of clean boards saying, "This will be a seventy-five-dollar piece; this one will go for a hundred and fifty; that one over there will be a five hundred–dollar painting." After the background had been applied to a number of boards, they would sit around his studio for two or three days until God showed

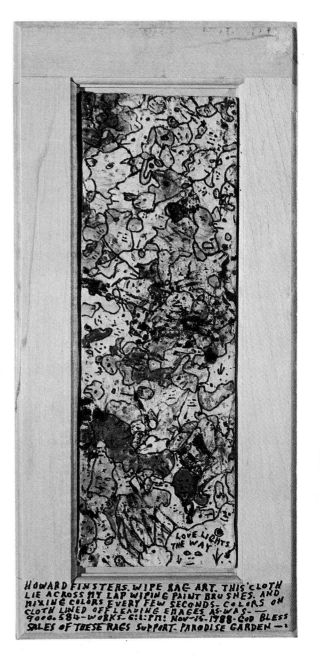

HOWARD FINSTER'S WIPE RAG ART: tractor enamel and ink on cotton, 19 × 9", 1988, #9000 584. (J. F. Turner. Photo: M. Lee Fatherree)

121

*Above:* Morning Clouds: enamel on wood, 36¹/₂ × 14³/₄ including frame, 1978, #1000 133. (Stephanie and Stanley Sackin. Photo: Robert Spencer)

*Opposite:* The Dog Story of the Bible: enamel on panel, 26 × 20", ca. 1976. (Chuck and Jan Rosenak. Photo: Robert Reck)

*Below:* Double Presidents Bed: enamel on metal, 48 × 54", n.d., #559. (Marion Stroud. Photo: Norinne Betjemann)

him what to put on them. Once the vision of art comes to him, he knows in his mind's eye what the paintings will look like. He says he simply copies his visions. His subjects vary as much as the surfaces on which he paints, but the inspiration is almost always the Bible.

"There ain't nothing that isn't in the Bible. I may have to hunt for it, but when I find it, I write about it. There's really no big difference in what I paint and what I used to preach. See, I paint my sermons now. Now my art is my church.[11] When I get a vision, I see the picture first and then I paint it. Jacob, when he had his vision, he wrote it; when I have my visions, I draw them. I have a subject I want to discuss and maybe I'll have a vision of a message. When Jesus tried to get sayings over to people, he used things that people were familiar with. Jesus used a wheat seed that every fool was familiar with. He used that wheat seed because it was familiar to people, and then he brought the Resurrection story out of it. When he used the mustard seed, he brought out the faith story. I used George Washington because he is a familiar aspect in the world. Everybody in the world knows Abe Lincoln and I use him and Washington because the people are familiar with them, and when they are looking at them they are getting my vision-message painting. So that is practically like Jesus done."

When Howard paints Washington, he believes he is keeping Washington alive. This is true with many of the heroes he has

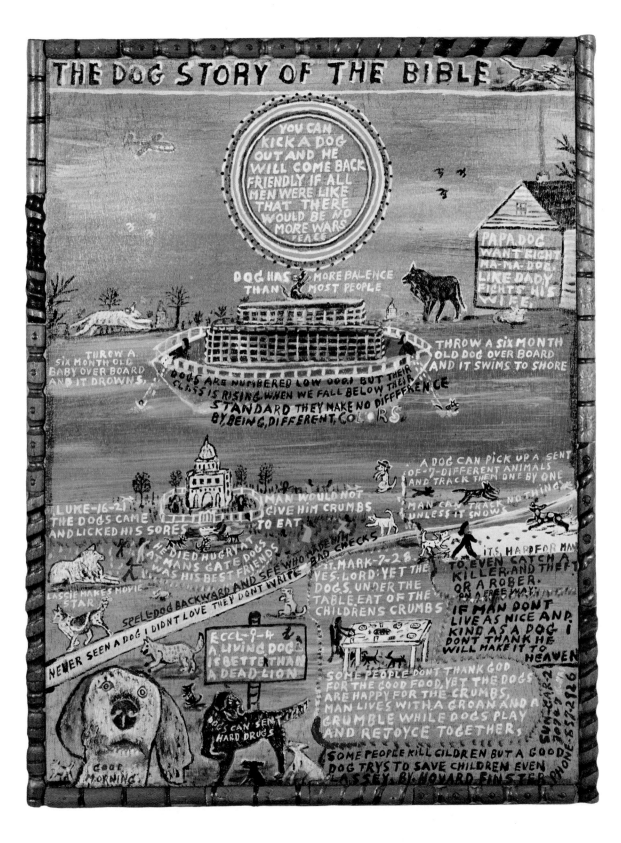

# THE DOG STORY OF THE BIBLE

YOU CAN KICK A DOG OUT AND HE WILL COME BACK FRIENDLY IF ALL MEN WERE LIKE THAT THERE WOULD BE NO MORE WARS PEACE

PAPA DOG WANT FIGHT MA-MA DOG LIKE DADY FIGHTS HIS WIFE.

DOG HAS MORE BALENCE THAN MOST PEOPLE

THROW A SIX MONTH OLD BABY OVER BOARD AND IT DROWNS,

THROW A SIX MONTH OLD DOG OVER BOARD AND IT SWIMS TO SHORE

DOGS ARE NUMBERED LOW 0001 BUT THEIR CLASS IS RISING WHEN WE FALL BELOW THEIR STANDARD THEY MAKE NO DIFFFERENCE BY BEING DIFFERENT COLORS

A DOG CAN PICK UP A SENT OF 7 DIFFERENT ANIMALS AND TRACK THEM ONE BY ONE

LUKE-16-21 THE DOGS CAME AND LICKED HIS SORES

MAN WOULD NOT GIVE HIM CRUMBS TO EAT

MAN CAN TRACK NOTHING UNLESS IT SNOWS

HE DIED HUGRY AT MANS GATE DOGS WAS HIS BEST FRIENDS

WHO MADE BAD CHECKS ST. MARK-7-28 YES LORD: YET THE DOGS UNDER THE TABLE EAT OF THE CHILDRENS CRUMBS

ITS HARD FOR MAN TO EVEN CATCH A KILLER AND THEFT OR A ROBER. ON A FREE WAY. IF MAN DONT LIVE AS NICE AND KIND AS A DOG I DONT THANK HE WILL MAKE IT TO HEAVEN

LASSIE MAKES MOVIE STAR

SPELL DOG BACKWARD AND SEE WHO THEY DONT WRITE

NEVER SEEN A DOG I DIDNT LOVE

ECCL-9-4 A LIVING DOG IS BETTER THAN A DEAD LION

DOGS CAN SENT HARD DRUGS

SOME PEOPLE DONT THANK GOD FOR THE GOOD FOOD, YET THE DOGS ARE HAPPY FOR THE CRUMBS, MAN LIVES WITH A GROAN AND A GRUMBLE WHILE DOGS PLAY AND REJOYCE TOGETHER,

GOOD MORNING.

SOME PEOPLE KILL CILDREN BUT A GOOD DOG TRYS TO SAVE CHILDREN EVEN LASSEY. BY HOWARD FINSTER

SUN-MAR-2 30963 PHONE-857-2926

VISION QUEEN HENERETTA: etched sheet metal with enamel, 15$^1$/$_4$ × 20$^1$/$_2$", 1980, #1000 855. (J. F. Turner. Photo: M. Lee Fatherree)

A page from one of the hundreds of "garage-sale" books that Howard stacks around his property. This likeness of Queen Henrietta has been used in several of Howard's works. (Photo: M. Lee Fatherree)

repeatedly drawn, such as Elvis, Henry Ford, Lindbergh, Uncle Sam, Santa Claus, and Jesus. He has a special affinity for inventors because he feels that they were sent to fulfill God's prophecy, as Edison did when he lit up the world, and as Henry Ford did when he invented the horseless chariot. He has drawn lesser-known historical figures whose likenesses he found in books purchased for pocket change at community yard sales. One such book, *The Wonderful, the Curious and the Beautiful in the World's History*, contains a black-and-white illustration of Queen Henrietta. In an interview recorded at the time of his one-man show at the Braunstein Gallery in San Francisco, 1981, Howard explained why he painted her:

"This is Queen Henrietta. I found her in an old school book and I liked the way she looked and she was the wife of Charles number one. I put her on there [the painting] and I thought people would know her across a big gallery floor and when they seen her it would be a drawing card and they would come straight over, and when they got over here I have my own poetry and also I have Bible verses concerning the queen. So I paint Henrietta and bring her into a subject with the Bible and take what the Bible says about a queen and a queen that is familiar to us here in the world. A lot of time when we are talking to somebody we talk about something they are acquainted with and that's the way we get acquainted with them. That gets the subject started and we can then go into something else the picture didn't actually show."[12]

He has always drawn from illustrations or photographs. "It bothers me to look at any living thing and try to draw it. You get a picture of a person and it's not all that much trouble to paint from it." Once he selects an image (sometimes as small as the face on a postage stamp, or as large as a life-sized photograph on a record album cover), he begins to draw, using a drafting system he designed, which involves placing dots equal distances from the nose, mouth, and ears. He then adjusts them proportionally to make the image bigger or smaller. When he has the face dotted out like the Big Dipper, he connects the dots.

Howard feels he can draw just about anybody. "You

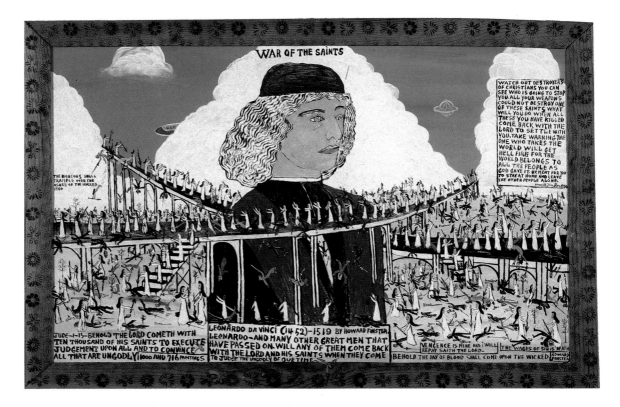

WAR OF THE SAINTS: enamel on wood, $19^{3}/_{4} \times 30^{1}/_{4}$", 1980, #1000 716. (Hugh McRae and Oriana Rodman. Photo: Stuart Rome)

can take a fellow's hairstyle and his nose, mouth, and chin, and you pretty well got it. It's the same for a woman. The most important is the hairstyle, it shows up more." Getting a correct rendering could take Howard many attempts and several hours. Once the image is completed to his satisfaction, he creates, in effect, a template, which he calls a "dimension," from which he can trace as many copies as he chooses. These "dimensions" allow him to juxtapose whatever images suit his purpose for a particular painting, sometimes with astonishing results. A dimension of Elvis Presley at age three (taken from a photograph) served for both a full-figure wooden cutout and a painting with a head-and-shoulder view of Elvis on another planet. He varied the image by adding a hatbrim full of friends and drawing on Elvis's shirt in the painting.

Always a practical man, Howard greatly admired the efficiency of Henry Ford's assembly line and applied it to his own work. His manipulation of his "dimensions," Bible verses, and original poetry permit him to create thousands of pieces of original art. At one point he

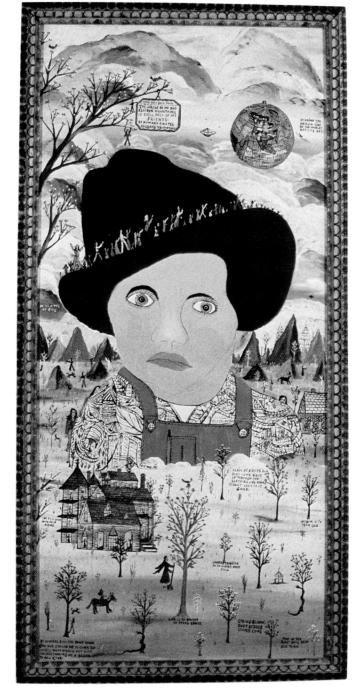

*Right:* THE HATBRIM ROAD: enamel on masonite, 48 × 24", 1980. (Photo: Courtesy Phyllis Kind Gallery)

*Opposite page:*

*Top left:* I always liked the photograph of Chairman Mao swimming in the Yellow River on the occasion of his eightieth birthday, and I re-created it on holiday. I used the photograph on a Christmas card and sent Howard one.

*Top right:* When I asked Howard to do a portrait of me from the Amazon River photograph, he sketched and cut out this dimension, which measures 9 × 7³/₄". (Photo: M. Lee Fatherree)

*Middle:* AS JOHN TURNER COMES UP OUT OF THE AMAZON RIVER TO LOOK: enamel on wood, 19¹/₄ × 37", 1980, #1000 708. (J. F. Turner. Photo: M. Lee Fatherree)

*Bottom:* Unbeknownst to me, my image resurfaced fifty-six paintings later, on an announcement for a one-man show in Chicago. (Photo: Carl Hammer Gallery)

bought an overhead projector to accelerate and improve upon his copying system. He utilizes not only the template/dimensions, but also the wooden forms from which they were cut. He adds a backing to the space left from the cutout forms and pours concrete into them, creating three-dimensional painted silhouettes of the images. He is proud of the fact that the only thing he wastes

126

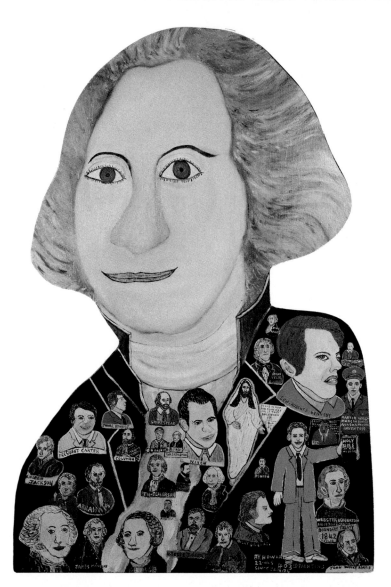

George Washington: enamel on
wood, 48×37¹/₂", n.d., #403.
(Jamestown-Yorktown Educational
Trust)

One of Howard's biggest "hits"
basking in the sun. (Photo: The
Arient Family Collection)

is the sawdust. If he cuts out more than two figures from a board, he paints what remains, calling it "scrap art."

He draws himself into many of his paintings, stating that "every artist should learn to draw himself first. People will remember who did the painting if they see a picture of the artist himself." When asked about why he uses every available inch in his paintings, Howard says he tries to make a "full painting." "You wouldn't want a picture without a background and trees and flowers and people walking around out there. I like animals in my paintings, and then I put my main subject in and then write about that subject. I use my finger to blend in the face, kinda shade it around the nose and chin and put some light around the forehead. Sometimes I do the hair with my fingernails. I put the clouds in with my fingers and sometimes there will be pictures of human beings in them and all I have to do is put the eyes on them." Howard uses a brush for all his detail and trim work.

As Howard's fame grew, owing to an abundance of media coverage, so did the demand for his art. Earlier, he had been able to supply his agent and the collectors of folk art, but now he was deluged with requests and checks that came through the mail. As he had done in the past with his clocks, he enlisted the help of his family.

Beverly Finster remembers: "We burned the designs into the picture frames. Then we started building the frames and framing the paintings. Then we started doing backgrounds. He'd say, 'Paint the bottom green and the top blue.' Sometimes you painted just white. You'd put a coat on, then sand it, and then a second coat. I would paint fifteen or twenty at a time. When the pressure was on in 1982, he needed me and my nephew Andy to do this work. He would pay us by the hour and we could do as much as we wanted to. He told us never to put anything on the boards except what he told us, because it had to be his art. We'd put on the first couple of coats just to get it ready for the art and the third coat was the art.

"On the patterned pieces [his grandson Allan cut those out, mostly "hits" like little Elvis, "The Devil's Vice," and the ever-popular angel with a trumpet], he would mark them out and we would color it just like you would in a coloring book. It was never a secret that Andy and I worked on the backgrounds. Visitors to the Garden

Cement "headstone" of St. John the Baptist, Paradise Garden. (Photo: Willem Volkersz)

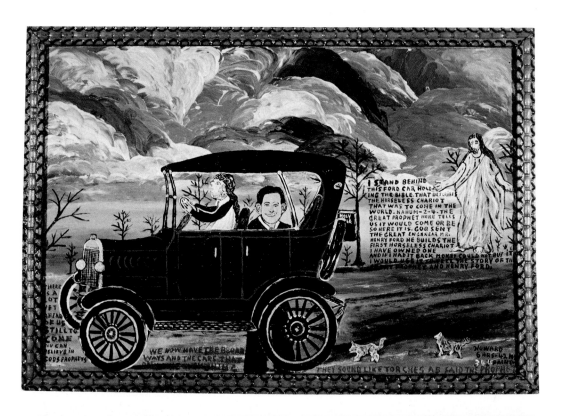

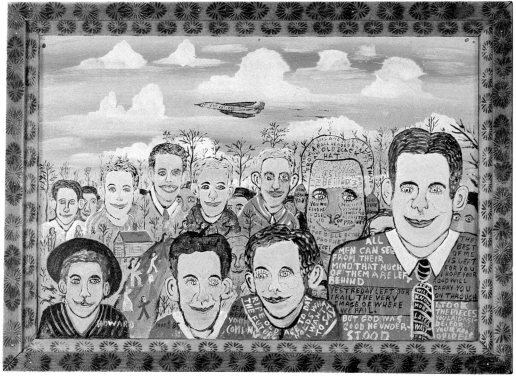

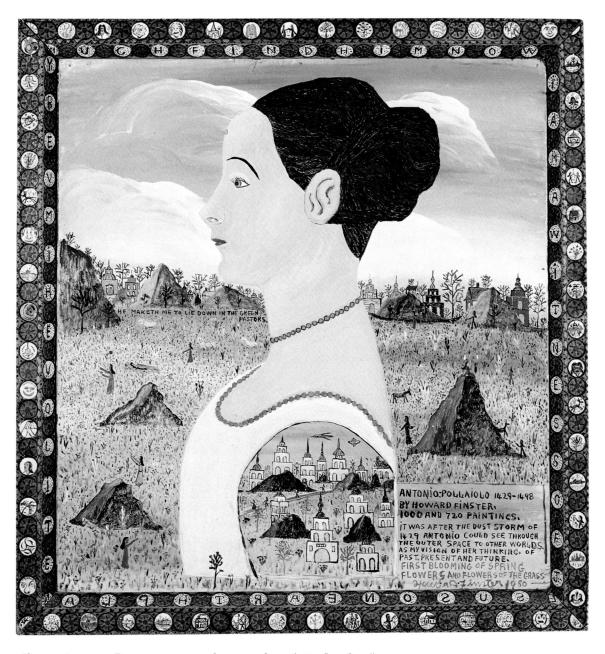

*Above:* Antonio Pollaiolo: enamel on wood, 23¹/₈ × 22″, 1980, #1000 720.
(Jeff and Jane C. Camp. Photo: Hardy & Sheffield Photography)

*Opposite top:* We Now Have Cars & Broadways that Run like Lightning: enamel on wood, 22¹/₂ × 32¹/₂″, n.d., #344. (Photo: Courtesy Phyllis Kind Gallery)

*Opposite bottom:* You Look Like This and You Look Like That: enamel on metal, 14³/₄ × 20³/₄″, 1978, #1000 85. (Permanent Collection of the Anderson Gallery, Virginia Commonwealth University. Photo: Allen Jones)

Though not frequently, Howard does sketch "visions of his paintings." (Photo: M. Lee Fatherree)

were always around and saw us working. In 1984 I was painting on the flesh and the hair for the angels, but Papa would paint the clouds, faces in the clouds, put gold and glitter on the trumpet along with his messages. He might do ten angels at a time and was sure to sell at least twenty-five a week in addition to his other work.

"He was pleased with his success and stressed it to us. He told us that we needed to learn what he was doing. He liked for it to be carried on. For him, he was doing it for religious reasons, but he also showed us how we could make money if we needed it. He wanted us to do our own art, using his patterns and techniques. I started doing art in 1980. I used his paint but I didn't use his techniques. One day I was working on a portrait and I was having trouble putting in the eyes. Well, I put it aside and went to bed. Papa picked it up and painted the eyes in, you know the way he does it, and when I got up in the morning and saw that, I got real mad!

"Some of his paintings were so pretty and beautiful and that surprised me. I had never seen anybody paint so differently and so fast. The biggest thing that bothered me was that the paintings were getting out before I could even see some of them. He's no different now, only more pressure is making him tired. Fame has forced him to make art faster. I think he is going to burn up physically, but mentally I don't think he will burn out on art."

Howard admits that "I just tried every shortcut I could to try to turn out production, because everything I made sold. When I got going on art, I stayed ninety-five percent behind all the time. I could sell ninety-five percent more of what I sell if I had it. Actually I hardly ever get anything to where I think it's finished. I get it where it looks normal as it possibly can and turn it loose as soon as I can."

One of the ways Howard kept up with the demand for his work for so long was by having about fifty pieces of art started at all times. "After I got started on painting, just like any profession, it become the more you've done

it, the better you got at it, and I started making forty or fifty pieces, working a little on this one and a little on that one, getting several pieces ready to go out. Some nights I'd turn out two, three pieces of art, some nights I'd turn out nothing." Working in several media, he was always starting something, putting something else down, and thinking about tomorrow's project. "I picked up a beer can and decided to use it to preach the Gospel over the world. I nailed it flat on a board, and turned it into a printing cut, and printed two hundred fifty copies. I figure there is enough empty beer cans to print the whole Bible and send it into the corners of the earth."

In a typical day Howard could work on a piece of sculpture in the Garden; greet visitors with his life's story and a couple of sermons; work in his woodshop; put up a couple of newspaper clippings in the chapel; talk on the phone; run some errands; work on a painting or two; and complete a cutout or three. Around 1984, when his output was doubling, Howard started telling visitors that his goal was to do five thousand works of art and then retire. When he reached that number in 1987, I asked him why he was continuing to fill as many orders as he could and he replied, "I said my goal was five thousand. After I painted that five thousandth piece, believe me, I didn't feel obligated to never paint another painting in my life. I felt plum loose from painting. I felt like that five thousand was all I was commissioned to do, but I had a feeling I could go further, and you know when somebody is in service and goes the limit, that's great, but when they go over their limit, well that's great, but when they overgo their limit, that's greater and that's what I'm doing. I am going over my limit. I'm going overboard. Suppose I could get to ten thousand and double my goal without ever feeling like I had to do it."

One of the questions most frequently asked about Howard is: "When does he ever get the time to do all that art?" On inspection, one finds on almost all of the paintings, besides the messages, his signature, the number of the painting, and the time of day it was completed. Before he started numbering his work in July 1977, he would often put only the number of hours he worked on the painting. Most of the works are completed in the late evenings and early mornings.

Art made from cement poured into women's gloves. (Photo: Jeff Camp)

133

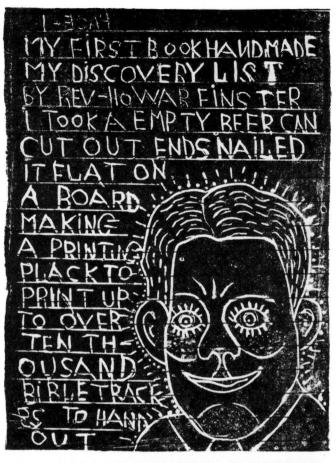

I-30-84
MY FIRST BOOK HAND MADE
MY DISCOVERY LIST
BY REV—HOWAR FINSTER
I TOOK A EMPTY BEER CAN
CUT OUT ENDS NAILED
IT FLAT ON
A BOARD
MAKING
A PRINTING
PLACK TO
PRINT UP
TO OVER
TEN TH-
OUSAND
BIBLE TRACE
S TO HAND
OUT

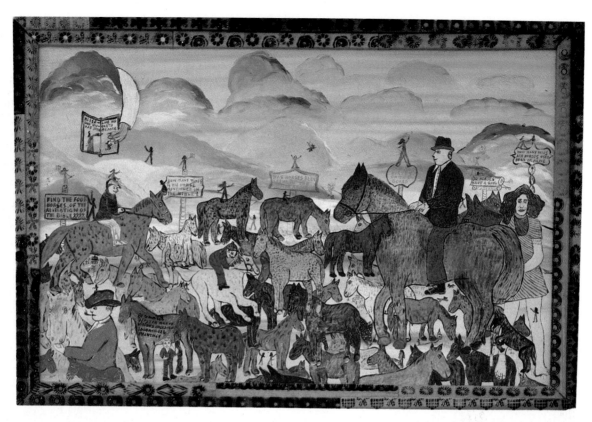

"I start painting, long about ten o'clock in the cool of the evening, when everything is quiet, no children running and things is closed up. I drink me a large cup of coffee and can paint for hours sometimes. It's quiet and I meditate. Painting is sorta like preaching. You got to have spiritual inspiration. I paint till just a little before daylight [4:00 a.m.] the next morning. I then sleep six or seven hours and take a few naps during the day, just like Tom Edison. I don't like to sleep. I think it is a waste of important time.

"Everything I look at is art. I can look at mountains on TV and I can see great faces that nobody else probably don't notice. I often lay here in my studio and go all over the world on TV to see what people are doing, what they are saying, and what their religion is. I never turn the TV set off in the night time. I like a good wrestling match, historical presentations, and that program on the educational station called 'Georgia Geographic.' I learn about everything from TV. I have to look at the TV to see what's going on in the world, and then I have to look at my visions and see if my visions compare with what's going

*Above:* HORSES ON EARTH LIKE NO ONE HAS SEEN BEFORE: enamel on wood, 29¹/₂ × 18¹/₂", n.d., #1000 128. (Stephanie and Stanley Sackin. Photo: Robert Spencer)

*Opposite page:*

*Left:* Howard's workshop. Several pieces are always in progress. In the back can be seen the two color backgrounds painted on cabinet doors. (Photo: J. F. Turner)

*Right:* Howard printed this from an etching he made with a nail on a beer can. (Photo: M. Lee Fatherree)

*Bottom:* Howard painting in his studio. (Photo: © 1986 Marianne Barcellona)

WORLDS GREATEST RIDDLE: mixed media and TV set, 11¹/₂ × 15¹/₄ × 9″, n.d., #1000 683. (Janet Fleisher Gallery. Photo: Norinne Betjemann)

on in the world. Afterwards, I write messages on the paintings about predictions in the Bible that I've seen on TV. Like AIDS. God said that in the last days there would be grievous sores.

"I don't read books. Some people have given me artist books. I think they are nice, but I don't see anything I want to draw, because I don't draw my visions by books. I don't paint after the paintings in the books. I don't claim to be that kind of an artist. I'm mostly a cartoonist. My work is kinda like a cartoon. If I were doing art like other people, I'd be where they're at. I'm doing art from another world. I'm like the guitar but the music comes from God. I'm just an instrument. If I made a horse like everybody makes a horse, I could finally make them where they look like real horses you see in a book, but it would take a lot more time and people have already seen that. There have been horses around since people have drawn, but there

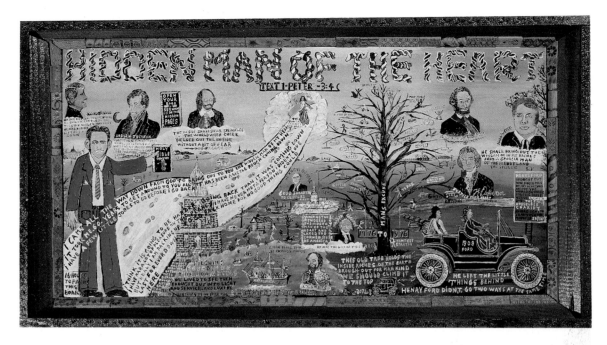

HIDDEN MAN OF THE HEART: enamel on wood, 22 × 41 ¹/₂" including painted and carved frame, 1977. (American Folklife Center, Library of Congress, Washington, D.C. Photo: Reid Baker)

are no horses in the world like I draw, and people love them and will buy them. They want something they haven't seen.

"If you don't have a talent of art, you have to go to school. That's the only way you can be an artist. You don't have to have a talent to be an artist. You can be educated to be an artist. But if you have a natural talent and try it out and you find you really can do art, you don't need to go to school, you need to start schooling yourself and doing things. If you don't have a talent of art and you want to be an artist, you go to school and they will learn you to be a professional artist. The professionals can't do better art than I'm doing. My work wouldn't be any different if I went to school.

"A fellow that don't think he can do anything and don't think he can paint like I thought one time, he should get his paint colors all out where he can reach them and then just shut his eyes and start dabbing all over the board dipping in different colors, and take his finger and touch it, and see that he gets the board all covered and do it blind, doing without looking. And when he gets through he might come up with a beautiful piece of art and get encouraged that he could really do something with his eyes open. If he could do something with his eyes shut, it gives him evidence and gives him security that he could do better with his eyes open.

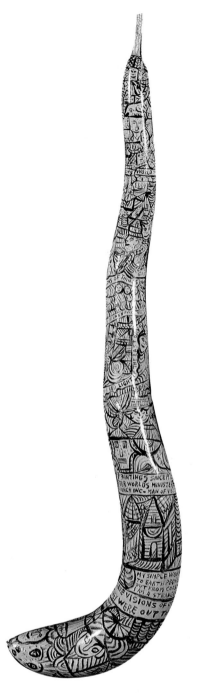

"I tell the artists, 'You talk about not knowing what to do, you can't get no headway, well, why don't you do like I done and get an old bicycle and paint pictures all over the bicycle and make that bicycle into something to where it would sell for three hundred and fifty bucks? That's what I done. Or grow a gourd and paint art on that gourd. I can take a gourd and paint it into art and sell it and buy a pickup load of gourds with that one gourd.' These young artists haven't sacrificed themselves to their art. They haven't dedicated themselves to it, and a lot of artists just make two or three pieces of art and just hang on to it and show it to everybody and never reproduce it. They think they have to have the very best stuff to paint on. I can walk into a junkyard a pauper and paint my way out as a rich man.

"The artists think they have to follow somebody else, but they need to do their own thing, and if they have visions like I do, do their visions. You should first desig-

*Above:* GOURD: enamel on gourd, 26 × 3¹/₂". (Ann and Edward Blanchard. Photo: Stuart Rome)

*Above right:* Howard painting an angel on one of his more popular cutouts, "Howling Wolf." (Photo: © 1986 Marianne Barcellona)

*Right:* Howard's palette. (Photo: Jim Abbott)

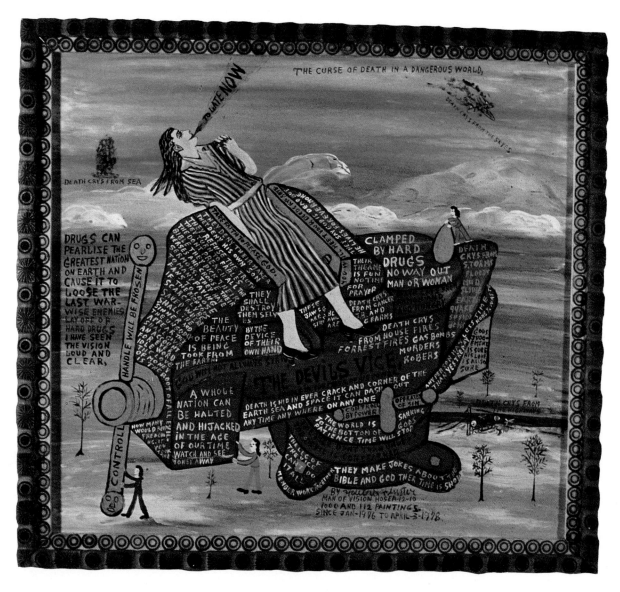

THE DEVIL'S VICE: enamel on wood, 21 × 23", #1000 112. (Photo: Courtesy Phyllis Kind Gallery)

nate a room for your work and fill it up with fifteen or twenty pieces of your art and then the TV station will come and film it. They won't come if you only have one or two pieces. You get enough of it and it becomes exciting to people, not just a painting here and yonder. Do everything you can think of and display it. That's what I done.

"I could sell a hundred thousand more than I make because it's different than what's out there. My vision is different. I'm an example. My art is a medium of showing the people. You can tell people something and they forget it, but if you draw it they will remember it. If I preach the Devil's vice story without the vice, they forget it in an

139

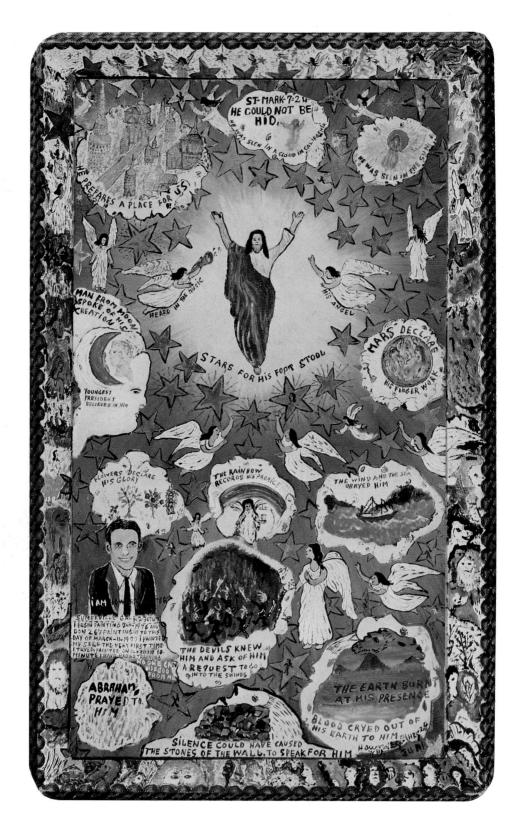

hour, but if I do the vice story with women in the vice, it plants it on their brain cells. It's something about a visual of a picture that stays on your brain cell, just like a negative in your camera. I've done six thousand, nine hundred and eight works of art and I think two or three hundred of them would be pretty perfect. Eighty-five percent of the paintings are okay and the rest of them sells as an item just because people who want my work will take anything they get with my name on it. I call that third-class art. First, second, and third. Third is pretty bum up, got crooked buildings on it and the animals aren't too accurate. Most second-class paintings are pretty good paintings. They don't have too much on them and what's on them is scattered.

"The most time I spent on a painting was one of my early ones for the Library of Congress. I put about three days on it. I painted five or six hours a day. Shortest time I spent on a painting was a head picture of Andrew Jackson. That took me forty-five minutes. I've done a variety of pictures on gourds. Some are thirty minutes, some are thirty-five minutes, and some as little as ten minutes. I could put a week in on just one person and I might make them perfect, but I'd lose a thousand dollars fooling with something like that. To do art like them fellows do in the books, it would take months. I'm a cartoonist. I don't fool with details like that. I don't back up from universities, from philosophers, dictators, or presidents, and what I'm telling you is that's the way it is, and if you don't know it now you are going to soon find it out. I am a chairman of sacred art."

When I was 60 years of age
God pulled back my hidden page
He put his brush in my hand
to reveal secrets hid from man
Go Howard and don't let up
when you are down I'll fill your cup
make it plain and tell it true
I will hold your crown until you get through

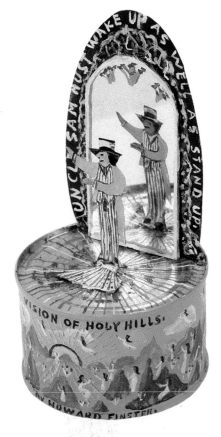

*Above:* UNCLE SAM MUST WAKE US AS WELL AS STAND UP: tin can with mirror, enamel on metal, $6^{1}/_{4} \times 3^{3}/_{8}$", 1980, #1000 773. (The Arient Family Collection. Photo: William Bengtson)

*Opposite:* HE COULD NOT BE HID: enamel on wood, $21^{1}/_{2} \times 34$" including painted and carved frame, 1977, #267. (American Folklife Center, Library of Congress, Washington, D.C. Photo: Reid Baker)

141

# CHAPTER 6

# Natural Born Talent

*I first heard of Howard Finster in 1975 from an acquaintance doing an article for* Esquire *magazine on eccentric backyards. I had been documenting "folk environments" in California for several years, and I asked her if she had stumbled upon any unusual creations in her national research. She mentioned a pretty amazing garden being worked on in Summerville, Georgia, and gave me Howard's address. The next day I sent him a postcard inquiring about his Garden. Two weeks later I received a one-hour cassette on which Howard not only told me about everything in his Garden, but also sang songs, picked tunes on his banjo, and recited poetry as well. Thus began a wonderful friendship.*

*I have known Howard for some thirteen years. The relationship we have is special, but not out of the ordinary. Treating each and every stranger as a sheep in God's flock, Howard has made himself accessible to a large number of people. In his early days as a pastor, he reached people through revivals, the radio, and his weekly newspaper column. As an artist he gained wide exposure through galleries, art magazines, and even the Johnny Carson Show. This publicity has led a steady stream of visitors to Paradise Garden, which has often included first-hand "fellowship" with the "preaching artist." Many of these early visits resulted in lasting friendships with art students, teachers, museum curators, and collectors of twentieth-century folk art.*

*Although much has been written about Howard Finster the artist, very little has been written about his art. This could be due to the fact that Howard's engaging personality and*

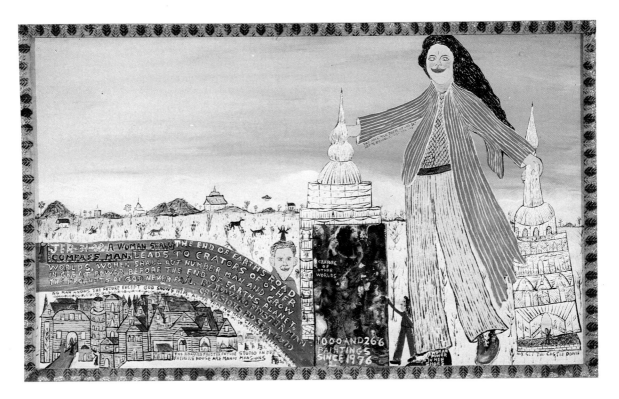

A WOMAN SHALL COMPASS MAN:
enamel on masonite, glitter, on frame,
22⅝ × 37⁹/₁₆" including frame, ca. 1978,
#1000 266. (Collection of Didi and
David Barrett. Photo: Barry Pribula)

the sheer volume and uniqueness of his art give writers more than enough "good copy" to fill a Sunday profile. One also has to consider the lack of interest shown by the "serious" art community. What writer would risk a reputation analyzing a non-academic artist who came to the mainstream as an uninvited guest when they could be reviewing a "safer" show at the Modern?

I hope to open wider the door to appreciation of Howard Finster's work by including here comments by the people who have been associated with and have followed the development of his career. While these people are not professional art critics, their knowledge of folk art, contemporary art, and Howard's position in both of these worlds is invaluable. Although this is most certainly not the last word on his style, technique, or presentation, I hope it will lead others to look further and deeper into this man's contributions.

Among those with whom I spoke were Robert Bishop, director of the Museum of American Folk Art in New York City, who first visited Howard's Garden and purchased some of his paintings in the seventies; Andy Nasisse, professor of art at the University of Georgia, Athens, who was instrumental in ac-quainting various university art departments with Howard's

*work; Victor Faccinto, director of the Fine Arts Gallery at Wake Forest University in Winston-Salem, North Carolina, who encouraged Howard to associate himself with Phyllis Kind's New York City and Chicago galleries, the first major galleries to represent him; Roger Brown and Jim Nutt, artists identified with the "Chicago Imagists" (the "Hairy Who"), both of whom appreciate and acknowledge the validity of "outsider art"; John Ollman, of the Janet Fleisher Gallery in Philadelphia, who curated a major exhibit of Howard's work and produced its accompanying catalogue in 1984; Lynda Hartigan, of the National Museum of American Art, who acquired works by Howard for the Museum's Permanent Collection; Ann Oppenhimer, of Richmond, Virginia, a long-time supporter of Howard's work and director of* Sermons in Paint, A Howard Finster Folk Art Festival *at the University of Richmond, Virginia, 1984; Ray Kass, professor of art at Virginia Tech at Blacksburg, Virginia, who organized what Howard refers to as an "art workout" at Mountain Lake, Virginia, in 1985; and Ned Rifkin, Chief Curator of Exhibitions at the Hirshhorn Museum and Sculpture Garden.*

Howard: "Nothing I ever tried or wrote amounted to anything until I discovered art. Then the woodcraft, poetry, and the paintings all came together. It was like taking schooling on all of them for no profit separately and then they all come in and join together in art. This is my last trade out of twenty-one trades I can do. I never knew nothing about folk art. I first started to learn about it when I was going to the big universities. I still don't understand too good what folk art is, but I think it's what you call a natural born talent. Without a professional education. You have an uneducated artist that starts on just instinct and what he has. Folk art is an identification of your own thing. It's different than what they do at the universities.

"My work is scrubby. It's bad, nasty art. But it's telling something. You don't have to be a perfect artist to work in art."[13]

Andy Nasisse, professor of art at the University of Georgia, met Howard Finster in the summer of 1975. He heard of the preacher-artist from Phyllis Kind in Chicago, and decided to pay him a visit. "The first time I saw him was from behind, and there was the barrel of a gun

sticking out of his back pocket. It sort of scared me. He told me someone had taken a shot through the window of his bike repairshop. He walked and talked me through the Garden and showed me the clocks he was making. He tried to sell me one for twelve dollars. I asked if I could buy one of the paintings, but he said no, they weren't for sale.

"I visited him again in 1977, and this time I told him I was with the university and invited him to give a talk to one of the basic art classes. I brought him down and he gave a talk while I showed slides of his Garden and work. It was his first talk, and he was shy. People were blown away and didn't know what to make of him. It was great. One fellow said that the one-hour talk was worth a whole year of art courses. He [Howard] was really surprised that people liked him and listened to him. In 1980 he came back and packed the Botanical Garden. He talked about his techniques of art.

"He subsequently received offers to lecture at other universities and I traveled with him to La Grange, the University of Miami, and the University of Colorado. Victor Faccinto of Wake Forest had him lecture there and also went with him to speaking engagements and show openings. At first Howard was a little insecure about going to the universities and had to have me with him the whole time, but by 1981 he traveled alone to San Francisco for a one-man show and a lecture at San Jose State."

In the 1940s, artist Jean Dubuffet sought out, collected, and wrote about art that he described as "works of every kind—drawings, paintings, embroideries, carved or modelled figures, etc.—presenting a spontaneous, highly inventive character, as little beholden as possible to the ordinary run of art or to cultural conventions, the makers of them being obscure persons foreign to professional art circles."[14] He called this *art brut,* or raw art. Roger Cardinal expanded on this in his 1972 book, *Outsider Art.*

In a review of a folk art exhibition, *Washington Post* art critic Paul Richards wrote that "Folk art, like pornography, is easier to recognize than it is to define."[15] This is especially true of Howard Finster's work, which leaves its footprints in many of the definitions of "folk art" by academics in their attempt to better understand and "pi-

geonhole" these artists. Howard is usually described as a folk artist because he was self-taught and was discovered in a rural environment. He fulfilled the criteria of a folk artist in much the same way as did memory painter Grandma Moses in the 1950s. Howard had strong community roots as a pastor and was part of the craft tradition, making and selling clock cases to the townspeople.

As his body of work grew and his fame spread, attempts were made to explain more clearly his work and inspiration. But the often-used terms "naive," "innocent," and "primitive" never seemed to capture the fire or energy of his vision. The term "outsider" was more appropriate, "outsider" as in those who are outside the art establishment, who have little if any knowledge of that system, and who, unlike many contemporary artists, have no desire to gain entry. Outsider art includes work done by the insane and psychotic. Outsiders have an urgency from within to create that has nothing to do with art history, the museums, or the folk art tradition. Outsider art is extremely personal and is often an expression of inner turmoil. Howard, however, realized early on that if he wanted to send out as many messages as humanly possible, he would have to make use of the gallery and museum "outlets" for his work.

Because he has profound religious convictions and a desire to communicate religious messages, Howard seems to me to be more of a visionary. He himself says that "I'm a visionary man sent to teach other people. I teach from my visions."

Andy Nasisse: "I feel most comfortable with the term 'visionary.' I think he is a visionary because every aspect of his creative output is evidence of deep, intuitive, spontaneously generated images that seem to be more than what he really is."

John Ollman: "Howard's paintings are a conduit of information, according to Howard, which exists outside himself."

Howard: "I am in the plan of God and whatever my art does is from God Almighty, from the worlds beyond. What I've got is credit to God. I'm only an instrument of God."

Robert Bishop, of the Museum of American Folk Art: "Howard's talent is innate, but the Bible gives him the

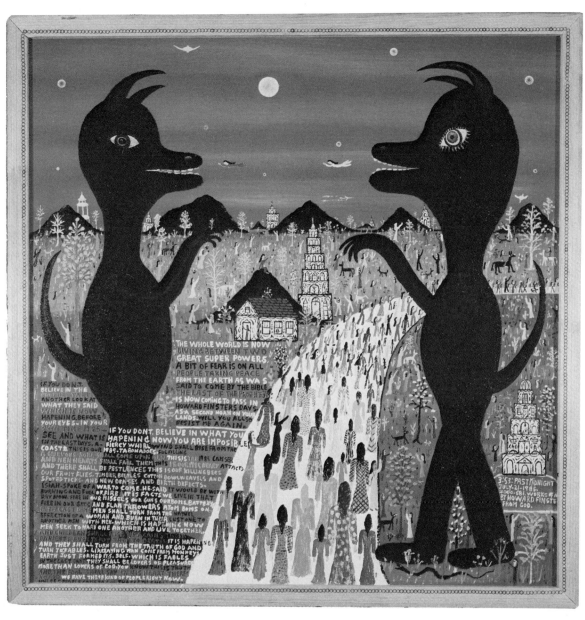

THE WORLD IS NOW LIVING BETWEEN
TWO GREAT SUPER POWERS: enamel on
wood, 48 × 48", 1985, #4000 581. (The
Denton Collection. Photo: Liz Hampton)

motivation for his art: Howard has the great advantage of working from divine inspiration, which gives him a personal strength. If God tells you to do something and you do it, then what you do is going to be very successful, and that has been Howard's success."

Howard: "No doubt in my mind that I have had the greatest working strength of any man who has been on earth's planet except Jesus Christ."[16]

Andy Nasisse: "[He] is a person who has no natural

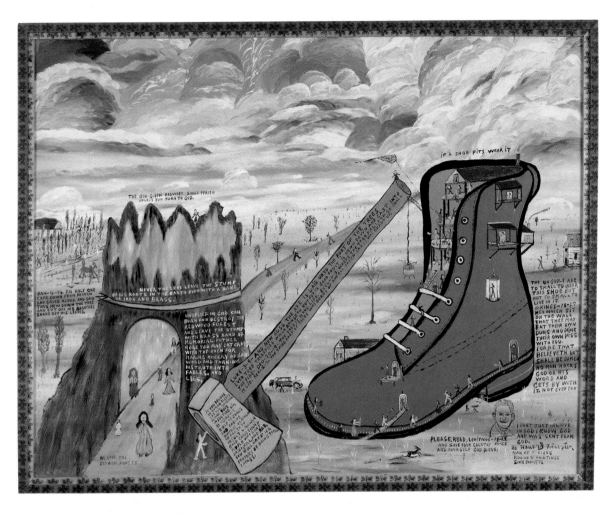

WE LOVE THE REDWOOD FORESTS: enamel on wood, 48½ × 37¾" including frame, ca. 1977, #1000 71. (Jean and Will Muiznieks. Photo: David J. Ross)

sense of limitations. A person who has the commandment and dedication, obsession and compulsion to make art. A person who becomes an instrument, leaving you to wonder where his creative gift is coming from."

Howard: "I'm constantly doing things nobody else has ever done in the world. Why? Because I have visions from other worlds. I have visions from God. God knows what people want. God knows what people will buy. God knows what will make a hit. I call on God for wisdom and strength, that's all I ask for. I say, 'Give me all the divine wisdom you've got, the heck with money.' I'm not Noah, I'm the second Noah. That's what it's all about. I'm a messenger. I don't go by ideas or by books, I go by visions. I am sure about myself and my work. I am sure about God and Jesus and the Bible. My responsibility is to get the message out all over the world."

Howard preaches through written messages in his paintings, which have been called "sermons in paint." Artist Jim Nutt says that rather than painting landscapes, "he is painting ideas in landscapes. It's his vision of the world, and he is trying to make it clear."

John Ollman: "Howard is brutally honest and will directly address an issue and moralize about how it's going to change our lives and the world we live in. You think about the issues he forces you to address. His art is confrontational. It doesn't let you alone. If you stop to look at it for a split second, you are sucked into it. All you have to do is read one passage and it sets up a series of questions that need to be answered."

Howard: "I study the tension. I am causing people to look at things in a different way—look at their life, look at their own future life."

Jim Nutt: "The contemporary artist and folk artist are both responding to things that are happening, such as political and social issues. Howard's work seems to be pretty much free of self-consciousness and that is what art is all about."

Roger Brown, one of the few major contemporary painters working in narrative, doesn't moralize the way Howard does, but works with some of the same themes. He points out that art is something that can deal with historical and daily events. "Howard deals with them because no one has ever told him he shouldn't. There were subjects that were taboo in the art world. You were supposed to do art. My encouragement to deal with these issues comes from people like Howard. Folk artists attempt to communicate through their work. It's the attitude of these people I'm responding to and would like to recreate in myself. It's like cleansing myself of all the ideas about style and tradition of Western art that are intellectualized. In fact it [the art] cleanses me of that and that allows my real self to come out without all that stuff that has been poured in. It was never poured in them [folk artists] so they are free of it and that is the point I would like to come to. When you see people work that way, you know it's possible. There is no way to make a person in the way that they are artists. I'm interested in the genius of genuine invention."

According to Jim Nutt, folk artists live outside the art community, and it makes a difference. "They don't think

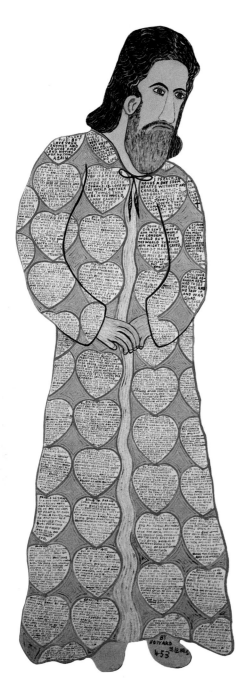

St. John Design Robe: enamel on wood, 81 × 25", n.d., #453. (Janet Fleisher Gallery. Photo: Stuart Rome)

about their art as we think about art as being outside of us. I think they are inside the art, which I think is a nice place to be."

Howard: "I'm an independent individual. I teach my visions and let people look at my visions. My work is for all people. It's not how you get it out there, whether it's a church, a gallery, or whatever it is. A gallery can carry my message out. What I'm leaving is a step into the light. What I'm leaving is another world. My messages and my work give hope after life is over, and that's what everybody needs is hope. Every picture I got has a sermon on it, and they're so many kinds of sermons that there has to be one everyone likes."

Howard's art is a by-product of his obsession with getting out the messages of the Lord. Because of his preaching background, he is verbal before he is visual. He comes from a culture in which words mean the most in conveying religious messages.

John Ollman: "Howard is not about composition, form, and texture—he is about message and content, and that content is in every painting. In some cases the image enhances the content. It serves as a vehicle for the content. The more you see of his work, the less you think of the image. It is a complete and total experience."

In a review of Howard's work, critic Tom Albright wrote: "Howard uses Bible verses, original poems, epigrams, and jeremiads to get his messages across, and none of the refinements of High Art are permitted to stand in the way."[17] Howard could not only count the number of angels dancing on the head of a pin, he could probably paint them there. His claustrophobic work has been described as emanating *horror vacui*—the abhorrence of a vacuum, a fear of empty spaces.

Howard: "I've never finished anything. Everything I've made I've left unfinished, because if I ever finished anything there wouldn't be a scratch left as big as a dot. Sometimes I put stuff on the paintings till you'd think nothing else couldn't go on them—but it could."

Andy Nasisse: "He seems to have an incredible need to fill space. He doesn't like leaving empty spaces, even with his voice, talking all the time—doesn't like that emptiness."

Victor Faccinto: "The only time I've seen him leave

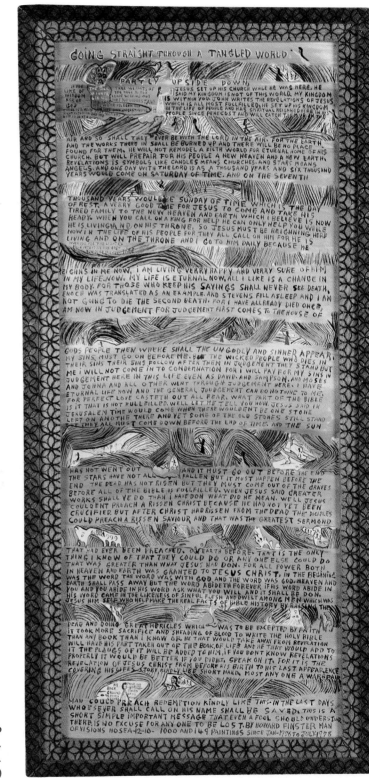

GOING STRAIGHT THRU A TANGLED
WORLD: enamel on wood, 36¹/₄ × 17¹/₂″,
1978, #1000 149. (Jeff and Jane C.
Camp. Photo: Ellen Page Wilson)

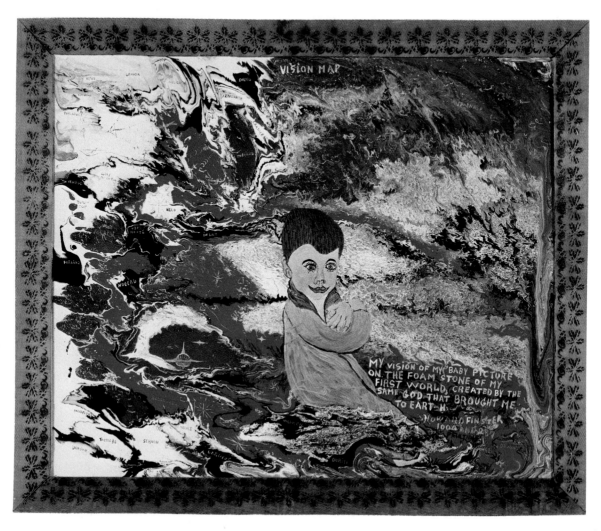

open space is when that open space has become a shape within the total background and composition. It isn't just an unfinished part of the canvas. It becomes a positive shape that jumps out of the canvas. You can't plan something like that. He just starts and the paintings finish themselves."

One critic has described Howard's work with his visions: "One of his 'art inventions' he calls 'captured visions' or 'crater paintings.' He uses ink and paint suspended in linseed oil, placed on a board, which he says develops like Polaroid film. He turns and swirls the mixture until the patterns suggest creatures to him. Then he dots the eyes of the 'varmints' that appear in it."[18] And another adds that "Finster's talent is essentially eidetic, reliant on the capacity that makes us see faces in clouds

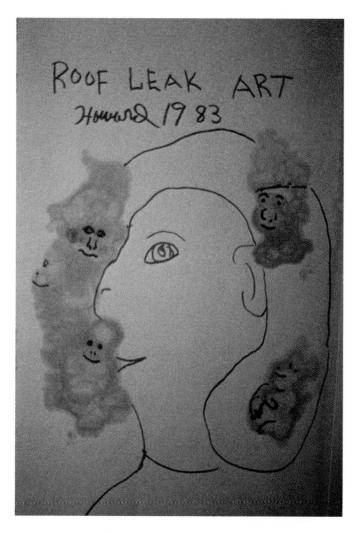

Roof Leak Art, World's Folk Art Church, Paradise Garden, 1984. (Photo: Clair Frederick)

and cracked walls. He evolves images and ideas from the accidental properties of his materials and from dreams, visions, and irrational associations. He trusts in chance and the unconscious, and they reward him with wonderful things."[19]

Howard: "Everything I see is art. I have visions of things before I do them. I can look at people's art that is done and all kinds of shapes and things are there and I find art in it. I can find art in art that is already done. I can look out through the woods and see faces and things that form on the leaves. I find all shapes of art in rocks. I get to molding pot metal and just letting it run out on the flat ground and it makes art itself. It's different things you wouldn't imagine, like gigantic animals."

Once, while looking for some of "God's folk art,"

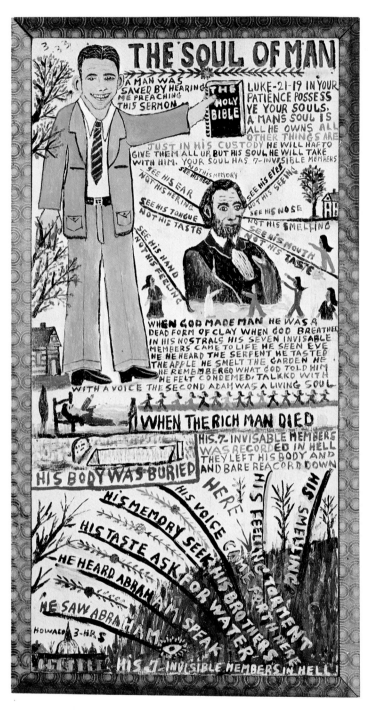

THE SOUL OF MAN: enamel on wood, 24 5/8 × 13 1/8", n.d. (Susan Hankla and Jack Glover. Photo: Hardy & Sheffield Photography)

Howard came across some briar roots that had been torn up near a parking lot. He took them home, painted the faces that were already there, and had what he called, of course, "briar-root art." "Howard's own sophistication should not be underestimated. He is acutely aware of the art object as an apt metaphor for God's power of creation. He often identifies his materials and the sources of his ability to focus the process of transformation with the wonder of divine inspiration."[20]

Andy Nasisse: "He's thrilled by his own creativity. It's one of those things that tends to grow and feed on itself. It seems to be like a physical sensation for him."

Victor Faccinto: "It makes sense for him to become a preacher. If you're an artist or a preacher, you can get away with murder because you're expected to be thinking in ways that aren't normal. That way it's justified. All these things he needs to express can be expressed because God told him what he should be doing, so he is completely free to express himself. He lets things flow without any predetermined controls, he is just a pure creative id. He has the purest form of creativity that I've ever seen. He does not debate over anything. It just pops out of him at a given moment. You know, he didn't have to struggle, and usually artists struggle a lot to come to something. Howard has a flow of visual imagery and when it starts flowing along, he has no purpose to what he is doing. It is just whatever is going to happen."

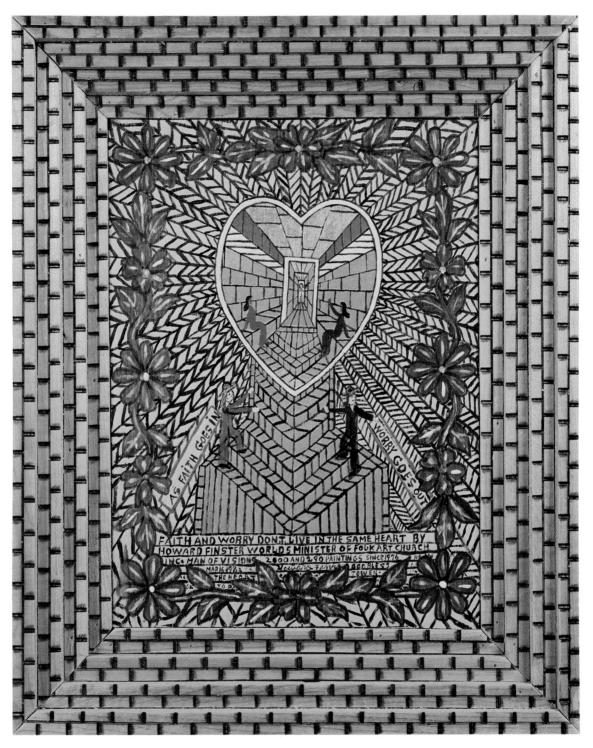

As Faith Goes in—Worry Goes Out: enamel on wood, 18¼ × 22¼″ including frame, 12 × 16″ without frame, ca. 1982, #2000 290. (The Arient Family Collection. Photo: William Bengtson)

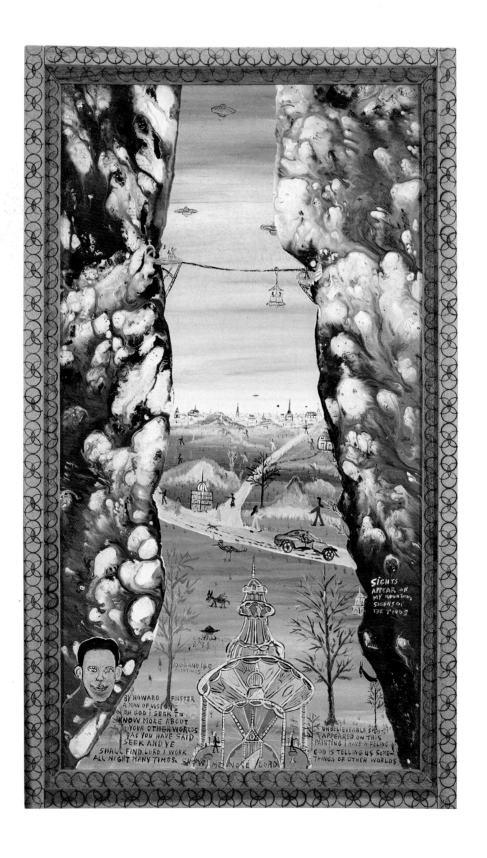

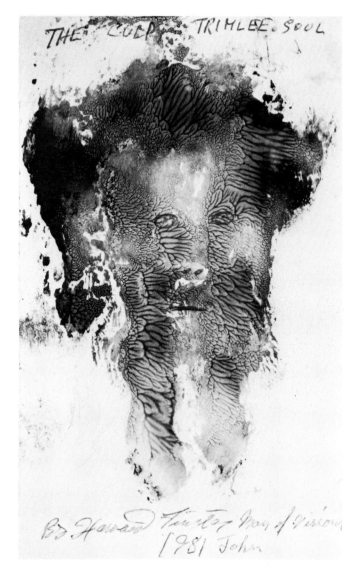

THE COLD TRIMLEE SOOL

By Howard Finster, Man of Vision 1981 John

Ray Kass, professor of art at Virginia Tech: "I don't think the man ever puts limits on his style. That's why I always compare him to John Cage. He is very close to a sort of autistic experience of chance, of probability as an aspect of himself."

Howard: "I didn't start calling myself an artist. They started calling me that."

Andy Nasisse: "I saw his art and I had already in my mind identified that type of work as being essential to what I thought of art. That work was evidence of the creative spirit when it comes out fairly unhindered and unconditioned by society and art school. Everything

Howard watches his art grow on this tree located in front of his studio, Paradise Garden. (Photo: Jim Abbott)

seems to be there. Everything seems to be right. He has created his own alphabet of images and words—something all artists attempt and very few achieve."

Victor Faccinto: "Howard has the ability to conjure up new ideas in art and he's come up with things that other artists would spend their whole careers trying to achieve."

Ray Kass: "I think that the scale, the integrity of his ambition, parallels that of the highest achievement in art in the contemporary West. If his work gets taken seriously, they'll have to open the door to the fact that there are alternative, parallel traditions that can bring a person into legitimacy in the art world. It says something about the continued revolt against tradition. He's a tremendously anti-bureaucratic force."

In 1981, Victor Faccinto wrote a proposal for work to be done by Howard Finster in his Garden. It was submitted to the National Endowment for the Arts (NEA), and a $4,000 grant was awarded him—the first time a folk artist has received such a grant. Victor Faccinto believed the NEA took an interest in Howard because "his work was beginning to influence other artists." Howard used the money to build another walkway in the Garden, in which he molded his bike repair tools—proclaiming himself a full-time artist.

In addition to giving lectures at universities, Howard also led "art workouts" at various schools, at which he would paint and share his art techniques with students over a period of a week. Ann Oppenhimer, who attended a workout at Mountain Lake, Virginia, in 1985, remembers Howard getting up at eight in the morning, having three or four spoonfuls of instant coffee in a cup with a little shot of whiskey as well. "He would spread all his cutout dimensions on the floor, and we could choose the ones we wanted to copy. A lot of students combined dimensions. They'd put the world with a swan, for example—they were inventing—they were making up new things. Many people have discounted Howard's workshops, claiming he was just teaching people to make little Howard Finsters, but that was not it at all. He was showing people a skill—how to make something. He also has good skills as a carpenter. He taught me a skill I didn't have before: how to use a saw. He also teaches people the

spirit of sharing, and what other artist has done that? Really let other people have such a personal involvement in their work? I've often felt that the thing that makes an artist important is not really the body of work but the ideas the artist produces. The ideas that Howard has contributed will live past his work. One of his main ideas was of sharing his tools, his knowledge, and his actual patterns."

At one workout at Lehigh University in Bethlehem, Pennsylvania, he imparted not only his art techniques but also encouragement to aspiring artists. As one student remarked, "I've gone from crayons to oils in one week. I guess he sees something in you that no one else can see, that maybe you yourself didn't know was there. Why am I painting? Because he inspired me. He told us that the white clouds in his paintings are like people floating around to help people in the living world move over to the good side. He teaches by example and then lets us go on our own. . . . The art techniques are Finster's, but the ideas come from the students."[21]

Howard: "I don't go to universities to listen to people. I go there to talk. I'm there to talk, not to listen. I'm a folk artist and I do strange art. I don't go there to be taught. I go there to teach. I don't want anybody telling me nothing. It took some time for me to realize why God provided me with only junk to make my park and why He gave me bad art materials to make my art. It took me some time to realize why God gave me only a sixth-grade education. If I would have gone through the university, then they would have taken all the credit for what God has done. I'm not a genius. I'm only a stupid little sixth-grade student that gets his visions from God. My knowledge comes from another world, not from universities."

Robert Bishop believes the university art community played an extremely important role in Howard Finster's early career and will continue to do so in the future. He remembers that some of the first visitors to the Garden were young university art instructors, who took Howard's work and

Howard cemented his bicycle repair tools in this walkway after he decided to "go full time in art." (Photo: J. F. Turner)

personality seriously. They offered not only encouragement but invitations for him to spread his word and techniques through their universities. Howard accepted and closed every talk with an open invitation to the students to come visit him at Paradise Garden. Many made the pilgrimage and got an hour or two of their hero's time; they also brought back a small piece of his art that was within their limited budgets. Upon the students' graduation, these pieces of art, as well as Howard's words, spread throughout the country and his work started appearing in group shows under every imaginable "theme." The fact that Howard made himself accessible and had plenty of affordable art available for visitors was critical in getting his message out and spreading his fame. This word-of-mouth reputation continues to serve Finster, in that many of those former students have gone on to teaching jobs and gallery jobs and will eventually be making major decisions in the art community as museum curators and art critics. Many of them will have a working knowledge of Howard Finster and one or two pieces of the artist's work.

Robert Bishop: "I don't consider Howard a folk artist. He is a self-taught, visionary, contemporary artist. There isn't a description of Howard's paintings because every one is unto itself. He is an artist and maybe even something different than that." There's a rather large group of young people who view him as one of the great twentieth-century American native painters, and he is.[22]

Victor Faccinto: "There's somebody in every sort of subculture that seems to have some relationship to Howard Finster in one way or another. You'll never find another artist like that."

Michael Stipe, lead singer for the rock group R.E.M., and a friend of Howard's since 1981: "When I first met him, I was completely overwhelmed by his manner of speaking and the things around him—like this bicycle that had the Virgin Mary's face painted on the seat. It seemed shocking, but it was completely honest. That was the biggest space on the bicycle, so that was where he wanted to put the most important thing.

"In every big society there ever has been and ever will be, there are going to be people like Howard. He is outside of it, but by being outside, he brings some kind of intuitive knowledge into it. Howard has affected me in a

THE FIRST TIME I EVEN SEEN A COMPUTER NORMAN AND LECORDO, SET IT UP FOR ME TO DO MY VERY FIRST COMPUTER ART. THIS TOOK PLACE IN THE LEE HIGH UNIVERSITY AT THEIR. EXPENCE.

HOWARD FINSTERS. FIRST COMPUTER WORK. Howard Finster

HOWARD FINSTER'S FIRST COMPUTER WORK: $8^1/_2 \times 10^3/_4$", 1987. (The Denton Collection. Photo: Michael Woods)

way that affects everyone else around me. Seeing as I'm not outside society, that is affecting society."[23]

"Over the years I've been real interested in what are called 'outsider artists,'" says David Byrne, who attended the Rhode Island School of Design in the 1970s, and is lead singer/songwriter with the rock group Talking Heads. In 1985, Byrne commissioned Howard to do a painting for the cover of the album "Little Creatures." He took Polaroids of the band members, sent a previous Talking Heads album, and enclosed a letter describing his intentions. "I didn't talk to Finster on the phone at all. I wanted to leave the design up to him. The letter talked about how I wrote the words to one of our songs, and I thought the inspiration was similar to the way he does his painting."[24]

Howard: "I'm trying to reach more people now than I did when I was preaching. On the Talking Heads [album cover] there are twenty-six wholesome verses of

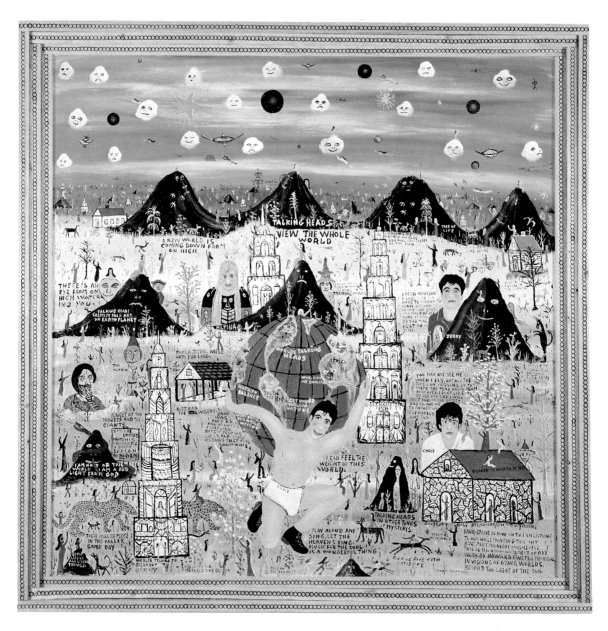

TALKING HEADS VIEW THE WHOLE
WORLD: enamel on wood, 48 × 48", 1985,
#4000 411. (David Byrne. Photo: Ellen
Page Wilson)

mine. That album sold over a million copies. I had twenty-six million verses go out and reach the world. That's more than I ever reached in the forty-five years I was pastoring. The rock-and-rollers are my missionaries."

Lynda Hartington, of the National Museum of Art: "Some of the early works by Howard really want to make a believer out of you if you are not already a believer. I think he does have power in his images to reach out to people, to make them stop and think in a believable way

about what the future is bringing and what it means to you, which says Howard is a successful communicator."

Ann Oppenhimer: "He's a communicator and that's his biggest skill. It's a different type of preaching. It's a way of life that he is really telling people about."

Andy Nasisse: "I feel he is a person who experiences religion directly. It isn't faith on which he bases this religion. He gets it first-hand. He wasn't putting on the dog when I visited him. He was really obsessive. He seemed obsessive about whatever I asked him at the time. Howard's eccentricity borders on egocentricity. Many times I really think that the man is not aware of anything that goes on outside of himself. But then he points out things that reveal incredible insight. So, I don't know. He sees and understands human nature in incredible ways. He can also be awfully sly at times. We've all seen that."

Victor Faccinto: "When I have visited Howard, it's always been, you're there and he's doing most of the talking, and you're just there interacting with him. I rarely even have to say anything, and when I do, he doesn't listen that much anyway. He's not much of a listener. Nobody can tell Howard anything because he knows everything, according to Howard. He does listen, on occasion, like when I talked about the university, because that world was unfamiliar to him."

Andy Nasisse: "He has always broken the rules. He has shocked people. He is really refreshing. His innocence and freshness never cease to affect people. The thing I value most is simply this friendship. He is sincere, honest, and caring. During all this time he has inspired me. I think he touches everybody."

John Ollman: "His early paintings are strong because they are religiously felt. In 1977 Howard learned how to manipulate the enamel and started taking more risks. At first he worried about painting a human face. Then he learned to make more complex paintings because he had acquired an extended vocabulary. His first six hundred paintings were religious and narrative. Around the thousandth, his works began to soar in terms of complexity, his use of different media. His visions became the subject of his paintings around number one thousand. In 1981 there was a dramatic increase in the number of secondary paintings that were mixed with the masterpieces."

163

Howard: "I like to do whatever I have a vision of, but if I don't have a new vision, I just keep repeating—like Heaven, Earth, and Hell. I can take one subject and do it in a hundred different ways and it's telling the same thing all the time."

Lynda Hartington: "I'm a little wary of someone who seems to be moving toward or has already arrived at developing a formula. Howard's art becomes a matter of productivity rather than real intention or content."

Andy Nasisse: "I think the early years were the most vital. I think between Victor, Jeff Camp, and myself, we had a good influence on Finster because we charged him up and let him be—which produced sort of a positive influence. It was during that time he did his best work. There was none of this 'repeat' business. He thinks of his artwork as being sermons, and multiples don't bother him at all, as he is trying to reach the largest number of people regardless of the quality of his work. I think some of his art is sloppy, and that's not really the kind of message he wants to send out. I think it sends out the wrong kind of message."

Victor Faccinto: "In the middle of these repetitive pieces come some nice, beautiful, original things. It wasn't as though his art had ended. He had found a way to make a living, and for him to reproduce what was demanded of him, he had to make cutouts of the same thing, and they were nice pieces. They weren't totally one-of-a-kind pieces, but that was important only to collectors."

John Ollman: "All of Howard's early paintings were created for and belonged to Paradise Garden. It was the persistence of the visitors that started stripping the Garden. It was the art marketplace that made Howard's work marketable, not Howard. If he was really interested in the commercial aspects, then he wouldn't exist."

Howard: "God didn't want me to give the paintings away like I have a lot of 'em. He really didn't want me to give them away. God wants you to get enough out of your paintings to keep you going. God wants man to take one talent and make another one with it. That's doubling your money. That's the Bible. That's God. God don't want no man to go out here and not prosper. God wants a man to put his money to work and make money with it. God doesn't want a man to waste his money. And God doesn't want a man to get married to his money.

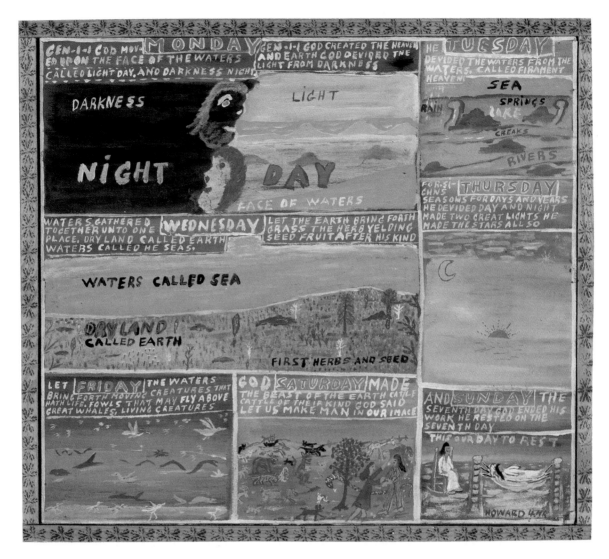

7 Days of Creation (Night and Day): enamel on wood, 21 × 24″, ca. 1976. (Chuck and Jan Rosenak. Photo: Robert Reck)

"I paint pictures for people. But I have to have enough to get a cup of coffee once in a while or I wouldn't be here to paint pictures for people. God wants a man to make some profit off his work, if it is divine work, because a minister is worthy of his hire. A minister that preaches full time shouldn't have to do nothing else. When my shows come out, it is art. I don't come on asking for money to carry on my program. I come on free. I'm hooked up with art, and people who are not even religious people are interested in art and they read my art. My art even goes in sex books. People see and read my art that don't go to church. You are supposed to get acquainted with all the different kinds of people, and that's the way you do it, through sacred art."

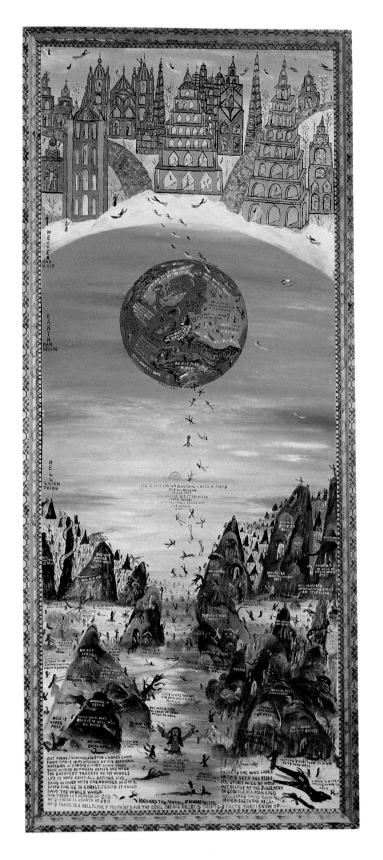

ITS A PITY FOR OUR BEAUTIFUL WORLD
TO PERISH: enamel on wood,
63 × 27", 1981, #1000 794. (Photo:
Courtesy of Phyllis Kind Gallery)

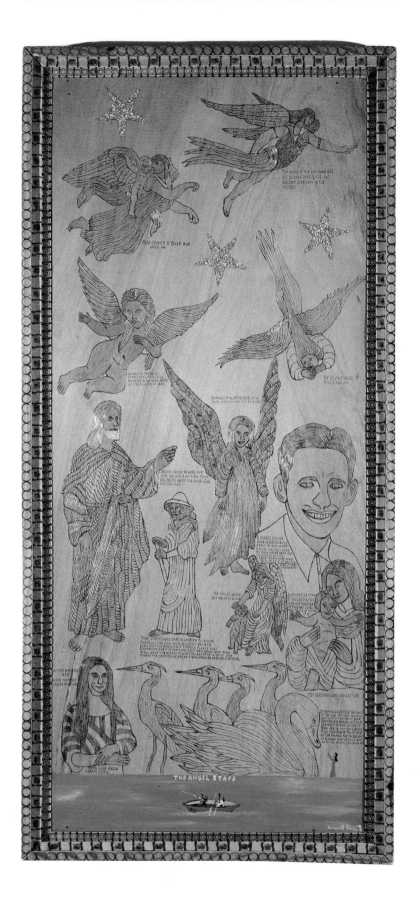

THE ANGEL STAFF: enamel on wood with pyrography, glitter, 60¹/₄ × 28¹/₂″, 1981, #2000 22. (Photo: Courtesy of Phyllis Kind Gallery)

Gallery owner Phyllis Kind was the angel who trumpeted Howard's name to the art world. She was able to incorporate him into the contemporary art mainstream, not as a *folk* artist, but as an artist. He was an outsider, whose work was admired by the Chicago Imagists, with whom he was shown. This group rose to prominence in the 1970s as a result of Kind's visionary approach to the contemporary art scene. Jim Nutt and Roger Brown were two of the first artists to acknowledge self-taught artists like Joseph Yoakum and Jesse Howard.

Howard Finster's work was now shown in a gallery that appreciated and aggressively promoted it. Kind gave Howard several one-man shows, which were reviewed in art publications. She also provided work for a show at New York's New Museum and at the 1984 Venice Biennale (*Paradise Lost/Paradise Regained: American Visions of the New Decade*), important stepping stones in the acceptance of Howard Finster as an artist, not simply as a novelty.

Ned Rifkin: "I became aware of Howard Finster's work at the home of Wake Forest faculty member Marvin Coats in the spring of '81 on my first trip as curator for the New Museum. I think it was the palette, the coloration, the scrawled language, and the kind of obsessive incantation of biblical, evangelical tones which first interested me. There was also the question of talent, and I saw some real pictorial talent. The point of view, the kind of visionary zealous evangelical tone of the work, was something I responded to. I felt quite freed by it in some sense. I thought it was fine work. It seemed to be unusually original in some manner of speaking. At the same time, intellectually, I knew that it was the work of a folk artist— that is, an untrained artist—and yet there was some sophistication to the work which I had not seen in any previous folk artist.

"In August of '82, the New Museum opened *Currents: Reverend Howard Finster,* curated by Jesse Murray. That was my first full exposure to his work. Later the museum was asked to submit a proposal to an NEA panel that was determining the representation of the United States in the 1984 Venice Biennale. The concept for the show, "Paradise Lost, Paradise Regained," came from Marcia Tucker. When I heard the concept, Howard Finster occurred to me, and I came up with a couple of

*Opposite page:*

*Top:* THE ANGEL OF THE WATERS: enamel on glass, 18³/₁₆ × 32" including frame, 1979, #1000 302. (Didi Barrett/Saralee and Paul Pincus. Photo: Barry Pribula)

*Bottom:* TRAIN: mixed media on wire, 14¹/₂ × 32 × 10", ca. 1979. (Janet Fleisher Gallery. Photo: Norinne Betjemann)

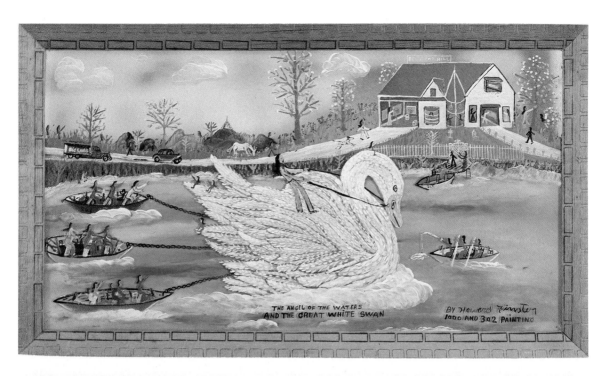

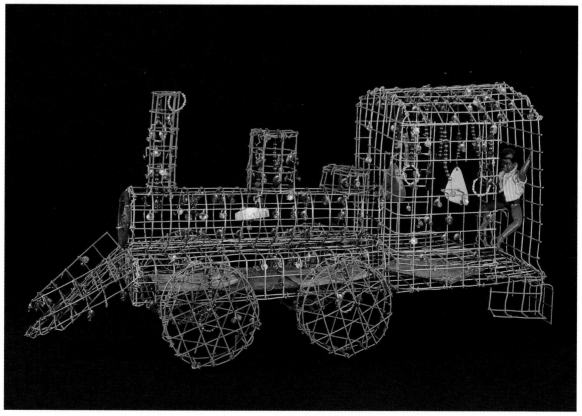

examples that were quite strong and the other curators [Tucker and Lynn Gumpert] assented.

"In some sense the inclusion of Finster, generally considered a folk artist, in the context of a serious American art exhibition (which included a number of talented and well-known artists, such as Roger Brown, David True, and Eric Fischl) at the Venice Biennale, one of the most important international art shows, really did help people to see him in the context of art generally and not of folk art. I think that was an important thing, and I'm very happy that I had something to do with that. There are a number of artists in New York and elsewhere who have a great deal of respect and admiration for Finster's work."

AMERICA IS A HORSE OF A NATION: enamel on masonite, 45⁹/₁₆ × 49¹/₁₆", n.d., #349. (Collection of Steve and Nina Schroeder. Photo: David Heald)

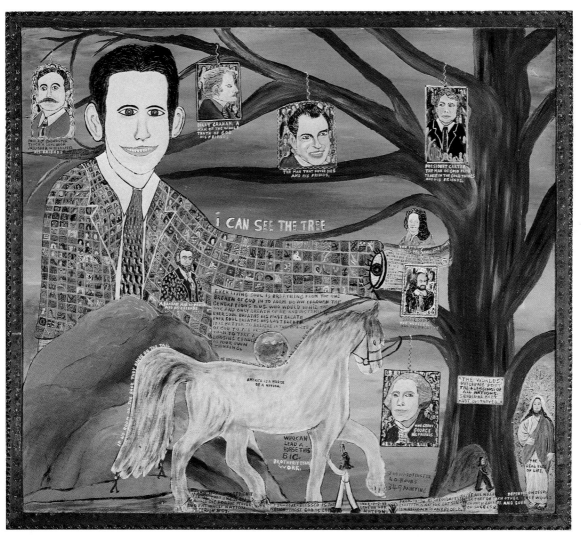

170

Howard's contact with Phyllis Kind was also important because it gave him a monthly income, without the restraint of a contract, thus allowing him to produce more art and to sell on his own to patrons such as Dr. Jim and Beth Arient. These pieces ranged from $1,000 commissions to smaller works that he held back for special friends.

Dear Brother and Sister Arient.

Here is the [photograph of the] Henry Ford painting. If you like it, send check for five hundred. I will send it greyhound. If you don't like it, it will sell in New York for twenty-four hundred and I'l do another later for you. You all are very fine friends and we think of you often.

*Howard Finster 12/30/80*

Phyllis Kind asked Howard only to send her big pieces that he generally spent more time on. The fact that he could continue selling from his studio provided him with the opportunity to get his messages out and additional funds in. As he says, "They can make me the biggest star they want to. I'm the same fellow. I don't take nobody's advice. I listen to them but I hardly ever take their advice because they don't have a sharp cut like I do in the first place." I asked Howard about another well-known folk artist, Grandma Moses. "My art is similar to hers. I'd been doin' art for years before I saw one reproduction of her paintings. Her art is better. She drawn better buggies, she drawn better people. She drawn better art than I drawn. You might call what I do 'art of my visions.'"

Robert Bishop: "Howard has looked at art books, not many, but it doesn't matter because he couldn't do what he sees in the books anyway because that implies techniques and he has no technique but his own."

Lynda Hartington: "He's a real original. When you look at his work, you know it's a Finster."

Howard: "People will be a medium of carrying my message on if they own my art. If you own my messages, after I am deceased, you're still keeping me alive. And this is not a message Howard Finster preaches and they

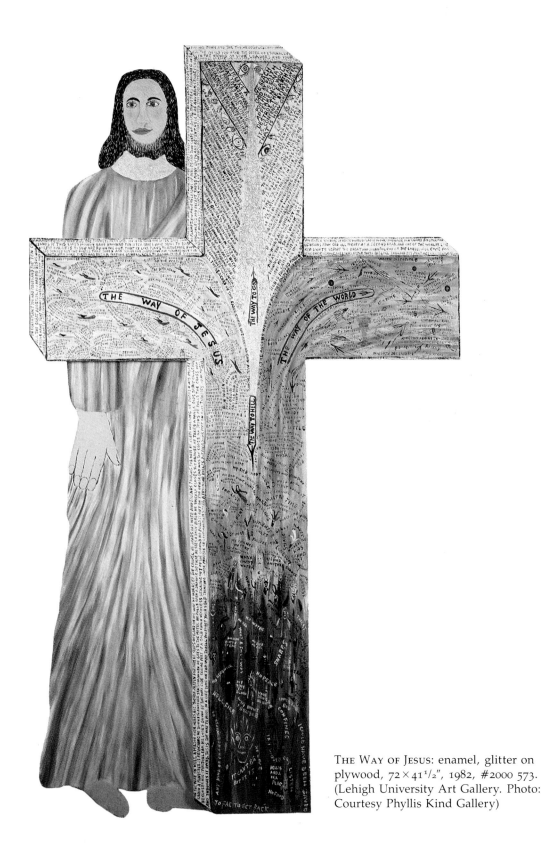

THE WAY OF JESUS: enamel, glitter on
plywood, 72 × 41¹/₂″, 1982, #2000 573.
(Lehigh University Art Gallery. Photo:
Courtesy Phyllis Kind Gallery)

forget from one service to another. This is a message they pay three hundred dollars to get it. And when they get it, they're not going to throw it in the waste can. And even if they don't read it, their neighbors are going to read it. And it's gotten now to where they don't want nothing without my messages on it. They demand my messages.

"I haven't painted enough paintings. I doubt I will ever stop. The paintings will get thinner and scarcer. If I have a new vision, it will bring new art. I've got a lot of visions of art that I've never drawn yet."

"One thing I have never been able to do, and that is to tell all I have seen and know." (Photo: © 1986 Marianne Barcellona)

# CHAPTER 7

# Howard's Heart Has Beat Five Hundred and Twenty-seven Billion and Two Hundred and Fifty-four Million and Forty Times

*Long before he was an artist, Howard was a writer of sermons, songs, and poems, many of which he had printed at his own expense. He was eager to relate and interpret his visions to wider audiences. He preached the sermons whenever and wherever he could, sang the songs to the accompaniment of his banjo, and frequently used the poetry to reinforce the messages of both. Always he carried with him the scraps of paper he refers to as "thought-cards" to record the vision, song, or poem as the inspiration struck.*

*Just as apparent naivete in his painting masks an accomplished artist, the inventive spelling and grammar of Howard's writing is at least partly intentional. Homonyms (words with different spellings but which sound alike) and malapropisms (humorous misuses of a word) abound in his writing. "The main thing about writing," he maintains, "is to put all your cannon words that mean two or three different things at one time. It gives you thoughts in some unusual ways or unusual words. They get your message across."*

"I started writing about fourteen years old and have been writing ever since. Why do I write?

"I like to take a few letters and make a few words and write a few lines like no one has heard. One reason I write is it gives me a thrill to tell of the mountains, the streams, and the hills. God's great creations, the mysteries and scenes, are more to me than just a dream. Each time I write, something new comes to me. I would like

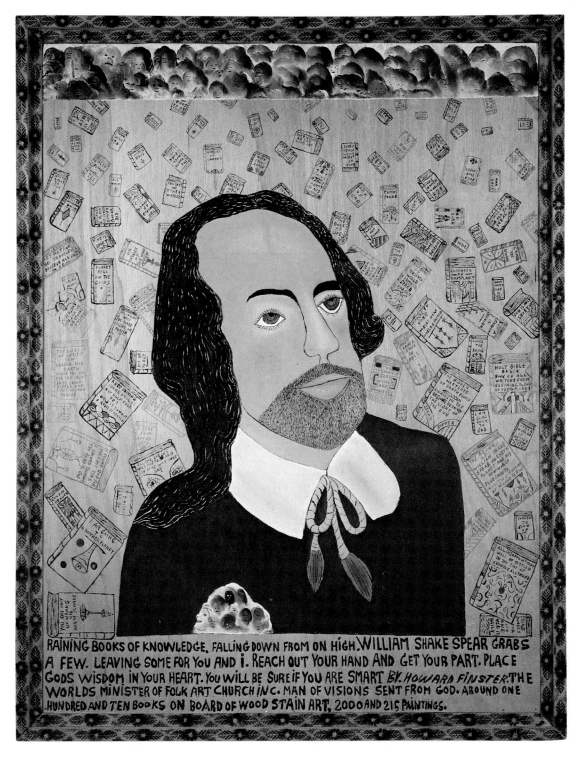

RAINING BOOKS OF KNOWLEDGE: enamel on wood (wood stain art), 42½ × 33″, 1981, #2000 215. (David Byrne. Photo: Ellen Page Wilson)

i HELP BAPTISE THE FIRST
MEMBERS OF MOON LAKE BAPTIST
CHURCH. THE CHURCH WAS
ORGANISED UNDER OUR TENT
AFTER A REVIVAL MEETING,
WE BAPTISED IN THE RIVER
NEAR BY. FLOYD CROW WAS MY
PARDANER IN THE WORK OF
THE LORD. HE STANDS TO THE
LEFT HE IS A GREAT MAN OF GOD,
THIS REVIVAL WAS A GREAT
WEEK IN MENTONE ALABAMA
THEY NOW HAVE A BEAUTIFUL
STONE CHURCH, THE LIVING
WORK OF GOD WRITTEN AND
PRINTED BY HOWARD FINSTER
SUMMERVILLE R#2 GEORGIA

THE STARTING
LINE FOR THE SPAN
OF LIFE. A HEART
BEAT AND A CRY FOR
WHEN WE BEGIN TO
LIVE WE ALLSO BEGIN
TO DIE. IF WE SHOULD
LIVE FOR 90 YEARS.
THE CLOCK COUNTS
OFF OUR TIME. IT
BEGINS AT OUR CRADLE AND
FOLLOWS US DOWN THE LINE
THE FIRST FEW YEARS IT SEEMS
SO SLOW. OH WHEN WILL WE BE
GROWN. BUT HALF WAY DOWN
THE OTHER SIDE WE CAN SEE
WHERE WE HAVE GONE.
WE TRY OUR BRAKES TO SLOW
THE SPEED OF DAYS THAT SW-
IFTLY PASS. BUT YET THE
CLOCK KEEPS COUNTING TIME
JUST AS FAST. THE BIRDS STOP
TO REST THE CREEPINGS TOO. BUT
THE CLOCK OF TIME KEEPS RUNNING
TO COUNT OFF TIME FOR YOU. SO
PUT YOUR TRUST IN JESUS HE GIVES
ETURNAL LIFE. COMPOSED AND
PRINTED BY HOWARD FINSTER
SUMMERVILLE R#2 GEORGIA
30747 PHONE 857-2926
JESUS SAVES A-MEN

to use a barrel of ink and a boxcar-load of paper too. The lack of money and the lack of time is the stumbling block that keeps me behind. While I'm scratching for only a penny, someone is wasting a dime. But that's okay—I'll do the best I can, if only I win just one man. Someone could buy me a load of paper and a big barrel of ink, but they just don't know my zeal. I guess they just don't think."

Liza Kirwin, Southeast Area Collector for the Archives of American Art: "In 1985, the Archives of American Art, a bureau of the Smithsonian Institution, asked the Reverend Howard Finster to consider donating his papers for research. A package arrived from Georgia containing a plywood cutout of Elvis Presley at the age of three, mounted on etched and painted plexiglass. Taped to the handmade frame was a note from Finster: 'What about real samples of all my eight samples of art I invented . . . like ink art, pot mettle art, brower root art, soder art, wood burning art, enamel art, clear plastic and natural wood art.' This was not the response we expected, but then collecting self-taught artists was out of the ordinary for the Archives of American Art."[25]

Kirwin was interested by the fact that Howard "didn't want to just leave his writings, but examples of his art techniques. He considers himself an inventor, a preacher, and a teacher. He doesn't make a distinction between his writing and his painting. It was all the same message. Many of the self-taught artists don't write. Howard is an exception in that he writes so much in a really wonderfully poetic way. It is powerful and truthful. It's not often you run into an artist who expresses himself so well and so clearly through his words. He uses language as a tool much as he does his sculpture. His disregard for the rules of language is similar to his art. He does things his way. He spells things the way they sound and he paints things the way he sees them.

"He is very much in control of the audience. I can be very quickly taken in by him and I don't know if that's a [talent for] seduction that a preacher has, or whether I am turned on by his ideas of what he is trying to do with his

"I print by hand because I can print with a pencil four times faster than I can type on a machine." (Photo: Archives of American Art, Smithsonian Institution)

art. He loved the idea of microfilm. Our mission and his mission were completely at one. He's sort of a mini-Smithsonian in himself. In the Garden he tries to collect all the inventions of mankind."

Howard: "I really like to write between the lines to bring up the loose ends and find the missing pieces and put them all together like a puzzle."

## The Hunter's Dream, composed by Howard Finster, October 28, 1968

Late in the evening into the night fall. In the shadow of the moonlight the whip-poor-will calls. Into the big timber, far in the hills, the hunter's gun is loaded to kill. He crushes on through the broken limbs, his hounds are hot on the trail. I can hear him say, "Old Sport is ahead, I never knew him to fail." What a beautiful sound as the race goes on. The red fox is out tonight, the joy and sport of a hunter's life. For this was his delight.

Where the wise old owl sounds off his voice. The echo comes back to me; I know there's two big round bright eyes somewhere high in a tree. On down the way by a little brook, with his light on a drift of sand, fresh coon tracks, my, what a hunting land.

Is this a dream or is it true? I think I've found a deer trail, too. On through the night time swiftly passed. I soon found a long smooth rock at last. Into my sleeping bag I zipped myself away. I fell asleep like Little Boy Blue in a big stack of hay.

The morning slipped upon me, the sun kissed my face. All four of my old hound dogs had just finished their race. They were lying around my rocky bed taking a nap too. Far away in the beautiful mountains, where the sky is heavenly blue, the wise old owl and the whip-poor-will were silent as the morning dew. The peace and calm of the worlds lay so still. From the highest mountain to the lowest hill, the

hunter's dream too short to know. Like a few moments of a big rainbow. Like many colors of one great sight. It only lasted one short night.

Howard: "I don't think I would ever quit prowling through space, so help me God. I wouldn't mind staying on the moon for a few days. They will eventually be growing stuff up there and living up there. They have just about covered the earth."

### The Astronauts

I saw Apollo 8 when she headed toward the
    moon.
I could feel pressed with fear, and began to
    pray for
Three men who I believed would circle the
    great moon, for the
First time of any race on earth.
The greatest fear I had was a question, Oh
    God will they
Recognize your great work, and testify of it.
Or will they come back and tell how the
    moon formed itself
in nature.
I watched late and early to hear and see
    them in space.
On Christmas Eve late in the evening seeing
    the great craters
And mountains on the moon, I heard one of
    them begin to read
From the Bible in Genesis of God's great
    creation and
Recognize God's work.
It stirred my soul with joy, put tears in my
    eyes to think our
Nation's very own are looking over a little
    piece of God's work
Up there reading about it from the Bible all
    the way back
To Earth.
Oh, if they could convince one infidel of
    God and His work, it

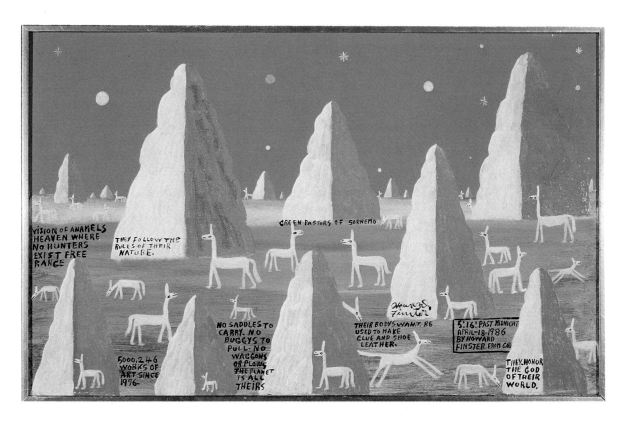

Would be worth more than all expenses
    which have been paid into it.
Thank God for someone who is not afraid to
    go up and look over
God's work and tell us about it.
If someone doesn't convince people of God
    and His work, I feel
Sure the end of time is near for all men on
    earth.
But if God's people which are called by his
    name will humble
Themselves and pray, God will hear from
    Heaven and heal their land.
I believe the hydrogen and atomic bomb and
    the voyage to the
Moon is allowed of God to show how
    helpless we are and how
Little our whole earth is and to help us to
    know we must love
And live together as nations or die together
    forever in vain.

—*composed 11:15 p.m., December 24, 1968*

VISION OF ANAMELS: enamel on wood,
24 × 36", 1986, #5000 246. (Photo:
Courtesy of Phyllis Kind Gallery)

Howard: "I ain't got too much against our government. I think our government is pretty good, but Communists is pretty good and some of it's taught in the Bible, you know. 'The little town—they had much to give to them that had little.' That's kind of a Communist idea that I like. You know, that all people were equal. But of course the way it is in our country, if there wasn't a few rich people, we wouldn't have no jobs. In the setup we've got, we couldn't. It would be hard for us to get on the equality right now because you see, the rich man, I need him and he needs me."

Howard Finster is the first to admit that at times it takes a strong, independent, and loving woman to live with a "stranger from another world." Pauline Finster has the patience of Job, the responsibilities of the old woman who lived in a shoe, and a tremendous love for her family. She is Howard's complete opposite and always—before the morning coffee—his better half. Where Howard is outgoing past the point of being entertaining, Pauline is painfully shy outside the family, yet makes many of the financial and career decisions as well as scheduling Howard, a person who doesn't follow schedules.

Because Howard "works in the night," he lives and catnaps in one of his four studios, while providing Pauline a home she can truly call her own. Where Howard's studio is as cluttered as his paintings, Pauline's living room is as bare as the cabinets that are raided daily by Howard and any of the fifteen grandkids stopping by. Until recently, none of Howard's artwork graced her walls, but now she has three small works hanging as well as one of his early wooden "what-not family picture shelves."

Howard: "Pauline's kinda a private-type person."

Pauline: "I like the flowers a lot in the older paintings, but the new work he's doing I really don't care for."

## TO ANSWER SOME QUESTIONS COULD TAKE A LIFETIME.

"I studied perpetual motion for many years. So far I have failed but collected new ideas of new models of hope. If I fail my last and final blueprint, then my ques-

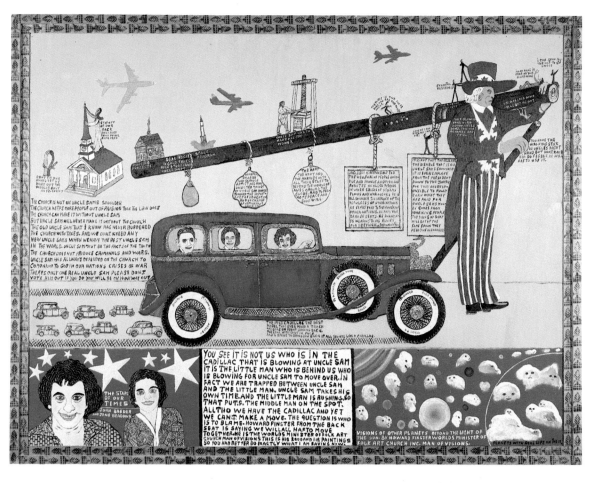

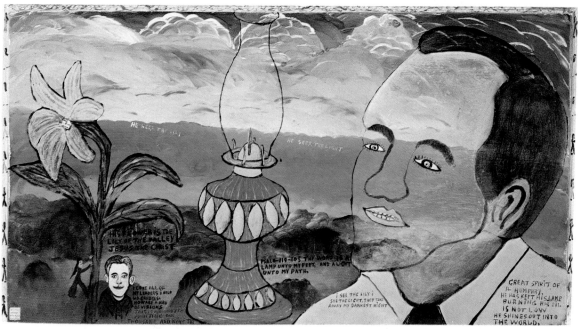

Drawing of perpetual-motion machine,
pencil on paper, 12 × 9¹/₄" (Photo: M.
Lee Fatherree)

tion is answered. So far this question is yet active, and no one but myself can answer it.

"I've found out that perpetual motion has to be as a thing that constantly unbalances itself. I lack that last finger touch of power to make a perpetual motion. I must accomplish it or fail before I am satisfied. I can be more satisfied if it is yes or no rather than go on thinking I can and yet never know. Same with my songs and my poem writing. Same with my woodcraft. Same with my ministry in this world."

"I found a scripture in the Bible that indicates there are some other planets, that there's living people on them, and that they might have a different setup. I want my wisdom and knowledge from God to go to people, to the government. I'd like to get ahold of him [the President] and give him some information on how to take care of some of these crises — like the water crisis.

"I'd like to build a gigantic helium balloon with mirrors on all sides, all around it, that will go plumb on up into the ozone where sunlight will hit the mirrors and reflect light into dark shadow places like Alaska. There's no limit to where you could take that sunlight.[26] I'm building a solar heat room. I had a vision of it one night, and I seen it in the dark and I couldn't go to sleep. When I have a vision to do something, ain't but one thing will satisfy me, and that's to get my hammer and get up there and do what I have a vision of. The Lord showed me how to make containers that collect heat, and put it out in the sunshine with rollers on it, the sun'll heat it all day, and you can take that unit and roll it in the bathroom, anywhere, and it heats the house.

"Jesus Christ wants preachers to do more'n just preach the Gospel. He wants them to get out there and tell people how to survive in time of need, how to raise food and how to do things. I think that's one of my

callings in the world to tell how to get ready for an emergency in the time of atomic fallout."

In a letter to Alan Jabbour, director of the American Folklife Center of the Library of Congress, Howard wrote:

Please get this information to the President. God has shown me how to draw a plant that can be built on a rock ledge of one square mile of wasteland. Turned into the world's 8th wonder, a plant that will start and operate and stop without one person or without battery or without rivers, without wells. It will start up over 100 small generators and will produce billions of gallons of water and purify it and store it all at the same time. It will run until it wears out without one single employee. It will also be used as the world's largest storage or hot-house.

UFO Factory: enamel on wood, 19 × 25", 1978, #1000 125. (Mark and Marcia Dunaway. Photo: Robert Spencer)

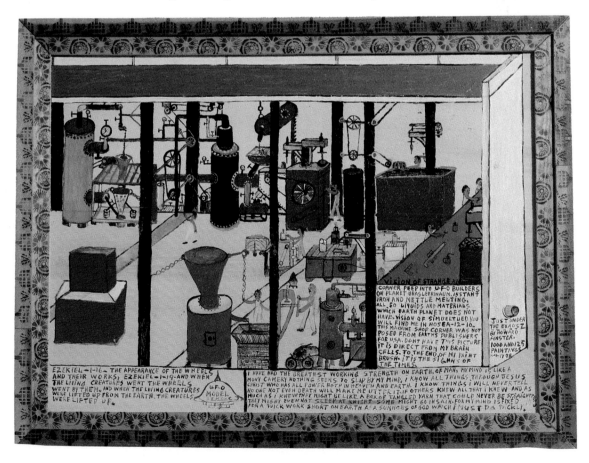

It will store one square mile of our largest aircraft. I can draw this picture with a contract agreeing that the President will be the first and only one to see this painting. Then he will release it to our chief engineers for study and building. The picture will be beautiful if even rejected. I am also studying how to turn smoke into liquid before it reaches the top of a one-hundred-foot smoke chimney and run the pollution back to a filter sterilizer in liquid. Get me in direct contact with the President by letter or phone. My country needs my ideas. . . . I'd hate to draw a war weapon and expose one of our secrets.

Alan passed the drawings onto the Department of Defense and they responded to Howard in writing:

Dear Reverend Finster:

Thank you for submitting your sketches and descriptions for review by the Department of Defense. I wish that all American citizens were so conscientious. It is refreshing and encouraging to hear from a private citizen who has no legal obligation to submit his ideas for review, but does so only out of a sense of patriotism and responsibility.

As to the materials that you submitted for review, you may exhibit such materials with no fear of compromising American security. Some of your visions do concern weapons of the past, as you suspected, and some concern weapons of the present and possibly of the future, but none of your sketches or descriptions is sufficiently detailed to be helpful to an enemy. Again, thank you very much for writing.

Sincerely,

William R. Bode,
Assistant to the Deputy Assistant
Secretary of Defense for Strategic and
Theater Nuclear Forces Policy

## Woodcraft Machines. Make Them Yourself. I Now Have Eleven in Operation

I invented three wood trimming machines that will make over one hundred different designs. I am soon to retire and my five children and thirteen grandchildren are not interested in woodwork, so I would like for my inventions and skill of craft to be passed on to you who are handicapped in rolling chairs and to anyone who is interested in making fancy work cabinets, toy furniture, clock cases, built-in radios, built-in TVs. I have one machine that will print one design a second. That's sixty designs a minute and thirty-six hundred designs an hour. This machine is operated from a stool or a chair. It is kindly like operating a sewing machine except it prints wood flat or round or square. It prints as deep as one sixteenth to one eighth. It makes a lifetime design that won't sand out. A child can operate it after they learn to space the designs. You can double run a piece of wood and it will change the design completely without changing the printing heads. In fact I can

VISIONS OF MODDLE STRUCTURES: enamel on masonite, 53½ × 29½", 1987, #6000 617. (The Denton Collection. Photo: Liz Hampton)

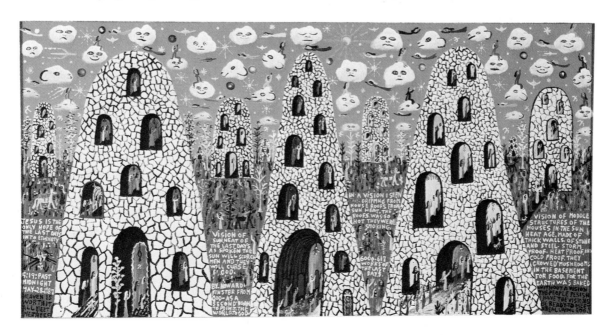

make six different designs without changing printing heads.

My shop has operated in privacy for many years. I have never demonstrated my machines to the public. When my craft is on market at trade days and in some show cases and truck-stops, people has asked it seems like a million times, "How did you do this kind of work?" I told them it was a gift from God, which truly it is. Everything I have made sold. You can build thousands of dollars worth of craft from planer mill scraps, shipping cartons, old TV cabinets, and scraps from house-building contractors. If you buy my book on woodcraft and bring it with you to my shop as identification you are not a manufactory of tools but that you are interested in home or school hobby or family extra money, for five dollars I will take you through my shop and demonstrate all eleven machines and show you how to operate them.

I will also show you how to build them, how to make the printing heads, how to build a smoke vent for health's sake, and how to use all eleven machines in an eight-foot-square room. Be sure to bring a pencil and a notebook to take notes, for you would never remember it all. If you wish you can bring your camery and make a shot of the machines. Do not come without calling in an appointment. I only teach two people at the time. It takes from forty minutes to one hour to start up eleven machines and run a little material through.

### HOWARD GOES HOLLYWOOD —FROM THE "DIALOGUE" COLUMN, BY JAMES BUDD, SUMMERVILLE *NEWS*, AUGUST 11, 1983

Part of an editor's job is insuring [sic] that important events in the area are included in the newspaper for history's sake. This paper has been around since 1885 and our old papers reflect the country's history like no other available

Invented printing head by
Howard from a plain card.
(Photo: M. Lee Fatherree)

record. With that in mind, here goes the
historian.

On Aug. 5, 1983, at 11:30 p.m., Summer-
ville resident and artist Howard Finster ap-
peared on NBC's *Tonight Show* with Johnny
Carson. As far as anyone knows, Howard is the
only resident of Chattooga County that has ever
appeared on the famous TV program.

Johnny Carson closed out his monologue
and introduced the guests for the evening. Car-
son called Finster "an artist, musician, collector
and I don't know what all." Carson mentioned
Finster was from Summerville, Georgia.

Howard was the first guest on the hour-
long show, and he had the audience rolling with
laughter in a few seconds. They loved his coun-
try wit and charm, and Carson, too, seemed to
enjoy Howard, although he didn't seem to know
what to make of the folk artist.

Howard performed a song *a cappella* that he
made up when he saw the lights and women of
Hollywood. Next, Howard picked up his banjo
and did another song he created while "stand-
ing in the halls of the Library of Congress."
During both songs, Howard moved across the
stage, making it difficult for the cameras to keep
up with him. The audience clapped along with
the songs and roared with applause at the
conclusion.

A filmstrip of Finster's "Paradise Garden"
was shown, depicting the two-acre garden be-
hind the artist's home. When the camera

zoomed in on a sidewalk in the garden, depicting various tools embedded in concrete, Finster explained it was to prove he had given up bicycle repairs to create sacred art. "I can't sleep at night, so I paint, and in the day I work on my garden," Finster explained to Carson.

Finster stayed on for about 15 minutes. When it was time for him to leave, the audience gave him another howling round of applause. Finster darted behind the curtain, and Carson's second guest, Robert Klein, a comedian, took the stage.

Klein did a stand-up routine and mentioned he was a fan of Finster's now. The audience applauded again.

Ironically, Klein was to appear the following week in Atlanta. When Carson mentioned the Atlanta show, he added, "That's Howard Finster territory, isn't it?"

Perhaps from now on, when international travelers come through the Atlanta airport for a stopover, they'll say to themselves: "Atlanta, that's Howard Finster territory." Or perhaps they'll think: "Hmm. Atlanta, isn't that near Summerville?"

Howard: "Psalm 3.3.2: Praise the Lord with Harps. Sing unto him with the Psaltery and an instrument of ten strings. Sing unto him a new song: play skillfully with a loud noise. Beloved if a man sings a song properly and in the spirit, it has music in it. What is the difference in music whether it is sung or played, as long as you understand it? When you blend the instrument music into the music of singing it makes a beautiful combination like a vase and the flowers together. But otherwise I have never found in the Bible where music or instruments are condemned.

"I love a banjo. The old banjos were no good. My brother learned on a screen door. Just patted his foot and drug his hand across the screen door, played music. We used to have people come to our house when I was little, play fiddles and banjos, on Saturday nights. And play till late in the night. And when everybody was gone, I'd get

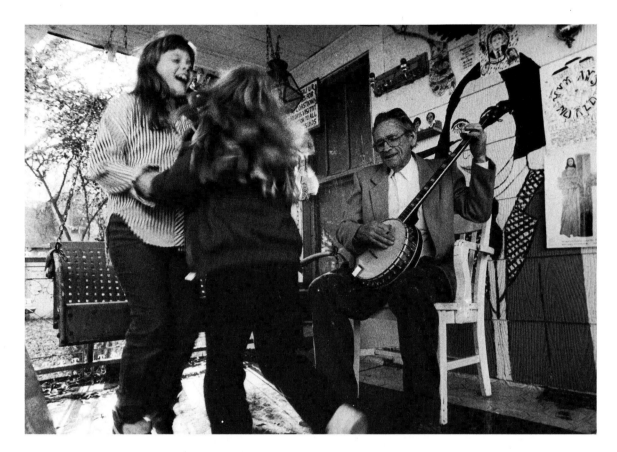

an old banjo out and I learned to play alone. I didn't want nobody around when I was training."

Art Rosenbaum, artist and musicologist: "As a kid, Howard learned the basic up-picking on the banjo that you find on the southern slope of the Appalachians. He learned to play at the Saturday-night dances when the cotton pickers would come and want to have a good time. He learned the piano so he could play it in church. He also plays the harmonica, guitar, and accordion. Where he is adequate on his instruments, he is exceptional vocally. He sings the traditional songs and hymns as well as Jimmy Rogers tunes. He occasionally will sing a song from beginning to end when recalling the old hymns and folk songs of his youth, but he usually strings them together in a kind of free-form assemblage. He puts together collages of song fragments in the same way that he puts elements together in his visual pieces."

In the sixties, Howard spent hundreds of dollars with such companies as Hollywood Music Productions and Five Star Music Masters in an effort to "make a hit" with

Howard picking a tune for the neighbor's kids on the front porch of his studio. "Children are the best people on earth. Mistakes of kids are gracefully hid behind my heart of love." (Photo: © 1986 Marianne Barcellona)

his original poems put to their musical scores. One such copyrighted song, "I've Added You Up by Numbers on My Little Adding Machine," exists as a 45 rpm on the Hallmark label:

> I've added you up by number. You beautiful
> starbright queen
> I've got your total figure on my little adding
> machine
> I've added you up by number to see how tall
> you stand
> I've got the perfect answer when you buckled
> your waist line band
>
> Don't gamble with my heart, dear, don't roll
> me like a dice
> Don't put me off so long, dear, don't make
> me pay such a price.
>
> I've added you up by number, dear, I've
> added you up by time
> I've added you up by love, dear—don't waste
> my wearied mind
> Don't roll me like a stone, dear. Let me gather
> the moss.
> Give me time to love you dear, to make up
> the time we've lost.

Howard: "The tack is the littlest part of filling the house that does the greatest job because it holds the shingle on. When the tack is gone, the shingle blows off. When the shingle blows off, the winter rain comes in, and without that tack the whole structure would be destroyed. I wrote a song about that and called it 'Just a Little Tack in the Shingle of Your Roof.'"

Art Rosenbaum: "This is one of Howard's didactic pieces. He recalls having composed it several years ago, 'in a private interview, up in Alan Jabbour's office in the Library of Congress.' It has the infectious lilt of some of Woody Guthrie's compositions, and it is inevitably requested by audiences at Howard's lecture-concerts. 'That song is reachin' around,' Howard says. 'That song is going over.' The fragility and interdependence of the parts of a house are metaphors for the difficulties in sustaining marriage relationships these days. 'I tell 'em

One of the poems Howard paid a music publisher to set to music. (Photo: M. Lee Fatherree)

in a jokin' way,' Howard explains, 'so many people separate, the [song] gets them back together. If my wife ever left me, maybe I could sing her back home.'"[27]

1. Just a little tack in the shingle of your roof
   [3 times]
To hold your house together

*Chorus:*
Come on back and stay with me
Come on back and let me see
Come on back and stay with me,
Make your little house what it ought to be

2. Just a little nail in the plank of your wall
   [3 times]
To hold your house together. [chorus]

3. Just a little plank in the wall of your house
   [3 times]
To hold your house together. [chorus]

4. Just a little rock in the pillar of your house
   [3 times]
To hold your house together.

On August 4, 1983, Howard appeared on Johnny Carson's *Tonight Show,* and sang a song he had made up after visiting with students on a campus in Virginia. It was sung to the tune of the last two lines of "Bury Me Not on the Lone Prairie."

Just a-hanging around in old Virginia land,
All the pretty girls fell into my hand.

Leaned back on my thumb, looked up in
    their face,
And they asked me did I really come from
    space?

I have nothing to lose, everything to gain:
If I lose my mind I get a super brain.

Art Rosenbaum: "People often wonder if Howard is a folk artist or folk musician because so much of what he does is new and without tradition. I find he uses old tunes and patterns, but he uses them for his own purposes. The music he used for 'super brain' is a folk tune that has been used as a ballad or a hymn for the last hundred years. He uses old hymns and old folk songs for his original pieces, much the way he does with his art. I think a key to understanding Howard's accomplishments is to understand that he has taken an oral culture and turned it into a visual one. This goes back to when the people in his church could remember the color of the tie he was wearing in the morning, but not the message of his sermon. He felt that those messages had to take a visual form to be remembered.

"Howard has the gift of what southern mountain people call 'mocking' or 'imitation.' He can imitate a black singing style. He can also imitate the birds in the forest and the animals of the barnyard. Howard can talk to the crows in their own language. When we were making a recording of him recounting childhood stories [Folkways: *Man of Many Voices*], he said, 'Let me do visions of sounds of the dinosaurs'—and he did it. In the same way he has a vision of a dinosaur or a space creature that gets a visible reality in his paintings, these sounds come to him with the same authenticity and he can re-

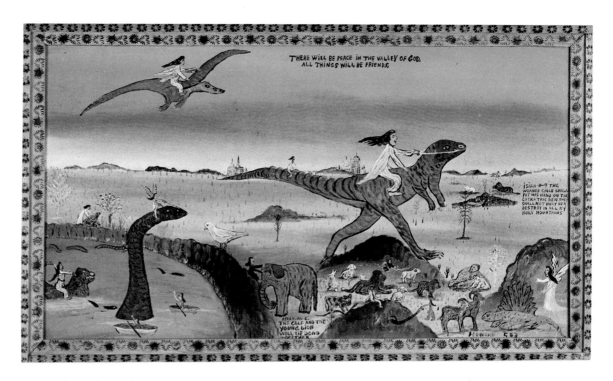

create them through his own voice. He can also write a song on any subject that comes to his mind, with the same spontaneity and fluidity."

PEACEABLE KINGDOM: enamel on wood, 43 1/2 × 25" including frame, n.d., #583. (Jean and Will Muiznieks. Photo: David J. Ross)

In 1981, Howard wrote to Lolly Watanabe, an employee of the Braunstein Gallery, with ideas for a Finster Fan Club:

> Number 1 idea is I will do a 15 × 19 painting for $250. It would be like this. You walk up to a friend and say, "For $250 and a Polaroid picture of yourself, I will make you a member of the Howard Finster Fan Club. Your picture will be sent to Howard and he will draw it in enamel on white maple—your own picture surrounded with a background of mountains or flowers or trees—or all with a personal poem or space story or a beautiful verse from the Bible direct from Howard."
>
> I might be able to do about three personal picture works each week. If it worked out, possibly I could put more time in and do five paintings a week. After a person becomes a Fan Club member, then once a year they could have a

request for a second painting at the same price.

Idea #2: I have a small setup on doing personal cassettes and you could make an offer to join Finster's Fan Club by saying, "Sir, Howard Finster will make a personal tape talking to you and singing to you and making music to you by guitar or harmonica or piano or banjo or all. He will do a tape in his own studio. All you do is present $12. You will be a member and will be first to get any new thing in line of his cards or give-away recopies. After you are on his mailing list, you will be entitled to write to him."

This is an idea for you to get directors of the universities to announce this deal to students. If some got their own paintings done and back they could show it off and others would get interested.

Howard: "I don't go around turning people in for cocaine and whisky. That's what I pay my sheriff for. I'm not here to push anything on you. I'm not here to take nothing away from you and I'm not here to establish no new kind of religion. Half the time I don't know whether I'm talking to church members or sinners. They're all alike to me.

"For thirty-six years I became acquainted to thousands of people. I can hardly remember many of their names. From two hundred to eight hundred fifty miles I

A letter sent to me that was covered in scotch tape. "It was handled by so many people in the post office I didn't want the drawing to get spoiled." (Photo: M. Lee Fatherree)

194

have traveled and I never have been anywhere yet that I didn't see a face that I had seen before. My radio friends and my revival friends, my reading friends and my church friends and my funeral friends and my wedding friends and my museum friends and my business friends is just too much for me ever to keep straight."

[*From a letter sent to Howard Finster, dated March 4, 1971:* "Mr. Finster, You don't know me, but I get a blessing from reading your poems in the Summerville *News.* I lost my darling precious son, Sgt. Larry W. Duke, in a helicopter crash in Viet Nam March 10th, 1970. It will be a year the 10th. I would like to know if you could or would write a poem for me to put in the paper next week in memory of Larry."]

"I had a young Buddha student come here and he made a piece of art and spent the night. This Buddha, he finally told me, 'Howard, I'm a Buddha.' I said, 'You are.' He said, 'Yeah.' I said, 'Well, America doesn't have too many original people in it. It has people from all over the world. It's kinda a free country and you can do anything you want to. If you can get anything out of Buddha, get it. But if you have cancer and are dying and Buddha can't help you, let me know and I'll try my God.'[28]

"This hand has painted one thousand and seven hundred and sixty-seven paintings since 1976, by visions and enamel. If God ever sees fit to bless this unworthy hand of mine, it will be the very best glory that earth's planet could ever hold and a joy to my soul. By being a Christian I have been able to withstand critics, thieves, murderers, adulterers, gossipers, and threats to me and to my family's lives and property.

"This is the hand I dedicated to God fifty-two years ago. It has had many wounds. Some of the prints have worn away. I have had no mercy on this hand. This hand has served many thousands of people. It has worked away from me to reach others in need. This hand of mine

Howard's handprint. (Photo: M. Lee Fatherree)

195

time and time again has taken the last bit of money from my pocket and handed it to sick ones and very poor people. So I am proud of this hand. Don't think I am bragging. I want other Christians to know they are not alone."

> Most of my life is an open book
> My art you can understand
> I only have a few secrets I keep
> Away from Man
>
> Oh endless space, oh endless dreams
> I study you very well.
> You keep slipping around the corner
> That your story I can never tell

"When I was fifteen I used to tell people's fortunes. I'd tell 'em their future. I got to know people that way. One time a fellow asked me what to do about some major conflicts in his family. I added up his troubles, stepped in his shoes, and looked at myself as if I were him. Then I told him what to do about his troubles. Later he returned and told me that it worked and things were solved in his home and while he was here he wanted me to tell him some of his past life. So I told him some rough moves he had committed and he became excited, stood up, and said he was having pains around his heart, walking the floor, me rubbing his arms. I ran and got some clear hot water and told him to drink it down quick, so he did, and he calmed down and lying on the bed he wanted me to tell him more. But I refused, for his past was still worse than what I had already told him. That's one reason I do not want to tell fortunes. Please don't come to me to hear your past or future. When man is uncapped he is without a hiding place, and it's better for him not to hear it."

"Oh mighty God, I am a stranger on earth's planet. No computer can read all of my visions. No books on earth can hold my story. Something tells me I know every person but just haven't met them all yet. For I look in on your soul, not your body. You are part of me for we came from the one breath of God. My mind is like a moving camera. Nothing seems to slip by. The storage of my warehouse brain cells are beyond usable numbers. I be-

lieve if most people knew as many things as I know and see as many things as I see, they would roll up like a box of tangled yarn and end up in a sanatorium, insane. But I am fixed with a special brain to do a quick work in the world. I am a positive man. Many people think I am doomed. Some think I am wrong. The reason they do is that they have never heard me out and if they did, I guarantee you I am able to give a good reason for anything I am or do or even think."

"I have a solid foundation to sit my reasons of life on, and a magnifying glass to make my feelings seen and understood. The thing about it is when I explain myself, my reason on earth, my visions, my inventions and my relationship with God, people just become in a long-faced coma and stand speechless almost. I assume they are saying in their mind he is the most insane man I ever met and then they say, 'Mr. Finster, I hafta go, I am running late,' and then they take off saying, 'I'll see you later when I have more time,' and I think all I got is time and I am really using it night and day."

"As I have been sent to do and summoned to do, I must do without favor or cost. When my work is finished on earth, my seven invisible members will be moved into a new body and the former things will pass away. I will immediately go to another planet without any knowledge of this planet. I came from God and I'm going back to God. There's a planet being prepared for me right now."

"My mind travels in space at night. One night I traveled beyond the light of the sun. I'll never forget it. It was the furtherest I've ever gone. Before I realized it I was going through space. I was going in a northeastward direction and I looked back and the sun was as little as the end of a matchhead and I was going into a real twilight zone, just about halfway between daylight and dark. I knew it was a twilight zone because there wasn't any cloud shadow. I knew it was a twilight zone because I was almost out of the light of the sun. I became frightened because I knew how far out I was and I knew it would take a year to come back at the speed of sound.
"When I looked the other way in a northeast direc-

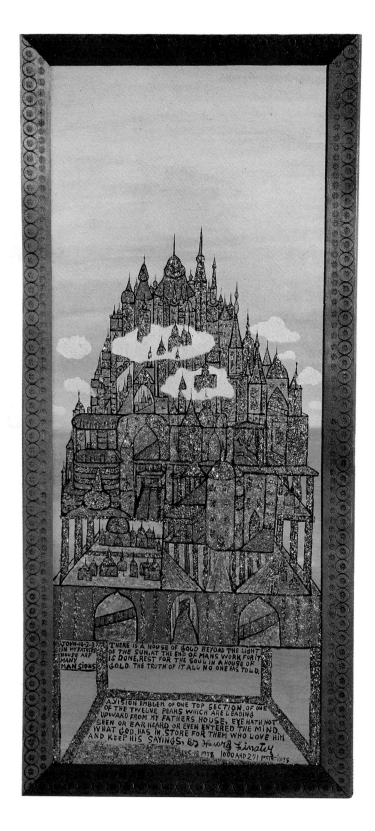

THERE IS A HOUSE OF GOLD: enamel,
glitter on masonite, 16 × 35½", 1978,
#1000 271. (J. F. Turner. Photo:
M. Lee Fatherree)

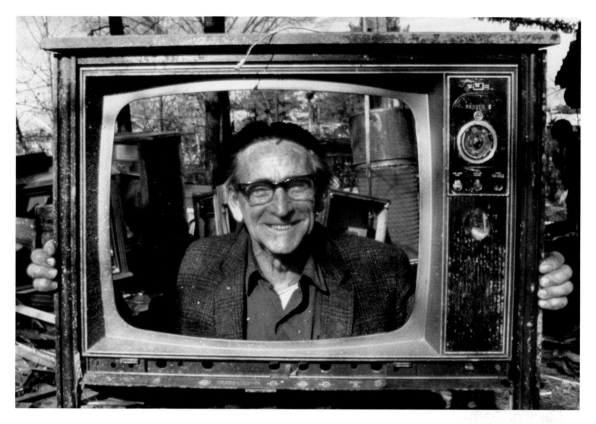

"I am my own TV set."
(Photo: Victor Faccinto)

tion, I seen a place in the sky that looked as far out there as the sun was behind me. It looked like a city lighting up the sky. When I turned around from that and looked at the sun again, I became frightened and when I became frightened I just instantly came out of that vision. Now how could I see that if I hadn't been out there? I've seen it, man, I was out there."

"I am my own TV, picking up visions all through the night hours of darkness. From thin air my pictures come in over a pattern wave beyond the light of the sun. I have visions that stack up in storage and when they cross my mind, I pull them out. I had a vision of a planet beyond the light of the sun. The people of that planet had neither air or oxygen, but more like solid muscles by the hundreds which vibrated 45,000 counts per minute with one thirty-second stroke per inch. Movement was almost invisible. Vibration generated the electrical power of the body movement activity. Like an electrical eel.

"They ate food like moss, in caves and on rocks,

which had all the food values needed and clear oil fluid, no water and that was it. Their bodies were in likeness of our flesh and full of millions of pours [pores] all the way through. The vibration carried the fluid flow. No dung or waste from the body except light moisture for the skin's surface. The moss food was ate only once or twice a week in small amounts which gave the strength of ten normal men. There was a great intelligence for the solid electrical brain. The unit was like a mussel flesh full of compartments larger than normal earth man's. They had natural knowledge of past, present, and future. There was a fixed number. No reproduction or deceased."

"My visions are like a woman going to have a baby. You don't know the day or the hour it comes on you. You just see them. I had a vision of Hell itself. It was a pale red with spots of dark red lakes of liquid fire. It had a light gravity and revolved slowly. As it turned, people were falling from both sides. They never reached the top and they never reached the bottom. They were falling night and day, for their pits were bottomless."

"I talked to Hitler in Hell not long ago. I remember saying, "Hitler, you are a fool." And he stood up and I could not tell which direction he was exactly looking, for it seemed he was looking down and up and straight ahead. He never as much sounded out one word and I don't know how or when I departed from him. He is still standing before me every time I think of this seen [scene]. You hafto be fixed to stand with the dead."

"I dreamed this morning about 9:30 a.m., June 25, 1979, that George Washington spent the night with me. I had talked to him several times, and Miss Washington was helping me polish a long piece of leather. She said George wanted it to shine like glass. I told her it would if we had the right kind of polish. I was afraid it would be hard to get it nice enough to suit George. Later, I was walking along a road with George and people were sitting all along this road as we walked by. They were laughing and talking as they heard me and George talk.

"What is the difference between a vision and a dream? A dream is something that's familiar to you. A

*Opposite:* LIFE IN THE ROCK OF AGES: enamel on wood, 24 × 18", 1980, #1000 722. (Betty Stores. Photo: Ellen Page Wilson)

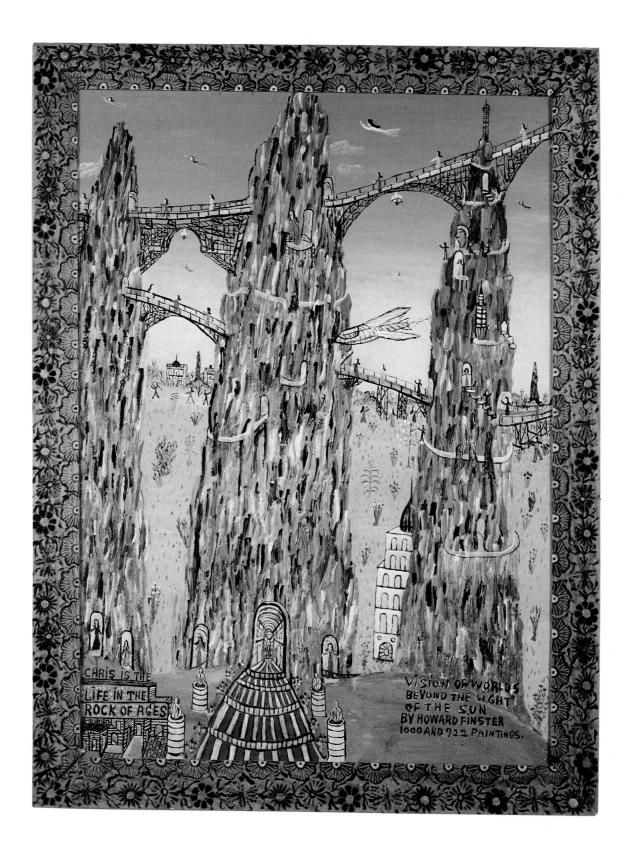

CHRIS IS THE
LIFE IN THE
ROCK OF AGES

VISION OF WORLDS
BEYOND THE LIGHT
OF THE SUN
BY HOWARD FINSTER
1000 AND 722 PAINTINGS.

*Right:* ELVIS PRESLEY: enamel on wood, 20×16", #442. (Photo: Courtesy Phyllis Kind Gallery)

*Opposite:* Howard and I visit Graceland. "Three days later I was down in the Garden, and I had a picture of him [Elvis] drawn on a canvas, and you could see it on both sides. The wind just kept blowing it down. I'd wire it and it would get blown down. I finally moved it up in front of the Cadillac. And while I was down there, I stooped over in one of my flower beds where this thing was hanging. And I felt like somebody walked up behind me, you know. It was three days after I visited his home. I looked around, and there he stood. He had on a light blue shirt, a dark pair of pants, and an open collar, just standing there behind me. I just looked back and seen who he was and I was trying to believe 'Am I seeing Elvis, or am I dreaming? Where am I at?' And I started back working on the flowers like I was having a spasm or crazy or something. Because he walked up and I looked back and seen him. And when I started back on the flowers, to be sure, I talked to him with my back to him, I says, 'Are you going to be around, can you stay awhile?' or something like that, you know. He says, 'Howard, I'm on a tight schedule.' And I looked back around and he was gone. And that's all I can tell you. That's all we had to say. He was just like he was when he was about halfway through his career, courageous and young like that."[29] (Photo: J. F. Turner)

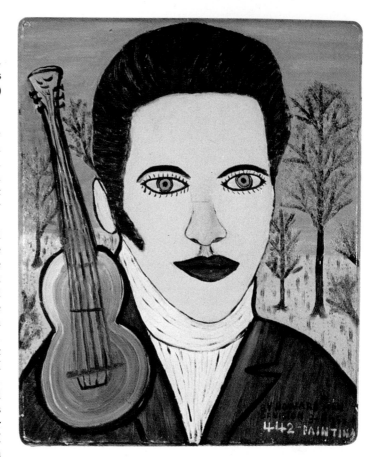

vision is something you have never seen before. Sometimes I dream a dream and sometimes I'll go for a month and never dream a dream. What little time I sleep, I don't really have time to dream a dream.

"On March 10, 1979, I was flying in loops and leaps. It was exciting to scale over the earth from eight feet to sixteen feet. When I came to small hedges and bushes, I would just turn my hand and scoop right over them. I could come within one inch of anything without even rubbing the side. I have actually flown at night many times and have never had any accidents. My flying has always been perfect and I can even fly through a loop in the air.

"Of course my mind and spirit was what really was flying. Some call it a dream, but when you have visions and dreams, you wonder what is the difference. When I was flying, I was enjoying it as much as if I had been in my body. When I have a vision, and my body and mind is in space, my body is dead until I return. When I am in space I don't feel that I can even remember about the body or

flesh. I feel transparent, have light speed, and my accuracy is perfect."

Victor Faccinto: "He has talked about astral travel. I'm sure his mind goes into other dimensions that not everybody is able or would want to go into and probably doesn't have too much control over. I think he does have these 'away from the body' experiences. That is what allowed him to do so much work. The images come so fast because he's moving around, not just sitting around Summerville, Georgia. He doesn't have any bad trips. He has to come back to Summerville to fulfill his reason to be here."

Howard: "On February 6, 1979, at fifteen minutes till one o'clock p.m., I went around the earth in about one and one half minutes sitting in my chair. When I got all the way around it was so interesting I wanted to orbit it one more time but I stopped on top and couldn't to save my life. I tried to push off as hard as I could for the second orbit, but couldn't move, so I came out of the vision, opened my eyes wondering why I couldn't go around as

many times as I wished. But no, I couldn't do it. The thought came to me that something else had ahold of me in my visions. I couldn't control my visions. I can't keep my visions going. When they stop that's it, I can't pick up the same vision again. It's always a new vision. I can't even have a vision when I want to. They come at unexpected times. I have to get them when they come. My visions can last ten or fifteen minutes and it seems like two hours of sleep. It's sorta concentrated, like a double rest.

"One night I saw an angel afar off but she went as though she would pass by without looking at me. I thought within myself, I have always desired to see a real angel. Can I withstand her presence without fainting? When I believed that I could, she immediately appeared setting sideways on a limb of a tree about five feet high and about twelve feet away. She appeared to me in a modern short dress. As she set with both legs to one side of a stooped limb, about six to fourteen inches in diameter, she cautioned me to be aware of the enticing unlegal motion of sex. That a man should have his own wife and that a wife should have her own husband. So in fact with me, that is really what I have done from birth to her appearance and from her appearance until this same moment."

"I have never known a woman except for my own wife. It gives me a feeling of satisfaction and I would not have it no other way, for that vision has become a living factor in my life and is part of me now. I can't get away from it."

"It seems that I can see more when my eyes are closed than I can when they are open. Because when my eyes are open, I only see the things which I have been seeing since I was a baby boy. I love them, but my invisible eyes are not confused with earthly things. When my physical eyes are closed in the darkness, my invisibles see so much until it seems as if my visions were spread out, they would lay a carpet across the sea and over most of the earth."

"I have seen great holes of liquid formations boiling up out of the earth, spreading out into art seens [scenes]

like a mountain or the mouth of a volcano. The lava turns into flat covers of beautiful art. I can watch it run down and reform in seconds into thousands of repeating seens of different kinds of art from the same running lava. Each time I come out of the vision, it is still running down into imaginal art of great circles."

"Why did man rather reach the moon than to reach the heart of the earth? Has man ever been deeper than fifteen miles? Can man reach the center of the earth? What does the center of the earth contain? How can a man know until he reaches the center? If diamonds are found on top of the earth and gold is panned from running streams, and multi-millionaires are rich from the crust of the earth by coal, iron, oil, gas, and uranium, then what values would be near the center of the earth? Would man be more profitable going toward the center of the earth or trying to reach the moon? After going so deep in the earth, would man lose gravity? If man could go through the earth, would he hafto dig from both sides? Would the material in the center of the earth be as hard as the crust of the earth? If it was eight thousand miles through the earth, would it be equal four ways? If soil was moved from the center of the earth, could it be used for growing plants? How deep does the volcano reach in the earth? Are there any living things as far as two miles deep in the earth? Is there water near the center of the earth? If there was a fifty-foot hole all the way through the earth, would it be a suction or a draft? Would the sunlight reach through from the other side

Einstein, painted from a postage stamp.

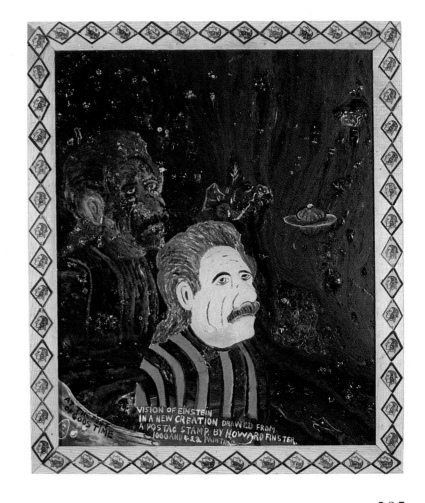

at midnight? If a man knew what was in the earth, would he be afraid? After a river of crude oil has been running out of earth for fifty years, what fills the place of its vacancy? Will natural gas always accumulate fast enough or is the supply in store? Does the freshwater supply feed from the ocean or from rainfall? What gives the pressure to assist the springs of water on high mountains?

"Yes, the earth must be operated twenty-four hours a day by the mighty hand of God. How often we go along and thank God for His wonderful blessings. We live on a round object which is set in space. It is called mother earth, where we prepare for eternity. Are you ready?"

### Saucers—Signs

Underneath the unknown
We are trying to go on
To see what is above this old world.

There are signs and saucers
Which are passing across us
The objects we don't understand
They are round and bright
They are seen of the knight
The secret and mystery of man

Are the objects for us?
Are the objects against us?
Do they seek for peace or war?
Our pilots can find them
But they are far behind them—
They can fly so fast & far

These signs and saucers
Which are far up above
Are known by their shape and
   size—
But what is inside?
Are they destructive?
Are they wise?

What hope has man
Underneath the unknown?
Is it wealth or silver or gold
Or is our hope in God above
Who knows the secrets untold

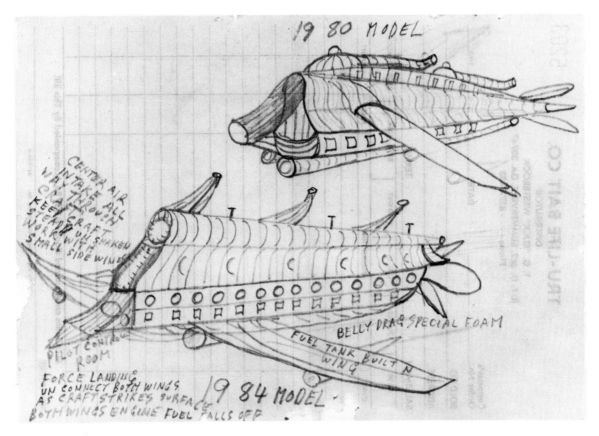

Two versions of a flying craft. (Photo: M. Lee Fatherree)

If only we have our peace with
  God—
Why worry about saucers or signs?
This world is not our home—
We will leave it far behind.

In 1982 Howard holed up for a week, because of the cold weather, and wrote his first book, entitled *Howard Finster's Vision of 1982*. In addition to the writing, he did his own page design and picture layout (Polaroids cut from visits and friends). He then took the assembled manuscript to the Summerville *News* and paid their staff to run five hundred copies, which he sold to visitors to the Garden and through the mail for five dollars. He is now on his third printing.

Howard: "Some people say I am pro-active."

Like millions of other Americans, Howard Finster likes to start the day off with a good cup of coffee. He usually has two to three tall cups of strong chicory coffee

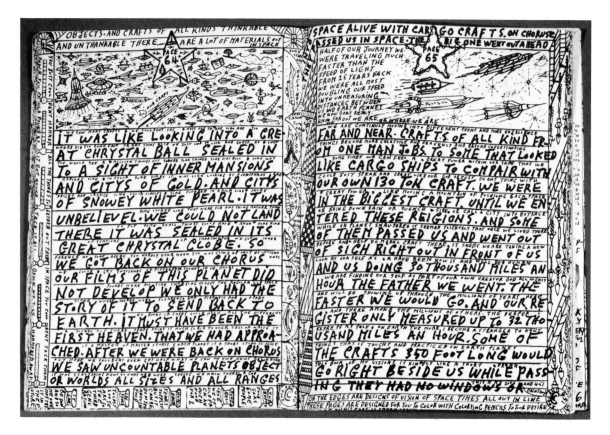

*Above:* A page from the self-published book *Howard Finster's Vision of 1982.* Eighty-seven of the 100 pages have this busy layout, with the remaining pages devoted to photographs of friends, family, memorable events, and sermons from his newspaper column. (Photo: M. Lee Fatherree)

*Opposite:* ·TRUCK DRIVERS COFFEE POT: enamel on wood and metal license plate, 13 × 19½", n.d., #1000 378. (Liz Blackman. Photo: Lannen/Kelly)

during the day. "My nerves I give a break just before I go to shake. Sometimes I can work three nights in a row all night and I go to sleep drinking my coffee looking at TV and sleep for hours holding my cup. I wake up and the TV has gone off the air and it's three in the morning. I just get up and look around and find something to do.

"I eat when I am hungry, anytime during the twenty-four hours. I like peanut butter. It helps me pick up weight. I like potted meat, deviled Spam. I drink Coke, honey, vinegar, and a sip of wine. Paul said to use wine for thy stomach's sake. I think Coca-Cola is the best drink in the whole world. I've been drinking it since I was a kid. Some of my art has Coca-Cola in it. I chew King B Sweet Twist tobacco. It helps take some of the fluids out of the body."

Many people, including those in the art community, are bewildered by the productivity of Howard Finster. They have a difficult time grasping the fact that one man has created and signed over 10,000 works of art in the rela-

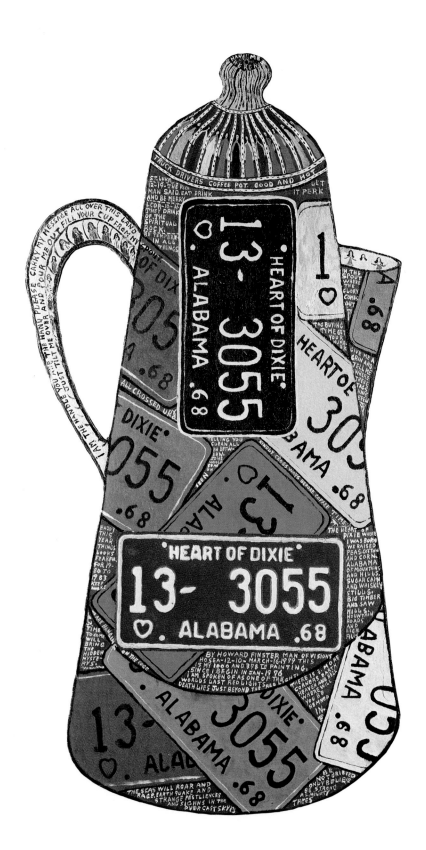

tively short span of thirteen years. This mind-boggling "art count" has prevented a number of people from close examination of Finster's work, and has led to countless stories about his creative force. People can't understand how Finster finds the time to raise a family, greet visitors to his environment, and make art as well. The facts are that Howard paints every night, from 11:00 p.m. to 4:00 a.m., and then sleeps until noon. In the afternoon, he conducts business, labors in his Garden, and prepares his art materials for the evening's work. Painting with the speed and ease that he employs when giving a sermon, Howard claims that he has not wasted a day in the last twelve years.

He often sings the praises of the medicinal worth of chewing tobacco and the "staying power" of a good strong cup of coffee. On one occasion Howard was observed making instant coffee and chewing two tablespoons direct from the jar.

I was interested in what effects two of his major non-spiritual fuels—caffeine and nicotine—had on his work and on his lifestyle. After giving a little background history, I showed a sampling of his work to a man familiar with both art history and medicine, Dr. Dean Edell, host of a highly respected radio and television medical information call-in program in San Francisco.

Dr. Dean Edell: "If I knew nothing about this man and just looked at his art, I wouldn't be surprised to find that this person was a chain smoker and a coffee drinker. Nicotine and caffeine have synergistic effects on the body and the mental state. In one test where nicotine was given by injection and not identified, many of the subjects thought it was cocaine. Nicotine is a very strong 'upper' that has effects on the mind that are only now being unraveled, and by the way, your body receives more nicotine from chewing than from smoking.

"Looking at Mr. Finster's work, he obviously likes to work definitively, quickly, and enjoys the process of lots of canvases in front of him, as opposed to a slow, careful, and painstaking approach. His attention to detail reminds me of a test done with amphetamines which showed that people on 'uppers' could concentrate longer on small detail tests than people not under their influence.

"Anyone can drink enough coffee and turn themselves into a blithering idiot. Caffeine has more of an effect on people who are a little nervous, highly stressed and anxious. When you put caffeine and nicotine together, you can certainly imagine a change in perception as well as the translation of what one sees. It is certainly possible that the combination of these psycho-active drugs can have an influence on one's aesthetic expression.

"You don't have to look deep or hard in art history to find a relationship between artists, alcohol, and even chain-smoking. This is the sense that people utilize to keep them going. It would be hard to imagine somebody like Mr. Finster putting out his kind of energy in a consistent way without some pharmaceutical or spiritual help, and that in itself alters aesthetic expression. Mr. Finster is borderline, meaning only that he experiences hallucinations. By this definition, most of the world's great visionaries may have been psychotic. I think that with high

Howard painting on his studio, 1984. (Photo: Jim Abbott)

dosages of caffeine and nicotine, a borderline personality can be thrown into a visionary or hallucinogenic state.

"I like his art. It is a disturbing, stark kind of communication. It is much less psychotic than the art found in mental institutions, but flirts with it in a way that is tantalizing."

## How to Live Longer

Train your mind to never stay on one thing too long. Keep a group of your interested subjects in the reach of your mind's bookshelves. Change from one subject to another. Drown out your troubles with your business. Learn to close up your brain cells against your troubles. Bring your troubles out long enough to decide the best thing to do. Then put even that off a while. Hold yourself against any sudden shock or strain talk. Talk to yourself out loud enough to hear you say to yourself, Death is sure anyway. Why does it matter when or where? I will do my best and leave the rest to God. Never rush even a kidney move or a bowel move. Give nature all the time it takes in the rest room. Never put off the call of nature. Nature tells you when to release waste when to eat when to drink when to eat when to rest when to work when to talk when to walk when to have sex. How to wait on sex till convenient and in order. Always learn to eat slow. Content don't talk while eating. When convenient eat alone or lay in your most comfortable position most desired. Try to live with your natural self. Never try to hold back a sneeze or yawn or even a fizzle. Let all your natural things function as a contented animal. Believe in a supreme being who lets people live after death. Condemn no man for nothing. Only affirm the truth.

Number of times that Howard has breathed
up to age 65 years 6 months 17 days and 11
    hours and 8 second old
Has breathed two hundred and thirty billion
    four hundred and sixty-one million
and forty-four breaths Howard has breathed.

*Opposite:* This self-portrait of Howard's "wirehouse" lets the viewer in on how he can process so much information at one time. (Photo: M. Lee Fatherree)

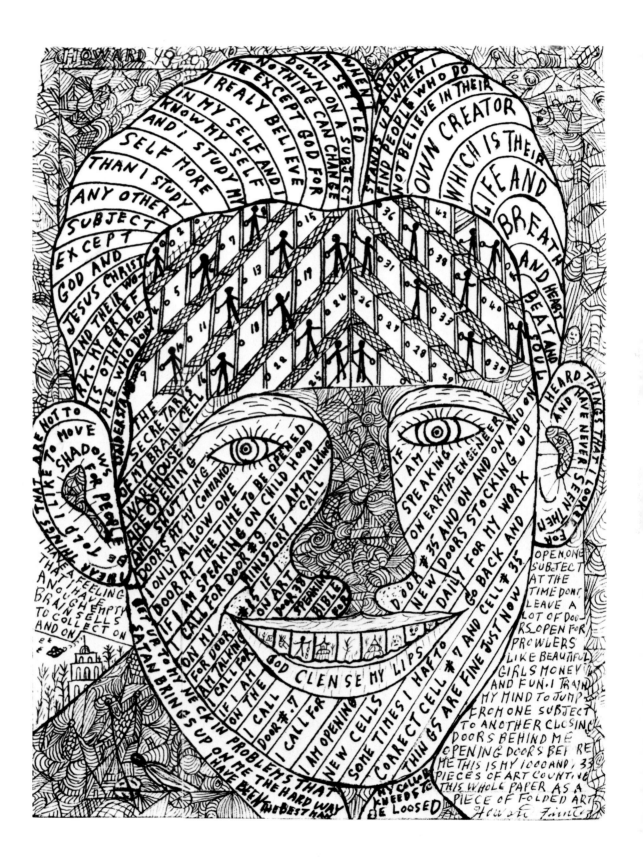

Howard: "I'm the easiest man to get along with in the world. I love my enemies. People come along and do me dirty and I turn 'em over to God. I take no man's word for granted until I run it through my brain cells. No power on earth can change my rejections. No power on earth can change when I add things up for myself. I have the right answer when I weight things out. I have the right weight when I run a survey. I have the right distance when a painting or picture is approved. By my meditation it is consolidated and sealed forever. No grip can pull it apart. And I don't want to be nothing else.

"I have never met or even heard of any person that I would want to be except myself. I condemn any mestake that I find in myself. I really despise myself sometimes. I almost wonder why I came this way. I prefer a world where people don't fuss and fight and kill and steal and drink and gamble and horhop and destroy themselves and their very soil and air and breath. The more I get acquainted with people on this planet and see how stupid they are, the more I realize I can't be one of them."

"A nuclear war will only be the beginning to the end. Before, the earth's molten center will come into contact with the cracks in the water table, causing the earth to explode in a steamy blast. A nuclear holocaust will help run these cracks into the fire. God's got it fixed where man can destroy the earth. If people don't come to God, the end will be short."

"Something talks with me, saying if you should live one thousand years you will never see all the visions nor never draw even a fraction of them. For me to see all things and draw all things would be like trying to dip the ocean dry with a thimble or move all the sand of the sea with a teaspoon. So I am just playing along with what my physical strength will support me to draw.

"My paintings have a spirit in it. I've had people call me up and say, 'Howard, when I read the message on the painting you sent me I cried,' and I tell them, 'I cried when I did that painting.' It's written in a spirit and people read it in a spirit.

"What fame is, it's just publicity. Jesus Christ needed publicity to get his messages out. I don't care about being what they call famous.

"My art has become a nightmare. I can't possibly get out enough stuff for the people that want my stuff. I've

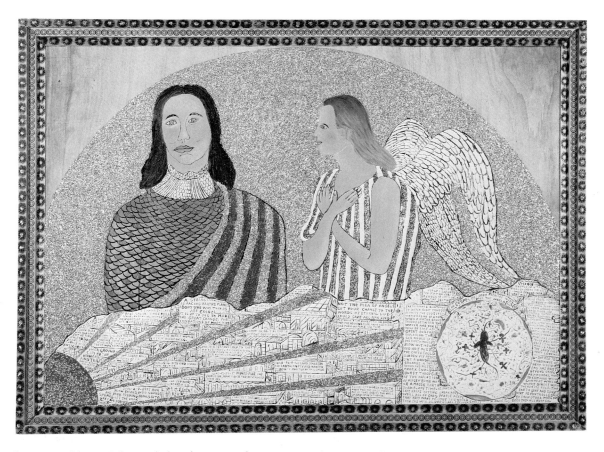

been working night and day for over eleven years, just taking catnaps. My galleries that sell for me are my main outlet. A lot of people think of me as a manufacturing plant that has stuff sitting around to be picked over. I don't know how much longer I can exist under pressure like I'm under."

A STRANGE LOOK IS FACING EARTHS PLANET: enamel, glitter on wood, 32³/₄ × 37¹/₄", 1981, #1000 899. (Phyllis Kind. Photo: Courtesy of Phyllis Kind Gallery)

Busy to live I am just hanging on
Orders and stories
are more than I can handle
It's kinda dimming my candle
It's hard to keep from flying off the handle
When I retired my work just begun
It's a lot of pleasure
But not much fun
I keep thinking there's a stopping place
but it don't seem possible
so much to do by writing to you
to count the rest I'll never get through
My body gets weak but my mind stronger

"I never had money to spare for one quart of whisky. I never had a taste of beer in my life. I only went on two fishing trips in thirty-three years. I never owned a new car in my life. I have seen about seventy-five thousand dollars which passed through my billfolds, which wore out four billfolds, for me, my money is gone. I am still working six days a week and enjoy it very much for this is the road to a better world and I have left some of the worst miles behind."

"My kids love me dearly but they just don't show it. I realize if I don't die today, I expect to die tomorrow, for I know the sentence of Death hangs over my head even from Adam and Eve. Many things have come to me unaware, but not Death. It has been waiting somewhere for me since I was born. Why should I worry about it? Everyone before me has tasted Death, and everyone after me will do the same. Death is not my problem. My problem is getting all my jobs done well before I leave, for I know there's nothing to do in the holy land where I am going. Don't let Death slip upon you unaware. Just prepare for it, for it is the better crossing."

Number of Howard's heartbeats up to this
   date
May 17, 1981:
Five hundred and twenty-seven billion
and two hundred and fifty-four million and
   forty times
Howard's heart has beat.

"I'd like to have been a surgical doctor because I believe I could take a human apart and put him back

Originally, Howard kept track of the paintings he had finished by numbering them on the door jamb of his first studio. When this was full, he moved onto cardboard sheets, foamcore, and other door jambs. (Photo: M. Lee Fatherree)

together the best of anybody in the world. I also would have liked to try my hand at the movies. I could go to Hollywood right now and set up and dominate a whole movie. I could tell how to do it and plan it. I wouldn't go there to be a star. I'd go to be a promoter. I could promote a movie that would go over just like my art. I would like to do a good clean comic movie because everybody in the world likes good comedy."

## THE LINE ACROSS MY TV SCREEN

Was watching a lady comedian. Her waist up was above line. Her bottom part below line. Me—a retired minister—I thought I should watch her from the top part. My eyes would keep jumping to her bottom part. And I decided to be in the clear I would just hafto change channels. It was so hard to turn the nob. Just shut my eyes used both hands. I was glad that I was still a man. But I was not too proud of controlling myself.

I have a vision of an air-conditioned glass room about 8 × 10 with curtains around it. It has something like a bank telling window and when people come to the Garden I'd be in that room and I'd get up on my rest bed or on a chair and roll up to the window and talk to them. I would have to limit it to about five minutes for each person.

I, Howard Finster, was lying on my bed one day and looking out over my Garden. A feeling come over me that I had lived and had a job on another planet before I come to earth. But the former things of my first planet had passed away so that they would not confuse me about my work on earth's planet, and now I desperately try to draw paintings to remind me of the work that I did on my first planet. I have visions of worlds beyond the light of the sun, unbelievable domes and mansions and trees that go up out of sight in the sky. I am a stranger from another world, and when my work is finished I will go back to other worlds.

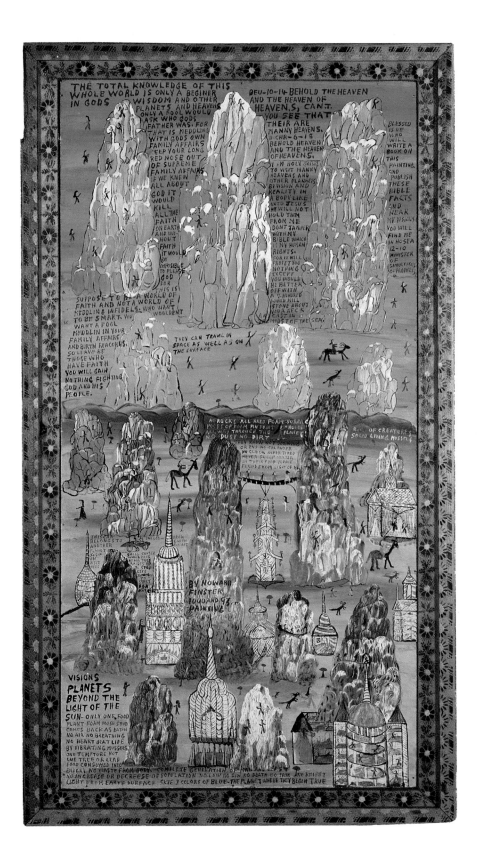

## The Silver Wings

On the silver wings. And the feathers of
  gold
I'm moving out. To the worlds untold.

Just like a rambling around. In a space up
  above.
Like floating wings of a snowey white dove.

On the silver wings and the feathers of gold
I find my self gliding in my soul.

Worlds up above. Worlds down below.
I can find those worlds any way I go
Oh the wings so high. And the sings so far
I find my self at the golden bars.

On the silver wings and the feathers of gold
I know my Lord has redeemed my soul.
Like the eagle's wings in the deep blue sky
I'm going home where I never shall die
never shall die
never never shall die.

---

. . . As the front bolt slid and the screen door opened, Howard greeted me in an uncustomarily low and old-sounding voice. "John, come on back in the bedroom and look at this TV program about oil being all over and inside the world."

He sat down on his "working bed." The shelf behind him was cluttered with empty Jiffy peanut butter jars, Hershey chocolate syrup containers, B12 pills, and a small jar of Tiger Balm oil that he uses, along with a heating pad, for the bursitis in his shoulder he claims he got from shaking thousands of hands since the first days of preaching.

The color on the TV set was out of adjustment and its speaker was strained. Howard started talking about the problems with the fuel pump of his 1978 Lincoln Continental, which I had been driving around Summerville the past eight days. His eyes were on the TV, his mind on the car, and his body was limp from spending six hours in the Garden damming a stream so the goldfish would make it through the winter.

*Opposite:* VISIONS OF PLANETS BEYOND THE LIGHT OF THE SUN: enamel on wood, $34^{1}/_{2} \times 19^{1}/_{2}$", 1978, #1000 93. (Herbert W. Hemphill, Jr. Photo: Stuart Rome)

I was leaving by Greyhound for Atlanta early the next morning. Howard raised his voice, turned his head, and looked deep into my eyes, saying, "The day will come when there will be a river of blood and when you turn on your faucets, blood will run out. There will be a great explosion in the center of the earth. It will start cracking and the cracks will get so deep and big that it will take a helicopter to cross them, and flying crafts from other planets will go by and never know there was an earth.

"A lot of things I see now I believe some day the scientists will one day find out there. I have visions of war machines, like one machine crawling on the ice, crawling on the dirt without any wheels. It has fins on it that pull it along like a snake. Some day somebody will probably create that thing. I wrote a book about all the things I've seen out yonder in space and after I die you will find those things coming true.

"There will be rumors and writing about me probably till Jesus comes back. There will be stories about my being a fake, like there were about Noah. There will be stories that all the stuff Howard predicted is coming true. One of the frightening things is sometimes people start worshipping a man like that, and that is a very bad thing to do. They shouldn't consider me nothing but as a piece on an automobile or an instrument. I'm a bicycle repairman. I'm a retired pastor, and God brought these visions upon me and I have these visions and I have to tell 'em to somebody and this world is all I got to tell 'em to. My work has a spirit in it. I write it in a spirit and the people read it in a spirit and that's the spirit that unifies all humans."

Three hours later I rose to the smell of Pauline's homemade biscuits and the sounds of her dog, Rambo, scratching at the front door. Half awake I stumbled downstairs to the breakfast table. In the living room, left for me to see, propped up on a chair, was the completed painting of Mary Magdalene's "vision angel" looking from another world to wish us all well.

## Howard Goes to Heaven

One beautiful morning I arose from sleep and all my work was caught up. I had all the riches that I would ever need. I looked at the

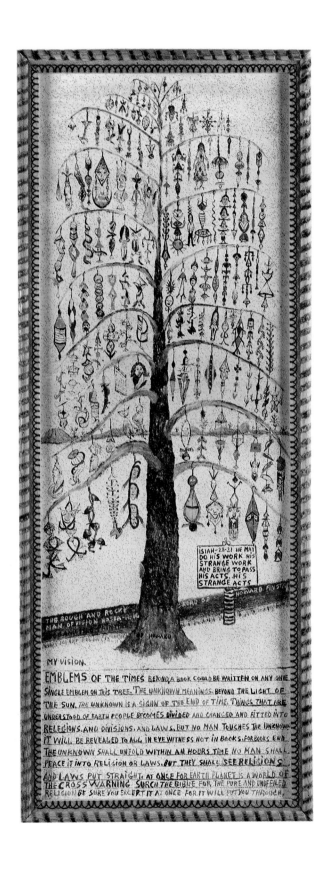

EMBLEMS OF THE TIMES: enamel on wood, glitter, 44 1/2 × 17 1/2. (Private Collection.)

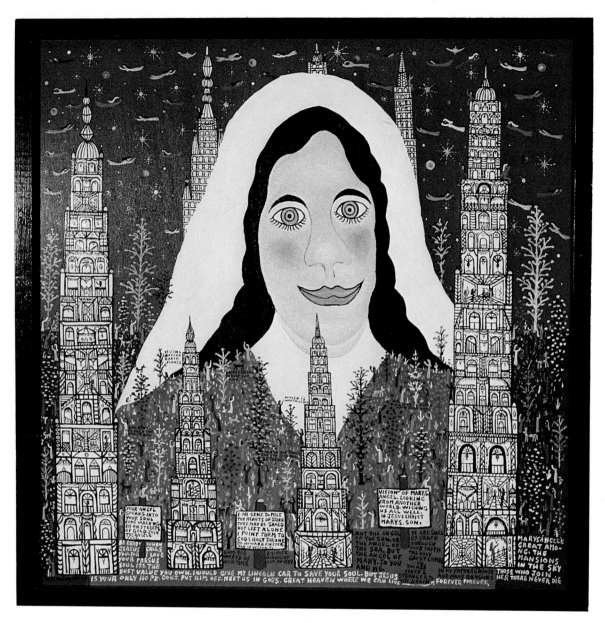

VISION OF MARY'S ANGEL: enamel on wood, 48½ × 48½", 1987, #6000 908. (Photo: Courtesy Phyllis Kind Gallery)

clock and pitched it in the waste can. I took the calendar from the wall and tore it in half. I took my insurance policy and pitched it into the waste. I took all my business books and papers, tax return forms, and threw them away. I went to my workshop and cut off the power and locked the doors. Every failing member of my body became strong and my young feeling returned to me.

I took my medicine cabinet and threw it away. I took my electric razor and pitched it out. I left my home without a suitcase or a change of clothes. I began to walk away without looking back.

I took my billfold and pitched it in the gutter. I took a road that led upwardly. I met a great company of people. Thousands and thousands of them, they were all smiling. I could see peace and love shining in their faces. Little children playing all along the streets. I reached down and raked my hand across the street and it was smooth as polished marble.

I looked up to see the sun but it was gone. The lamb of God was the light. The light was so equal, every corner and turn shined. There was no such thing as darkness. I could see the most beautiful domes and structures near and far of pure gold. They didn't have a sun glitter, they shined on all sides, the grass an even color by miles and miles. The top of the grass was level as mohair. After time had passed and passed and passed, I never grew tired. No such thing as thirst or hunger. The mansions were vacant of beds. There were no railroad lines or planes overhead. The only sounds were beautiful singing, and the music beyond describing and groups of people talking and meeting one another. God Himself in person. People bowing by thousands at the presence of Jesus, who they had always wanted to see face to face. Everyone who had believed in Christ was present. Bible debates were unknown. Everyone lived with a shout in his soul. Praise to God. The joy and peace and luxury were so great that the former things were forgotten. You could pass one object a thousand times and it was just as new as ever. Nothing could be improved. It was so perfect.                    —1968

Howard Finster, "The Holy Man of the South," October 1987. "I am slowly tipping my hat in the shade of the setting sun." (Photo: J. F. Turner)

# Notes

1. "My brother and I, . . . cut it off":
Adapted from Art Rosenbaum's notes
to the Folkways Records album
#FC7471, "Howard Finster—Man of
Many Visions."

2. Quoted in "Howard Finster—Artist,
Preacher, Poet, Guru, Gardener," by
Frederick H. Leighton, 1987
(unpublished).

3. Gayle White, "A Folk Art Fantasy . . .
Howard Finster's Paradise," Atlanta
*Journal & Constitution*, January 18, 1976,
p. 16.

4. "The two and a half acres . . . build
this park": Summerville *News*,
Summerville, Georgia.

5. "I'd take trade-ins . . . the field
snakes": "Howard Finster, a Well-
Known Stranger," by Dick Randall,
*Cornerstone*, vol. 3, no. 70 (1984), p. 21.

6. "I seen kids . . . a contribution":
Leighton, *op. cit.*

7. "A couple of . . . visions like me": Cliff
Bostock, "Artist from Another World,"
*Atlanta Weekly*, March 25, 1984, pp.
12–17.

8. "I have so many . . . kick up about it":
From "The Reverend Finster, A Man of
Visions," by Patrick Thornton, Gale
Gallagher, Natalie Ruddell, Sonja
Boerth, and Sean Bagley, in *South
Wind*, vol. 1, no. 2 (1981), Calhoun
High School, Calhoun, Georgia; Bob
Linn, editor.

9. "I also represent . . . at my place":
Randall, *op. cit.*, p. 22.

10. "All he does . . . mailman for me":
*Unschooled Talent.* Owensboro Museum
of Fine Art, Owensboro, Kentucky,
1979.

11. "There ain't nothing . . . is my
church": Bostock, *op. cit.*

12. "This is Queen Henrietta . . . actually
show": *Howard Finster: Man of Visions*,
videotape by John F. Turner, Berkeley,
1981.

13. "My work is scrubby . . . work in art":
Tom Kirwan. "Publicity Doesn't Spoil
Howard Finster & His Unique Paradise
Park," Summerville *News*, March 31,
1977.

14. Jean Dubuffet, *Prospectus et tous écrits
suivants* (Paris: Gallimard, 1967), vol. 1,
p. 173.

15. Paul Richards, "Gentle Strokes from
Gentle Folks," *The Washington Post*,
November 19, 1981.

16. "No doubt . . . Jesus Christ":
*Unschooled Talent, op. cit.*

17. Thomas Albright, review in the San
Francisco *Chronicle*, Wednesday, April
29, 1981.

18. Judith Jedamus, "Georgia Preacher
Paints His Visions," *Colorado Daily*,
(Boulder), November 11, 1982,
pp. 1, 11.

19. Peter Schjeldahl, "About Reverence,"
*The Village Voice*, August 31, 1982, p. 73.

20. "Howard's own sophistication . . .
divine inspiration": Deborah C.
Phillips, "Howard Finster," *Arts
Magazine* (October 1980), p. 24.

21. Kurt Pfitzer, "A Preacher-Painter Leads Students to Their Own Artistic Roots," *Lehigh Alumni Bulletin* (Winter 1987).

22. "There's a rather . . . and he is": Cathy Trost, "This Fundamentalist Uses Paintings, Plants to Spread the Word," *The Wall Street Journal*, July 2, 1986, p. 1.

23. "When I first . . . is affecting society": Quoted in Susan Cummings, "Reverend Finster: Paradise in a Paintbrush," *Spin* (September 1985), pp. 51–52.

24. "Over the years . . . does his painting": Quoted in *ibid*.

25. Liza Kirwin, "Documenting Contemporary Southern Self-Taught Artists." Paper presented to the Folk Art Society of America, Richmond, Virginia, October 1, 1987.

26. "I'd like to build . . . take that sunlight": Jedamus, *op. cit.*

27. Art Rosenbaum, *Folk Visions and Voices: Traditional Music and Song in North Georgia* (Athens, Ga.: University of Georgia Press, 1983).

28. "I had a young Buddha . . . try my God": "Many Worshippers One God," *Southwind* magazine, Calhoun High School, Calhoun, Ga. (Spring 1985), pp. 46–63.

29. "Three days later . . . young like that": Leighton, *op. cit.*

# Biographical Summary
## COMPILED BY
## VICTOR FACCINTO AND J. F. TURNER

1916   Born December 2 to Samuel and Lula A. Finster in Valley Head, Alabama

1919   First vision. Deceased sister Abby steps down from the sky

1930   Completes sixth grade, Violet Hill School, Alabama. End of formal education

1932   Begins preaching at age sixteen. Publishes his first message in Fort Payne *Journal*, "Two Ways of Life"

1935   Married to Pauline Freeman, October 23

1936–56   Father of Earline (September 24, 1936); Gladys Lorene (August 23, 1939); Roy Eugene (March 27, 1941); Thelma Gene (September 18, 1945); Beverly Wylene (May 24, 1956)

1939   Preaches first tent revival at Chapel Hill, Georgia

1941   Pastors first church, Rock Bridge Church, Desota State Park, Alabama. Builds and opens grocery store in Trion, Georgia

1945   Begins construction of first garden museum, Trion, Georgia

1951–76   Ministry continues. Conducts revivals, baptisms, weddings, and funerals. Works as cloth inspector and machine repairman in local mill; employed at furniture factory; does carpentry and plumbing work. Starts Finster's Arts & Crafts business and produces "family picture" clocks by the hundreds; runs bicycle and lawn mower repair business

1961   Moves to Pennville, Georgia (just outside Summerville, Georgia)

1970   Begins construction of Paradise Garden in Pennville, Georgia

1975   Atlanta television station Channel 5 runs a story on Paradise Garden; visit to the Garden by Anna Wadsworth of Georgia Council of the Arts; appears in *Esquire* magazine article, "Backyards"

1976   Winter: receives a "divine feeling" that instructs him to "paint sacred art." Summer: experiences vision of "Man by the Gate." Begins making art full time. Sells paintings to Cynthia Carlson and Bert Hemphill. First exhibition appearance in *Missing Pieces*, Atlanta Historical Society

1977   Four paintings commissioned by Alan Jabbour to hang in the Library of Congress

1977–81   Represented and promoted by Jeff Camp of the American Folk Art Company, Tappahanack, Virginia

1978   Listed as a "National Treasure" in Jane and Michael Stern's book, *Amazing America*. Travels to Washington, D.C. (with *Missing Pieces* show) and meets Rosalyn and Amy Carter

1980    Releases first record, 7", 33 rpm recording of "Just a Little Tack," produced by Wake Forest University Fine Arts Gallery, Winston-Salem, North Carolina. First issue of *Folk Image* by the American Folk Art Company devoted entirely to the drawings and writings of Howard Finster. Featured in June issue of *Life* magazine

1981    Represented by Phyllis Kind at the *Folk Art of Reverend Howard Finster,* one-man show at the Braunstein Gallery, San Francisco

1982    Recipient of *National Endowment for the Arts, Visual Artist Fellowship in Sculpture.* One-man show at the New Museum, New York City. Self-published 100-page book, *Howard Finster's Vision of 1982: Vision of 200 Light Years Away Space Born of Three Generations. From Earth to the Heaven of Heavens*

1983    Travels to Hollywood, California, for an August 4 guest appearance on Johnny Carson's *Tonight Show*. Athens, Georgia, rock group, R.E.M., releases MTV music video filmed in Paradise Garden

1984    Drawing used for cloth napkin design, Fabric Workshop, Philadelphia, Pennsylvania. Selected by the New Museum as part of the American section of the Venice Biennale

1985    Commissioned by David Byrne to do a painting for the cover of Talking Heads album, "Little Creatures," a million-selling lp; selected by *Rolling Stone* magazine as album cover of the year. Receives key to the city of Summerville and has retrospective show at the First National Bank of Summerville, Georgia. Paints Easter egg for White House celebration.

Featured in *People* magazine as one of the "Five Off-the-Wall Individualists [who] Are Expanding the Dimensions of Contemporary American Art"

1986    First use of Howard Finster as subject in college religion course, "Religion and the Arts," Lehigh University, Norman Girardot, instructor. Show at Cavin-Morris Gallery, New York City, entitled *Howard Finster: The Early Works, 1975–1980*. Article by Cathy Trost, "This Fundamentalist Uses Paintings, Plants to Spread the Word," appears in *The Wall Street Journal*, July 2, 1986, pp. 1, 16

1987    Work shown with that of artists Red Grooms and Jonathan Borofsky in *Contemporary Cutouts: Figurative Sculpture in Two Dimensions* at the Whitney Museum, New York City. James Dickey, Janette Carter, and Howard Finster, Master Artists-in-Residence Workshop at the Atlantic Center for the Arts. Fah Sah Lah Cah Lo Festival held in Paradise Garden. Billboard erected by Summerville Chamber of Commerce, giving directions to Howard Finster's Paradise Garden. Howard receives computer from Lehigh University, and prints out "Howard Finster's Computer Art"

In first negative publicity out of hundreds of articles, Howard Finster is called a "wacko" by John Vlach, director of the Folklife Program at George Washington University, in "The Selling of Howard Finster," by Jack Hitt, in *Southern* magazine

Meeting with Chattooga County community leaders Sue Hurley, A. J. Strickland, Sue Spivey, Karen Cook, and author J. F. Turner to discuss and lay plans for the community of Summerville, Georgia, to purchase Paradise Garden as a "living landmark" to share with the world

# Selected Bibliography of Howard Finster

## COMPILED BY
## ANN F. OPPENHIMER AND J. F. TURNER, 1989

I tell you nobody can write my story.
It's too long. Tapes won't hold it. Volumes won't hold it.
—*William Howard Finster*

### BOOKS

Archer, Barbara. *Outside the Mainstream: Southeastern Contemporary Folk Art.* Atlanta: High Museum of Art, 1987.

Bihalji-Merin, Otto, and Tomasevic, Neobjsa-Bato, eds. *World Encyclopedia of Naïve Art,* Scranton, Pa.: Harper & Row, Inc., 1985. First published in 1985 by Scala/Philip Wilson; distributed by Harper & Row, Inc.

Bishop, Dr. Robert. *Folk Painters of America.* New York: E. P. Dutton, 1979.

———. *The All American Dog: Man's Best Friend in Folk Art.* New York: Avon Books, 1977.

Bishop, Dr. Robert; Weissman, Julia, McManus, Michael, and Niemann, Henry. *Folk Art: Paintings, Sculpture & Country Objects.* New York: Alfred A. Knopf, 1983.

Emmerling, Mary Ellison. *American Country.* New York: Clarkson N. Potter, 1980.

Ferris, Bill, and Peiser, Judy, eds. *American Folklore Films and Videotapes, An Index.* Memphis, Tenn.: Center for Southern Folklore, 1982.

Finster, Howard. *Folk Image.* Tappahannock, Va.: American Folk Art Company, 1980.

———. *Howard Finster's Vision of 1982. Vision of 200 Light Years Away Space Born of Three Generations. From Earth to the Heaven of Heavens.* Summerville, Ga.: Privately printed, 1982.

———. *Sample of Life's Story and Poem Book, No. 1.* Summerville, Ga.: Smith Printing Co., 1945.

———. *The Scrap Book of All Times.* Summerville, Ga.: Privately printed, 1988.

Johnson, Jay, and Ketchum, William C., Jr. *American Folk Art of the Twentieth Century.* New York: Rizzoli International Publications, 1983.

Maresca, Frank, and Ricco, Roger, with Weissman, Julia. *American Primitive, Discoveries in Folk Culture.* New York: Alfred A. Knopf, 1988, pp. 266–267.

Meyer, George H., ed. *Folk Artists Biographical Index.* Detroit: Gale Research Co., 1987.

Patterson, Tom. *St. EOM in The Land of Pasaquan: The Life and Times of Eddie Owens Martin.* Winston-Salem, N.C.: The Jargon Society, 1987, pp. 227–229.

Payella, August. *Folk Art of the Americas.* New York: Harry N. Abrams, 1981.

Rosenbaum, Art. *Folk Visions and Voices: Traditional Music and Song in North Georgia.* Athens, Ga.: University of Georgia Press, 1983.

Stern, Jane and Stern, Michael. *Amazing America.* New York: Random House, 1978.

———. *Elvis World.* New York: Alfred A. Knopf, 1987.

Turner, John F., and Dunham, Judith. "Howard Finster: Man of Visions." In *Folklife Annual 1985*, edited by Alan Jabbour and James Hardin. Washington, D.C.: Library of Congress, 1985, pp. 158–173.

## EXHIBITION CATALOGUES

*American Folk Art: The Herbert Waide Hemphill, Jr., Collection.* Dialogue by Michael E. Hall and Herbert W. Hemphill, Jr. Essays by Russell Brown and Donald B. Kuspit. Milwaukee: Milwaukee Art Museum, 1981.

*Apocalyptic and Utopian Images in Contemporary Art.* Bethlehem, Pa.: Moravian College, 1983.

*Baking in the Sun: Visionary Images from the South.* Essays by Andy Nasisse and Maude S. Wahlman. Lafayette, La.: University of Southwestern Louisiana, 1987.

Barbour, Bill, and Barbour, McLane. *Visionary Constructions.* Ohio State University Gallery of Fine Art, 1985.

Barrett, Didi. *Muffled Voices: Folk Artists in Contemporary America.* New York: Museum of American Folk Art, 1986.

Browning, Robert H. *Ikon/Logos: Word as Image.* New York: Alternative Museum, 1981.

Dewhurst, C. Kurt; MacDowell, Marsha; and MacDowell, Betty. *Reflections of Faith: Religious Folk Art in America.* New York: E. P. Dutton, 1983.

*Enisled Visions: The Southern Non-Traditional Folk Artist.* Essays by Didi Barrett and Richard Gasperi. Mobile, Ala.: The Fine Arts Museum of the South, 1987.

Esman, Rosa. *Outsiders: Art Beyond the Norms.* New York: Rosa Esman Gallery, 1986.

Fabri, Anne R., ed. *American Folk Art from the Collection of Herbert Waide Hemphill, Jr.* Essay by Sid Sachs. Oceanville, N.J.: The Noyse Museum, 1988.

*First in the Hearts of His Countrymen: Folk Images of George Washington.* New York: Fraunces Tavern Museum, 1978.

Gregson, Chris. *Wheels in Motion: Naive Images of Transportation.* Richmond, Va.: Meadow Farm Museum, 1987.

Gumpert, Lynn. *The End of the World: Contemporary Visions of the Apocalypse.* New York: New Museum of Contemporary Art, 1983.

Hankla, Susan. *Horse of a Different Drummer.* Richmond, Va.: Richmond Arts and Humanities Center, 1982.

———. *Retrieval Art in the South.* Richmond, Va.: 1708 East Main, 1983.

*Howard Finster, Man of Visions: The Garden and Other Creations.* Foreword by John Ollman. Philadelphia: Philadelphia Art Alliance, 1984.

*Land of Our Own: 250 Years of Landscape and Gardening Tradition in Georgia, 1733–1983.* Atlanta: Atlanta Historical Society, 1983.

*Language, Drama, Source, and Vision.* Essay by Marcia Tucker. New York: New Museum of Contemporary Art, 1983.

Manley, Roger. *A Blessing from the Source: The Annie Hooper Bequest.* Winston-Salem, N.C.: North Carolina State University, 1985.

Metcalf, Eugene, and Hall, Michael. *The Ties That Bind: Folk Art in Contemporary American Culture.* Cincinnati: Contemporary Arts Center, 1986.

Meyer, Ruth. *New Epiphanies.* Columbus: Ohio Foundation on the Arts, 1983.

Murry, Jesse. *Currents: Reverend Howard Finster.* New York: New Museum of Contemporary Art, 1982.

*Naivete in Art.* Essays by Herbert W. Hemphill, Jr., and Gail Mishkin. Tokyo: Setagaya Art Museum, 1986.

Nosanow, Barbara Schissler. *More Than Land or Sky: Art from Appalachia.* Washington, D.C.: Smithsonian Institution Press, 1981.

Oppenhimer, Ann. *Intuitive Art: Three Folk Artists.* Blacksburg, Va.: Virginia Tech, 1986.

Oppenhimer, Ann, and Hankla, Susan, eds. *Sermons in Paint: A Howard Finster Folk Art Festival.* Richmond, Va.: University of Richmond, 1984.

*Paradise Lost/Paradise Regained: American Visions of the New Decade: The 41st Biennale de Venezia, 1984/United States Pavilion.* Essay by Marcia Tucker. New York: New Museum of Contemporary Art in association with the United States Information Agency, 1984.

Patterson, Tom. *Southern Visionary Folk Artists.* Winston-Salem, N.C.: The Jargon Society, 1984.

Pederson, Ron. *American Folk Art from the Collection of Martin and Enid Packard.* Detroit: Calvin College, 1981.

Read, Jill. *Art from the Heart.* Essay by Judy McWillie. Athens, Ga.: Clarke County Office of Cultural Affairs, 1983.

Rumford, Beatrix T. *Folk Art USA Since 1900 from the Collection of Herbert Waide Hemphill, Jr.* New York: Publishing Center for Cultural Resources, 1980.

Scalora, Sal. *Reverend Howard Finster: Man of Divine Visions.* Storrs, Conn.: Atrium Gallery, 1986.

*Southeast Seven/Nine.* Essay by Patrick White. Winston-Salem, N.C.: Southeast Center for Contemporary Art, 1986.

*Spectrum: In Other Words.* Essay by Ned Rifkin. Washington, D.C.: Corcoran Gallery of Art, 1986.

Stebich, Ute. *Beyond Tradition: Contemporary American Folk Art.* Katonah, N.Y.: Katonah Gallery, 1984.

Styron, Tommy. *Innocence and Experience.* Greenville, S.C.: Greenville County Museum of Art, 1985.

*The Political Landscape.* Rutgers, N.J.: State University of New Jersey, 1985.

*Transmitters: The Isolate Artist in America.* Foreword by Elsa S. Weiner, Preface by Marcia Tucker. Essay by Richard Flood. Dialogue by Michael and Julie Hall. Philadelphia: Philadelphia College of Art, 1981.

*20th Century American Folk Art from the Arient Family Collection.* Essays by James Arient and Didi Barrett. Chicago: Northern Illinois University Art Gallery in Chicago, 1987.

*Unschooled Talent.* Owensboro, Ky.: Owensboro Museum of Fine Art, 1979.

Viera, Ricardo, and Girardot, Norman. *The World's Folk Art Church: Reverend Howard Finster and Family.* Bethlehem, Pa.: Lehigh University, 1986.

Volkersz, Willem. *Word and Image in American Folk Art.* Kansas City, Mo.: Mid-America Arts Alliance, 1986.

Wadsworth, Anna, ed. *Missing Pieces: Georgia Folk Art, 1770–1976.* Atlanta: Georgia Council for the Arts and Humanities, 1976.

*What I Do for Art.* Introduction by Kathleen Goncharov. Essay by Lisa Nicol Peters. New York: Just Above Midtown, Inc., 1982.

## VIDEOTAPES AND FILMS

Atchley, Dana. *Paradise Garden* ("Video Postcard").[videotape]. 1983.

Brown, Ken. *Howard Finster: Man of Visions.* [videotape]. 1983.

Des Roberts, Julie, Carr, Dave, and Paskal, Randy. *Howard Finster: Man of Visions* [film]. Los Angeles: No Hands Productions, 1988.

Faccinto, Victor. *Paradise Garden* [videotape]. Winston-Salem, N.C.: Wake Forest University, 1982.

Gayton, Tony. *Athens, Ga., Inside/Out* [film]. Athens, Ga.: Spotlight Productions, 1987.

Girardot, Norman. *Howard Finster at Lehigh* [videotape]. Bethlehem, Pa.: 1986.

Hanson, Jack. *Howard Finster* [videotape]. San Francisco: KGO-TV, 1981.

Jones, Kenley. "Outsider Art." On *NBC Nightly News* [videotape]. Atlanta: WXIA-TV, December 28, 1986.

Kuralt, Charles. "Herbert Hemphill." *Sunday Morning* [videotape]. New York: CBS, August 22, 1987.

*Missing Pieces: Georgia Folk Art 1770–1976* [film]. Atlanta: Georgia Council of the Arts and Humanities, 1976.

Oppenhimer, Ann. *Intuitive Art: Three Folk Artists* [videotape]. Richmond, Va.: University of Richmond, 1986.

———. *Video Snapshots* [videotape]. Richmond, Va.: University of Richmond, 1986.

Pierson, Arthur. *R.E.M.'s Radio Free Europe* [videotape]. Hollywood: A&M Records, Inc., 1983. Reissue, on *R.E.M. Succumbs,* 1987.

Rubnitz, Tom. *Howard Finster* [videotape]. New York, 1979.

*The Tonight Show Starring Johnny Carson* [videotape]. Los Angeles: National Broadcasting Co., August 5, 1983.

Turner, John. *Howard Finster: Man of Visions*

[videotape]. San Francisco: San Francisco State College, 1981.

Walker, Bob. *Well-Known Stranger: Howard Finster's Workout* [videotape]. Blacksburg, Va.: Cima Productions, 1986.

## DISCOGRAPHY AND RECORD COVERS

*City Without a Subway* [record cover]. Nashville: WRVU/91 ROCK, 1986.

Eugene, Gene. *Adam Again: In a New World of Time* [record cover]. Monterey Park, Calif.: Blue Collar Records, 1986.

Faccinto, Victor. *The Sound of Howard Finster.* Durham, N.C.: Cine/Com Services, 1981.

Faccinto, Victor, and Camp, Jeffrey. *A Portion of a Sermon and Just a Little Tack.* Winston-Salem, N.C.: Wake Forest University Art Gallery, 1980.

Finster, Howard. *Howard Finster: Man of Many Voices.* Recording by Art and Margo N. Rosenbaum. Notes by Art Rosenbaum. New York: Folkways Records, FC7471, 1985.

———. *You Are Eternal* [audiotape]. Produced by Mike Noland. Columbus, Ohio: Coronet Recording Studio, 1984.

R.E.M. *Reckoning* [record cover]. Athens, Ga.: Night Garden Music, 1984.

Rosenbaum, Art. *Folk Visions and Voices: Traditional Music and Song in Northern Georgia.* Vol. 2. New York: Ethnic Folkways Records, FE34162, 1984.

Talking Heads. *And She Was* [record cover]. New York: Sire Records Company, 1985.

———. *Little Creatures* [record cover]. New York: Sire Records Company, 1985.

———. *Road to Nowhere* [record cover]. New York: EMI Records, 1985.

———. *The Lady Don't Mind* [record cover]. New York: EMI Records, 1985.

## PERIODICALS

"Art Brut, Madness and Marginalia," *Art & Text* (December–February 1988), vol. 27, p. 101.

Barrett, Didi. "Miniatures: The Ubiquitous Howard Finster," *The Clarion* (Winter 1987), p. 14.

———. "Special Section: Folk Art Environments," *The Clarion* (Winter 1988), pp. 44–45.

Barry, Linda. "Ernie Pook's Comeek," cartoon of Finster. *East Bay Express.* Berkeley, Calif., July 12, 1985, p. 31.

Basch, Rebecca. "Reverend Howard Finster," *Houston City Magazine* (January 1987), p. 83.

Beach, Laura. "Hemphill Collection Goes to the Smithsonian," *Antiques and the Arts Weekly,* February 13, 1987, pp. 1, 64–66.

Beals, Kathie. "Move Over for New Generation of Folk Artists," *Gannett Westchester Newspapers, Weekend,* November 23, 1984, p. 9.

Bendetti, Joan M. "Who Are the Folk in Folk Art," *Art Documentation* (Spring 1987), vol. 6, no. 1, p. 4.

Berkman, Sue. "Material Value: Primitive Urges," *Esquire* (March 1986), pp. 25–26.

Bishop, Dr. Robert. "Just Plain Folk," *Horizon* (March 1984), pp. 37–43.

———. "The Affects and Effects of Collecting: Artists and Objects," *Ohio Antique Review* (January 1984), p. 13.

Biskeborn, Susan. "A Gallery of Mythical Delights," *The Seattle Weekly* (March 1987), pp. 37, 39.

Blahr, Bill. "Concrete Park in Georgia Is a Heavenly Place," *Concrete Products* (March 1978).

Bostock, Cliff. "Artist from Another World," *Atlanta Weekly,* March 25, 1984, pp. 12–17.

Bostock, Jennifer. "New Backing for Folk Art," *Throttle* (April 1988), p. 9.

Brewster, Todd. "Fanciful Art of Plain Folk," *Life* (June 1980), pp. 112–113.

Brown, Frances. "Coming Soon: Howard Finster Folk Art Festival," *Style Weekly,* October 23, 1984, p. 6.

Bushyeager, Peter. "Howard Finster," *New Art Examiner* (Summer 1984), p. 18.

"Celebration for Howard Finster," *Folk Art Finder* (January–February 1984), pp. 14–15.

Chenoweth, Ann. "Regional Art Southern Style," *Arts Voice* (September–October 1983), pp. 1, 6, 7.

Cohen, Art. "Art for Aid's Sake," *Spin* (June 1986), p. 17.

Cohn, Dianne. "Howard Finster: Girardot Builds a Monument to Lehigh's Friend and One of America's Best Known Folk Artists," *Lehigh Week* (Bethlehem, Pa.), October 21, 1987, p. 3.

Cummings, Susan. "Reverend Finster: Paradise in a Paintbrush," *Spin* (September 1985), pp. 51–52.

Damrosch, Barbara. "Backyards: The Garden of Paradise," *Esquire* (December 1975), p. 162.

DeCurtis, Anthony. "Athens, Ga.: Summing Up a Scene," *Rolling Stone*, April 23, 1987, p. 27.

Demos, Mary Ann. "The Shape of Things: Folk Sculpture from Two Centuries," *The Clarion* (Winter 1982–83), pp. 24–31.

"Drive to Save Finster Garden," *Kansas Grassroots Art Association News* (Winter 1988), vol. 7, no. 4, p. 8.

Dudar, Helen. "Mr. American Folk Art," *Connoisseur* (June 1982), pp. 70–78.

Eff, Elaine. "Folk Art: The Heart of America," *The Clarion* (Summer 1978), pp. 17–23.

Finster, Howard. "A Stranger," *Modern Cracker* (Fall 1979), pp. 7–11.

———. "George Washington in Command, 1983," *Interview* (photo with caption) (February 1987), p. 17.

———. "Little Creatures, 1985," *Rolling Stone*, July 18, 1985, p. 21.

———. "Little Creatures, 1985," *Rolling Stone*, February 27, 1986, p. 28.

"Finster Works on View at Two New York Galleries: Ricco Johnson Gallery and Phyllis Kind Gallery Mount Major Retrospectives," *Antiques and the Arts Weekly*, November 18, 1983, p. 44.

"Folk Art," *Art and Auction* (January 1984), p. 83.

"Folk Art Fantasy," *Country Living* (February 1982), pp. 50–51.

"Folk Art USA Since 1900," *Folk Art Finder* (July–August 1980), pp. 1, 12–13.

"Folklife Annual 1985," *Folklife Center News* (Library of Congress) (October–December 1985), pp. 11–12.

Follent, Sarah. "Apocalyptic Fables from the Deep South," *The Australian*, June 17, 1985, p. 11.

Frederick, Clair. "Howard Finster: Man of Visions," *Throttle* (April 1986), p. 4.

Friedman, Kenneth, and Frank, Peter. "Building a Contemporary Collection," *Diversion* (May 1982), pp. 78–90.

Gablik, Susi. "Art Alarms: Visions of the End," *Art in America* (April 1984), pp. 11–15.

Gambrell, Jamey. "This Side of Paradise," *Artforum* (May 1982), pp. 87–88.

"Garden of Heavenly Delights," *New Look* (March 1986), p. 94.

Groninger, Vicki. "A Folk Artist of Spirit," *Sunday Camera Magazine* (Boulder, Colo.), (September 1984), pp. 12–13.

Hankla, Susan. "Books: Howard Finster's Vision of 1982," *Style Weekly* (Richmond), November 6, 1984, pp. 27–28.

———. "Folk Writing: Books to Save Us," *Southern Exposure* (July–August 1983), pp. 66–68.

———. "How to Get Right With God: Visionary Gospel of the Rev. Howard Finster," *Deluxe* (Dallas), vol. 2 (1986), pp. 12–13.

———. "REPO-etic Man: Howard Finster," *XTRA* (Dallas) (May 1985), p. 63.

———. "Retrieval: Art in the South," *Southern Exposure* (May–Junf 1984), pp. 44–46.

———. "Sermons in Paint to Light Up UR Gallery," *Style Weekly* (Richmond), September 18, 1984, pp. 20–21.

Heath, Leanne B. "An Art of Simplicity," *Southern Homes* (May–June 1987), pp. 110–121.

Hitt, Jack. "The Selling of Howard Finster," *Southern Magazine* (November 1987), pp. 52–59, 91.

Horwitz, Elinor. "Appalachian Artists Gain National Recognition," *Appalachia* (November/December 1981–January/February 1982), pp. 30–33.

"Howard Finster," *Folk Art Finder* (November–December 1980), p. 8.

Jabbour, Alan. "Director's Column," *Folklife Center News* (Library of Congress) (July–September 1983), pp. 1–3.

————. "Nation's First Lady Attends Opening Night 'Folk Art and Folklife' Exhibit at Library of Congress," *Folklife Center News* (April 1978), vol. 1, no. 2, pp. 1, 4, 5.

Jensen-Osinski, Barbara. "Finster's Fantasies," *Lehigh Alumni Bulletin* (Winter 1987), pp. 12–15.

————."John Turner Asks Letter Campaign," *Folk Art Messenger* (Fall 1987).

Jordan, Mary Beth, "In Hell's Kitchen, A Home at Heaven's Gate," *Metropolitan Home* (December 1988), vol. XX, no. 12, pp. 78–79.

Kaufman, Nancy, "At Home with Folk Art," *House Beautiful* (September 1985), pp. 30–39.

Kemp, Kathy. "The Art World's Newest Darling Is in a World of His Own," *Kudzu* magazine in *Birmingham Post Herald,* May 23, 1986, pp. 4–6.

King, Dean. "Folks for Folk," *Art and Auction* (March 1988), pp. 30, 32.

————. "Sketchbook: Finster Phenomenon," *Art and Antiques* (February 1988), pp. 21, 24.

Kirwin, Liza. "Documenting Contemporary Southern Self-taught Artists," *The Southern Quarterly* (University of Southern Mississippi) (Fall 1987), pp. 57–75.

Knippers, Edward. "Success and Howard Finster," *Christians in the Visual Arts Newsletter* (Spring 1985), pp. 1–2.

Lorenz, Patricia Brincefield. " 'Art from the people, by the people, for the people': The Herbert Waide Hemphill Jr. Collection of American Folk Art," *Folk Art Messenger* (Spring 1988), p. 1.

"Many Worshippers, One God." *Southwind* (Calhoun High School, Calhoun, Ga.) (Spring 1985), pp. 46–63.

Mashburn, Rick. "Homemade Art: Promoting and Protecting Southern Visionary Folk Art," *Spectator* (Winston-Salem), January 17, 1985.

Maxfield, David. "Archives Collector Documents Self-Taught Painters and Sculptors of Deep South," *Research Reports* (Autumn 1987), no. 52, p. 3.

McKenzie, Barbara. "Unexpected and Plain Visions: The Architecture of Howard Finster's Chapel," *Art Papers* (July–August 1985), pp. 28, 30–31.

McMillan, Ann, and Hughes, Forrest. "Artists

Speak at Opening," *University of Richmond Magazine* (Winter–Spring 1985), pp. 15–16.

"Meadows to Showcase Folk Art: Baking in the Sun: Visionary Images from the South," *Centenary* (Shreveport, La.) (Summer 1987), p. 3.

Morgan, Charlotte. "A Blessing from the Source: The Annie Hooper Bequest," *Folk Art Messenger* (Spring 1988), pp. 8–9.

Morris, Randall. "Book Review: Cat and Ball on a Waterfall," *The Clarion* (Winter 1987), p. 26.

————. "Book Review: Two Hundred Light Years Away," *Folk Art Finder* (November–December 1983), p. 16.

Murry, Jesse. "Reverend Howard Finster: Man of Vision," *Arts Magazine* (October 1980), pp. 161–164.

"One of a Kind: Howard Finster," *People Weekly,* January 7, 1985, p. 48.

Oppenhimer, Ann. "Disciples in the Garden," *Folk Art Messenger* (Fall 1987), p. 4.

————. "New Finster Book Out: *The Scrap Book of All Times,*" *Folk Art Messenger* (Spring 1988), p. 7.

————. "Outside the Mainstream: Folk Art in Our Time: A Weekend to Remember," *Folk Art Messenger* (Summer 1988), pp. 4–5.

————. "Sermons in Paint," *Commonwealth* (Norfolk, Va.) (September 1984), pp. 24–25, 47.

Patterson, Tom. "God's Last Red Light," *Spectator* (Winston-Salem), April 9, 1986, cover and pp. 7–9.

————. "Roadside Art: Beating a Path to the Homemade World of James Harold Jennings," *Art Papers* (November–December 1987), pp. 26–31.

————. "Some Brief Reflections on the Art That Can't Be Named," *Art Papers* (November–December 1986), p. 38.

————. "Spirit in the Land," *SF Camerawork Quarterly* (Summer 1987), pp. 15–16.

————. "The Real, Raw Root-Doctors of Post-Modern Art," *Art Papers* (November–December 1986), pp. 45–46.

————. "The Reverend Howard Finster," *Brown's Guide to Georgia* (December 1981), pp. 49–52.

Perry, Pam. "All in Family at Blue Rat," *Creative Loafing* (Atlanta, Ga.), November 30, 1985, pp. 1–2B.

Pfitzer, Kurt. "A Preacher-Painter Leads Students to Their Own Artistic Roots," *Lehigh Alumni Bulletin* (Winter 1987), pp. 16–19, 43–46.

Phillips, Deborah C. "Howard Finster," *Arts Magazine* (October 1980), p. 24.

Pohlen, Annelie. "The 41st Biennale: A Few Highlights But No Festival." *Artforum* (September 1984), pp. 103–106.

Prince, Daniel. "Howard Finster's Paradise Garden: A Plan for the Future," *The Clarion* (Winter 1988), pp. 56–57.

Randall, Dick. "Howard Finster, A Well Known Stranger," *Cornerstone*, vol. 13, no. 70 (1984), pp. 3, 21.

Ratcliff, Carter. "The Art of Innocence," *Elle* (February 1987), pp. 238–240.

"Roadside Rock: Georgia Hot Spots, Summerville," *Rolling Stone*, July 16, 1987, p. 108.

Rose, Cynthia. "Rev on th' Lev!!!," *New Musical Express* (London), August 11, 1984, p. 20.

———. "Stranger Than Paradise," *New Musical Express* (London), October 12, 1985.

Seggerman, Helen-Louise. "Fraunces Tavern Toasts Father George," *Antique Monthly*, November 1, 1978, pp. 15A, 16B.

Seibels, Cynthia. "Collecting Contemporary Folk Art or Nostalgic Americana," *Ohio Antique Review* (August 1985), pp. 6–7.

Sieveking, Brian. "Howard Finster Serigraph to Benefit Folk Art Society," *Folk Art Messenger* (Winter 1988), p. 11.

Swann, Hope. "Southeast Seven 9 Opens at SECCA," *SECCART* (Winston-Salem, N.C.) (March–April 1986), pp. 1–2.

Tannebaum, Rob. "Home Is Where the Heads Are," *Rolling Stone*, August 15, 1985, pp. 43–44.

Terry, Evelyn. "Naive Art," *UR Magazine* (University of Richmond) (Summer 1979), p. 4.

"The Reverend Finster, a Man of Visions," *South Wind* (Calhoun High School, Calhoun Ga.) (1981), vol. 1, no. 2, pp. 36–60.

"The Reverend Howard Finster," *Art XPress* (September–October 1981), pp. 52–53.

"The Ties That Bind," *Folk Art Finder* (April–June 1987), p. 4.

Thornton, Patrick, Gallager, Gale, Ruddell, Natalie, Goerth, Sonia, and Bagley, Sean. "The Reverend Howard Finster, A Man of Visions," *South Wind: A Reminiscence of Local History and Culture*, vol. 1, no. 2 (Calhoun High School, Calhoun, Ga.) (1981), pp. 3–4, 36–60.

Tromble, Meredith, and Turner, John. "A Natural Voice: The Outsider Influence in San Francisco," *Art Today* (Summer 1988), vol. 3, no. 2, pp. 12–19.

———. "Striding Out on Their Own," *The Clarion* (Summer 1988), vol. 13, no. 3, p. 42.

Tuttle, Lisa McGaughey. "Revelations: Visionary Content in the Work of Southern Self-Trained Artists," *Art Papers* (November–December 1986), pp. 35–38.

Van Biema, David. "So Outside He's In, Howard Finster Paints What He Sees—Visions of Angels, Devils and Elvis," *People Weekly*, July 6, 1987, pp. 109, 111–112.

Van Sickle, Andrew. "God's Last Red Light: Rev. Howard Finster," *Clifton Magazine* (University of Cincinnati) (Spring 1987), pp. 38–43.

"Venice Biennale," *Kansas Grassroots Art Association News* (Winter 1983–84), p. 3.

Viveney, Rhonda. "The Gospel According to Rev. Howard," *Zelo* (1987), vol. 2., no. 2, pp. 38–39.

Weissman, Julia. "Environmental Folk Art, An Ancient Tradition in a Modern World," *The Clarion* (Winter 1982–83), pp. 32–37.

Wintman, Elaine. "Book Review: Folklife Annual 1985," *SPACES* (Winter–Spring 1987), p. 3.

### Newspapers

Abbott, Kay. "Artist Documentary Subject, Crew Seeks Local Reactions," Summerville (Ga.) *News*, September 10, 1987, p. 1.

———. "Artist Finster's Works Displayed This Week," Summerville *News*, May, 1985.

———. "Finster Proposal: Paradise Garden Gift to County?" Summerville *News*, July 9, 1987, pp. 1B, 8B.

———. "To Assist With His Art: Finster Receives Computer," Summerville *News*, January 29, 1987, pp. 1B, 5B.

Albright, Thomas. "Flying Saucer-Style Gospel Art," San Francisco *Chronicle*, April 29, 1981, p. 31D3.

Alexander, Cam. "Folk Artist 'Not of This World,'" *Collegian* (University of Richmond), October 25, 1984, pp. 6–7.

"A New Sign," Chattooga (Ga.) *Press*, August 12, 1987, vol. 5, no. 2, p. 1.

Annas, Teresa, "Area Provides Rich Lode of Folk Art," *The Virginia-Pilot* and *The Ledger-Star*, February 24, 1980, p. F8.

Arnold, Gina. "Rock Music Mecca in Tiny Southern Town," San Francisco *Chronicle*, April 26, 1987.

Atkins, Robert. "New Museum's New Space," *Newsday*, October 7, 1983, p. 17.

"Beer Can Art," Summerville *News*, November 23, 1978, p. 7B.

Bethany, Marilyn. "Folk Sculpture, A Quirkily American Art on View," *New York Times*, January 14, 1983, p. C22.

Billingsley, Anna Barron. "Georgia Pastor Now Preaches Through Paintings," Richmond *News-Leader*, November 3, 1984, p. 2.

Brown, Sydney. "A Noah's Art: Preacher Turns Painter to Spread His Doomsday Message," Richmond *News-Leader*, July 2, 1980, pp. 33–34.

Brunner, Kirsten. "Art Shows Demonstrated Finster's Ability, Charisma," *Brown and White* (Lehigh University), September 30, 1986, p. 7.

Bruno, Susan. "Old, New Art Provides Look at Revolution," Newport News (Va.) *Daily Press*, January 27, 1980, p. B3.

Budd, James. "Dialogue—Howard Goes Hollywood," Summerville *News*, August 11, 1983.

———. "Finster Endeavors Draw National Artistic Acclaim," Summerville *News*, September 9, 1982, p. 1B.

Carlson, Brigitta. "A Preacher's View of Gardening," Winston-Salem *Journal*, March 9, 1980, p. C7.

Cavedo, Brad. "Former Evangelist Rises in the World of Folk Art," Richmond *Times-Dispatch*, May 25, 1980, p. E2.

Chadwick, Susan. "Folk Art Conveys Mystic Voice of 'Man of Visions,'" Houston *Post*, August 24, 1986, p. 4F.

Colander, Pat. "Art Folks," Naperville (Ill.) *City Star*, September 24, 1987, pp. 24, 26–27.

Connelly, David. "'By Howard Finster From God to You,'" Shreveport (La.) *Journal*, August 26, 1987, pp. 1C, 4C.

Cook, Karen. "Biography of Finster May Boost Chattooga," Summerville *News*, October 15, 1987, pp. B1, B5.

———. "450 Attend Unusual Concert at Paradise Garden," Summerville *News*, October 1, 1987, p. 5B.

———. "Magazine Debates Folk Art 'Exploitation,'" Summerville *News*, November 12, 1987, pp. 1B, 8B.

Damsker, Matt. "Howard Finster: Inspiration from Above," Hartford *Journal*, September 24, 1986.

Donohoe, Victoria. "An Imaginative Approach Makes Finster's Art Unique," Philadelphia *Inquirer*, April 25, 1987, p. 3C.

Doub, Julie. "Folk Arts Lack Formal Training," *Old Gold and Black* (Wake Forest University), February 29, 1980.

Downey, Maureen. "Finster Finally Finds Fame in His Own Neighborhood," Atlanta *Journal and Constitution*, May 17, 1985, pp. 1C, 4C.

"Finster Retrospective to Begin Tour Here," Summerville *News*, May 9, 1985, p. 6B.

"Folk Art Exhibition at Botanical Garden," Athens (Ga.) *Observer*, November 1980.

"Folk Artist, Grandsons Start Lehigh Residence," *Call Chronicle* (Bethlehem, Pa.), September 23, 1986.

Fox, Catherine. "Artists Who Hear Spiritual Calling," Atlanta *Journal and Constitution*, November 23, 1986, p. J1, J6.

———. "Focusing on Folk Art," Atlanta *Journal and Constitution Weekend*, May 21, 1988, pp. 21–22.

———. "The Garden of Finster's Delights,"

Atlanta *Journal and Constitution,* August 9, 1987, pp. J1, J3.

Fox, Kathy. "Folk Artist Finster's New Visions Are Heavenly Sent If Not Particularly Divine," Atlanta *Journal and Constitution,* November 27, 1983.

Fundsen, Owen. "Preacher Uses Popular Folk Art to 'Reach Millions,'" Cincinnati *Enquirer,* March 8, 1987, p. E6.

Gehman, Geoff. "Saving Scraps and Souls," *Morning Call* (Bethlehem, Pa.), September 22, 1986.

Glueck, Grace. "The Rev. Howard Finster," *New York Times,* December 9, 1983, p. C26.

———. "When Artists Portray Utopia and Armageddon," *New York Times,* January 15, 1984, pp. C1, C33, C35.

Green, Barbara. "Jeff Camp's Life Is One of Heartfelt Collecting," Richmond *News-Leader,* September 3, 1981, pp. 22–24.

Green, Roger. "'Visionary' Art and a Welcome Return," New Orleans *Times-Picayune,* April 29, 1983, p. 57.

Grimm, Fred. "Interplanetary Folk Art," Miami *Herald,* February 27, 1984, pp. 1–3.

Heller, Faith. "Visionary Folk Artist Has Vibrancy," Winston-Salem *Journal,* January 20, 1985, p. C8.

Henderson, Van. "Retired Minister Howard Finster Bucolic Artist, Prophet," Chattanooga *News-Free Press,* Sunday, February 5, 1984.

"Howard Finster Day Proclaimed." Summerville *News,* May 16, 1985.

Jedamus, Judith. "Georgia Preacher Paints His Visions," *Colorado Daily* (Boulder), November 11, 1982, pp. 1, 11.

Johnson, Patricia C. "Galveston Groups Work Together to Help Isle, Artists," Houston *Chronicle,* August 24, 1986, p. 15.

Kirwan, Tom. "Publicity Doesn't Spoil Howard Finster & His Unique Paradise Park," Summerville *News,* March 31, 1977.

Kouffman, Avra. "Reverend Gains Pop Culture Status," *Michigan Daily* (University of Michigan), October 6, 1987, p. 8.

Larson, Kay. "Now, Voyeur," *The Village Voice,* June 9, 1980, p. 72.

Levin, Kim. "The Day Before," *The Village Voice,* January 3, 1984, p. 74.

Lewis, Jo Ann. "Grass Roots," *Washington Post,* May 5, 1983, p. B7.

Linn, Robert. "A Man of Visions: Summerville's Howard Finster Cut from a Different Cloth," *Calhoun [Georgia] Times and Garden County News* (August 1983).

"Man of Talents," Trion (Ga.) *Facts,* May 23, 1977.

Maslin, Janet. "Film: 'Athens, Ga.' on Rock Bands," *New York Times,* May 29, 1987, p. C14.

Maxfield, David M. "Many Self-Taught Artists Receive Recognition in U.S. and Abroad," *The Item* (Sumter, S.C.), November 15, 1987, p. 8C.

———. "Self-Taught Artists' Work Defies Categorization," *Fauquier Democrat* (Warrenton, Va.), November, 12, 1987, pp. C7, C14.

McGill, Douglas C. "A New Look at Folk Art," *New York Times,* May 1986.

———. "Folk Art Show Sidesteps Issue of Definitions," *New York Times,* August 2, 1986.

McKenna, Kristine. "The Rev. Howard Finster: How Great Thou Art?" *Los Angeles Times/ Calendar,* October 23, 1988, pp. 4–5, 89.

McLeod, Harriet. "Band Film Bogs Down with Barbecue," Richmond *News-Leader,* April 9, 1987, p. 31.

McMillan, Ann. "Finster Folk Art Featured at UR," Richmond *News-Leader,* October 27, 1984, p. A45.

Merritt, Robert. "Images Blast Viewer at Show," Richmond *Times-Dispatch,* September 17, 1983, p. B8.

———. "Newer Finster Work Seems Slicker," Richmond *Times-Dispatch,* November 3, 1984, p. B6.

———. "Review: Horse of a Different Drummer," Richmond *Times-Dispatch,* May 9, 1982.

"Mrs. Strickland's First Grade Enjoyed an Outing at Finster's Park in Pennville Monday Afternoon," Trion (Ga.) *Facts,* May 25, 1966.

"1909 Newspaper Ad Subject of Finster Painting," Summerville *News,* September 9, 1982.

Nobles, Barr. "Artifacts of the Elvis Cult," San Francisco *Chronicle*, January 1, 1988.

Perry, Tim. "Only Two 'Beauty Spots' in World," Chattooga (Ga.) *Press*, August 10, 1983, pp. 1–2.

Prime, John Andrew. "Visions of the South: Folk Artists Create in Isolation," Shreveport *Times*, August 30, 1987, pp. 1E–2E.

Proctor, Roy. "Five American Folk Artists," Richmond *News-Leader*, May 15, 1982.

———. "It's June—and Folk Art Is Bustin' Out All Over," Richmond *News-Leader*, June 6, 1987, p. A52.

———. "Retrieval-Art in the South Is the Real Thing," Richmond *News-Leader*, September 24, 1983, p. A54.

Purcell, Pamela. "Finster Is Focus of PBS Documentary," Chattooga (Ga.) *Press*, September 30, 1987, pp. 1–2.

Raynor, Vivian. "Art: The Outsiders at Rosa Esman Gallery," *New York Times*, January 17, 1986.

Redd, Adrienne. "Howard Finster Brings His Maverick Art to the LV," Bethlehem (Pa.) *Globe-Times*, September 11, 1986, p. D3.

———. "Whimsy Works Wonder," Bethlehem (Pa.) *Globe-Times*, September 25, 1986, pp. D1, 3.

Regan, Kate. "Inspired Folk Art from the South," San Francisco *Chronicle*, February 2, 1986, pp. 12–13.

Rosenberg, Scott. "Documentary About a Musical Ghetto in Georgia a Bit Off-Key," San Francisco *Examiner*, April 23, 1987, p. F7.

Rosenfeld, Arnold. "The Rev. Howard Finster, A Vision Both Mysterious and Great," Dayton *Daily News*, February 5, 1984.

Russell, John. "Art: New New Museum," *New York Times*, October 7, 1983, p. C29.

Saltman, David. "Preserving the Papers of American Artists," *Washington Post*, April 21, 1986.

Schjeldahl, Peter. "About Reverence," *The Village Voice*, August 31, 1982, p. 73.

Silverman, Jennifer. "Finster's Bizarre Folk Art Enlivens Alumni Memorial," *Brown and White* (Lehigh University), September 12, 1986, p. 12.

Smith, Wes. "After Vision, Preacher Paints, Builds for God," Minneapolis *Tribune*, January 17, 1983, p. 8E.

———. "Howard Finster, Man of Visions, World's Minister of Folk Art Church," Atlanta *Journal and Constitution*, December 16, 1981, pp. 1B, 12B.

———. "Rev. Finster's Garden Latest Collector's Rage," Chattanooga *Times*, December 26, 1981, pp. C1–2.

Sozanski, Edward J. "Divinely Inspired Art Made of Castoff Objects," Philadelphia *Inquirer*, June 10, 1984, pp. 1H, 14H.

Subtle, Susan. "Presidential Material," San Francisco *Chronicle*, February 13, 1987.

Teepen, Tom. "Pastor's Art for a Larger Flock," Atlanta *Journal and Constitution*, January 31, 1984.

Thompson, Lil. "God Said to Paint: So He Does His Art and Spreads Word," Winston-Salem *Journal*, September 18, 1984, p. 28.

Thorson, Alice. "Tartt's 'The Outsiders': Insightful View of Folk Art," *Washington Times*, January 1, 1987, p. 2B.

Trost, Cathy. "This Fundamentalist Uses Paintings, Plants to Spread the Word," *Wall Street Journal*, July 2, 1986, pp. 1, 16.

"Visionary Artists," *New York Times*, Sunday, January 15, 1984.

Weinstein, Ann. "The Art Fare Is Fine and Varied at Center in the Square," Roanoke (Va.) *Times and World-News*, October 20, 1985, p. E10.

Welzenbach, Michael. "Visions of a Folk Artist," *Washington Post*, June 25, 1984, p. B7.

White, Gayle. "A Folk Art Fantasy . . . Howard Finster's Paradise," Atlanta *Journal and Constitution*, January 18, 1976, pp. 16–17, 19, 22.

Woodhouse, John. "The Rev. Finster's Brush with God Was Dipped in Paint," Maui *News*, November 8, 1987, p. D3.

Woolcock, Phyllis. "An Unusual, Naive Sermonizer in Paint," *Courier Mail* (Brisbane, Australia), May 28, 1985.

Wyatt, Jane B. "Pennville's Man of Visions

Takes Art to New Dimension," Rome (Ga.)
*News-Tribune,* May 18, 1986.

Zimmer, William. "Political Messages," *New York Times,* October 27, 1985, p. 26.

### *Unpublished Manuscripts*

Barrett, Didi. "Rev. Howard Finster: Painting by Numbers," New York, December 1984.

Finster, Howard. Undated letter to Alan Jabbour, American Folklife Center, Library of Congress, Washington, D.C.

Leighton, Frederick H. "Rev. Howard Finster: Artist, Preacher, Poet, Guru, Gardener," Term paper, University of Michigan, September 1987.

Morris, Randall. "Outsider Art," New York, May 1986.

"My Life's Story," *The Finster Archives,* Berkeley, California.

Prince, Daniel C. "Howard Finster's Paradise Garden: An Analysis of the Structure and Philosophical Background."

Tavel, Jose Enrique. "A Theory of Architecture Based on the Synthesis of Bricolage and Linguistic Devices," thesis presented to the faculty of the Division of Graduate Studies in partial fulfillment of the requirements for the Degree Master of Architecture, Georgia Institute of Technology, August 1987.

*The Howard Finster Papers.* Archives of American Art, Smithsonian Institution, Washington, D.C., 1988 Microfilm #4033-4034.

### *Audiotapes*

Blasdel, Gregg, interviewer. Interview with Howard Finster, Summerville, Georgia, 1977.

Faccinto, Victor, interviewer. Interview with Howard Finster, December 1978 and May 1980.

Finster, Howard. *Howard Walked Through Hell Last Night,* "chain tape."

Finster, Howard. Lecture at University of Georgia, Athens: Georgia Folklore Society.

Finster, Howard. *You Are Eternal.* Nolan, Mike, and Schlaegel, Dave, recordists. September 8, 1984.

Turner, John, audio compilation by. *Howard Finster's Life Story.* Copyright © 1988 by The Finster Archives.

Volkersz, Willem, interviewer. Tape-recorded interview with Howard Finster at the artist's studio in Summerville, Georgia, March 17, 1977. Transcribed by the Archives of American Art, The Smithsonian Institution, Washington, D.C.

# Record of Exhibitions: Howard Finster

## COMPILED BY
## ANN F. OPPENHIMER AND J. F. TURNER

1976:
*Missing Pieces: Georgia Folk Art 1770–1976*, Atlanta Historical Society, Atlanta, Ga. (traveled)
*The All-American Dog*, Museum of American Folk Art, New York, N.Y.

1977:
*Rev. Howard Finster*, Phyllis Kind Gallery, New York, N.Y.

1978:
*First in the Hearts of His Countrymen: Folk Images of George Washington*, Fraunces Tavern Museum, New York, N.Y.
Janet Fleisher Gallery, Philadelphia, Pa.
*Folk Life and Folk Art*, Library of Congress, Washington, D.C.
*The Heart in American Folk Art*, Museum of American Folk Art, New York, N.Y.
Phyllis Kind Gallery, New York, N.Y.
*Naive Visions*, Virginia Commonwealth University, Richmond, Va.
*Visions of U.S.A.*, Museum of International Folk Art, Santa Fe, N.M.

1979:
*America Now*, U.S. International Communications Agency, Washington, D.C.
Children's Museum, Norfolk, Va.
Janet Fleisher Gallery, Philadelphia, Pa.
Phyllis Kind Gallery, Chicago, Ill.
Phyllis Kind Gallery, New York, N.Y.
*The Many Aspects of Contemporary Folk Art*, University of Richmond, Va.
*Outsiders*, Memorial Art Gallery, University of Rochester, N.Y.

*Unschooled Talent*, Owensboro Museum of Fine Art, Owensboro, Ky.
Yorktown Victory Center, Yorktown, Va.

1980:
*Folk Art Since 1900 from the Collection of Herbert Waide Hemphill, Jr.*, Abby Aldrich Rockefeller Folk Art Center, Williamsburg, Va.
*Howard Finster, Miles Carpenter, and S. L. Jones*, Brotherhood Winery, Washingtonville, N.Y.
*Man of Visions: Hidden Man of the Heart*, Botanical Gardens, University of Georgia, Athens, Ga.
*Masterpieces of Folk Art*, Otis/Parsons Gallery, Otis Art Institute of Parsons School of Design, Los Angeles, Calif.
*Masterpieces of Folk Art*, Phyllis Kind Gallery, Chicago, Ill.
*Rev. Howard Finster*, Phyllis Kind Gallery, New York, N.Y.
Wake Forest University Fine Arts Gallery, Winston-Salem, N.C.

1981:
*American Folk Art from the Collection of Martin and Enid Packard*, Calvin College Center Art Gallery, Grand Rapids, Mich.
*American Folk Art: Herbert Waide Hemphill, Jr., Collection*, Milwaukee Art Museum, Milwaukee, Wis. (traveled)
Braunstein Gallery, San Francisco, Calif.
*Ikon/Logos: Word as Image*, Alternative Museum, New York, N.Y.
*More Than Land or Sky: Art from Appalachia*, National Museum of American Art, Washington, D.C.
*Out There: An Exhibition of Man's Invasion of*

*Space*, Contemporary Arts Center, New Orleans, La.

*Religion Into Art*, Pratt Manhattan Center, New York, N.Y.

*This Side of Paradise*, Concord Contemporary Art, New York, N.Y.

*Transmitters: The Isolate Artist in America*, Philadelphia College of Art, Philadelphia, Pa.

*Twentieth Century American Folk Art*, Memorial Union Art Gallery, University of California, Davis, Calif.

1982:

*A Sampling of American Folk Art*, Webb and Parsons Gallery, New Canaan, Conn.

*Currents: Howard Finster*, New Museum of Contemporary Art, New York, N.Y.

Gasperi Folk Art Gallery, New Orleans, La.

*Horse of a Different Drummer*, Carriage House Gallery, Richmond Arts and Humanities Center, Richmond, Va.

*Rev. Howard Finster*, Phyllis Kind Gallery, Chicago, Ill.

*What I Do for Art*, Just Above Midtown/Downtown, New York, N.Y.

1983:

Alexander Gallery, Atlanta, Ga.

*Apocalyptic and Utopian Images in Contemporary Art*, Moravian College, Bethlehem, Pa.

*Art from the Heart*, Clarke County Office of Cultural Affairs, Athens, Ga.

*Grass Roots Art*, Anton Gallery, Washington, D.C.

*The End of the World: Contemporary Visions of the Apocalypse*, New Museum of Contemporary Art, New York, N.Y.

*Intoxication*, Monique Knowlton Gallery, New York, N.Y.

*Land of Our Own: 250 Years of Landscape and Gardening Tradition in Georgia, 1733–1983*, Atlanta Historical Society, Atlanta, Ga.

*Language, Drama, Source, and Vision*, New Museum of Contemporary Art, New York, N.Y.

*New Epiphanies*, Gallery of Contemporary Art, University of Colorado, Colorado Springs, Colo.

Objects Gallery, Chicago, Ill.

*Reflections of Faith: Religious Folk Art in America*, IBM Gallery of Science and Art, New York, N.Y.

*Retrieval-Art in the South*, 1708 East Main, Richmond, Va.

*Rev. Howard Finster*, Carl Hammer Gallery, Chicago, Ill.

*Rev. Howard Finster*, Gasperi Folk Art Gallery, New Orleans, La.

*Rev. Howard Finster*, Phyllis Kind Gallery, New York, N.Y.

*The Shape of Things: Folk Sculpture from Two Centuries*, Museum of American Folk Art, New York, N.Y.

1984:

*American Folk Art of Today: The Collection of Barry M. Cohen*, Meadow Farm Museum, Richmond, Va.

*Art Rosenbaum and Howard Finster*, Anton Gallery, Washington, D.C.

*Beyond Tradition: Eleven Contemporary American Folk Artists*, Katonah Gallery, Katonah, N.Y.

Gasperi Folk Art Gallery, New Orleans, La.

*Howard Finster: Man of Visions: The Garden and Other Creations*, Philadelphia Art Alliance, Philadelphia, Pa.

*Outsiders*, Webb and Parsons Gallery, New Canaan, Conn.

*Paradise Lost/Paradise Regained: American Visions of the New Decade*, American Pavilion of the 1984 Venice Biennale, Venice, Italy.

*Sermons in Paint*, Marsh Gallery, University of Richmond, Va.

*The Watermelon Show*, Willard/Lee Gallery, Richmond, Va.

1985:

*The Finster Family Show: Three Generations of Georgia Folk Artists*, Blue Rat Gallery, Atlanta, Ga.

*Folk Art, Then and Now*, Stamford Museum and Nature Center, Stamford, Conn.

*Innocence and Experience*, Greenville County Museum of Art, Greenville, S.C.

*A Jolly Good Fellow: Images of Santa, 1848 to Present*, Meadow Farm Museum, Richmond, Va.

*Language/Visions and Voices,* Lawrence Gallery, Rosemont College, Rosemont, Pa.

*Overloaded with Wisdom: A Selection of Contemporary American Folk Art from the Collection of Sal Scalora and Mary Deane Scalora,* Aetna Institute Gallery, Hartford, Conn.

*Religious Visionaries,* John Michael Kohler Arts Center, Sheboygan, Wis.

*Rev. Howard Finster,* Ray Hughes Gallery, Brisbane, Australia.

*Rev. Howard Finster and His Friends,* Roanoke Museum of Fine Arts, Roanoke, Va.

*Sermons in Paint,* First National Bank of Chattooga County, Summerville, Ga.

*Southern Visionary Folk Artists,* Sawtooth Center for the Visual Arts, Winston-Salem, N.C.

*The Political Landscape,* Robeson Art Center Gallery, State University of New Jersey, Newark, N.J.

*The Unschooled Artist: Expressions of the Folk, Visionary, and Isolated Artist,* Anton Gallery, Washington, D.C.

*Twentieth Century American Folk Art,* De Saisset Museum, University of Santa Clara, Santa Clara, Calif.

*Visionary Folk Artist, Howard Finster,* Christians in the Visual Arts Conference, Wheaton College, Wheaton, Ill.

*Visions,* University Gallery of Fine Arts, Ohio State University, Columbus, Ohio.

1986:

*The Alabama Man Is Coming Home,* Frame and Art Gallery, Birmingham, Ala.

*Heaven and Dixie: Southern Visionary Folk Art,* Mia Gallery, Seattle, Wash.

*Howard Finster: Contemporary American Folk Artist,* First National Bank of Chattooga County, Summerville, Ga.

*Howard Finster, Man of Visions,* Galveston Art Center, Galveston, Tex.

*Howard Finster: New Work,* Phyllis Kind Gallery, Chicago, Ill.

*Howard Finster: Paintings,* Real Art Ways, Hartford, Conn.

*Howard Finster: The Early Work 1975–1980,*

Cavin-Morris Gallery, New York, N.Y.

*Intuitive Art: Three Folk Artists,* Squires Gallery, Virginia Tech, Blacksburg, Va.

*Kind at Koplin,* Koplin Gallery, Los Angeles, Calif.

*Muffled Voices: Folk Artists in Contemporary America,* Museum of American Folk Art, New York, N.Y.

*Naivete in Art,* Setagaya Art Museum, Tokyo, Japan.

*Outsiders: Art Beyond the Norms,* Rosa Esman Gallery, New York, N.Y.

*Sightings: Boat Images by Outsider Artists,* John Michael Kohler Arts Center, Sheboygan, Wis.

*Southeast Seven 9,* Southeastern Center for Contemporary Art, Winston-Salem, N.C.

*Southern Comfort/Discomfort,* Mint Museum, Charlotte, N.C.

*Southern Exposure: Folk Artists from the American South,* Ames Gallery, Berkeley, Calif.

*Spectrum: In Other Words,* Corcoran Gallery of Art, Washington, D.C.

*The Ties That Bind: Folk Art in Contemporary American Culture,* Contemporary Arts Center, Cincinnati, Ohio.

*The Watermelon Show,* 476 Broome Street, New York, N.Y.

*The World's Folk Art Church: Reverend Howard Finster and Family,* Ralph Wilson Gallery, Lehigh University, Bethlehem, Pa.

*Word and Image in American Folk Art,* Mid-America Arts Alliance, Kansas City, Mo.

1987:

*A No-Theme Show,* Art Works, New York, N.Y.

*American Mysteries: Rediscovery of Outsider Art,* San Francisco Arts Commission Gallery, San Francisco, Calif.

*Baking in the Sun: Visionary Images from the South,* University Art Museum, University of Southwestern Louisiana, La. (traveled)

*Contemporary Cutouts: Figurative Sculpture in Two Dimensions,* Whitney Museum at Philip Morris, New York, N.Y.

*Enisled Visions: The Southern Non-Traditional Folk Artist,* Fine Arts Museum of the South, Mobile, Ala.

*Folk Art from the Collection of John Turner*, Limn, San Francisco, Calif.

*Folk Art from the South*, Leslie Muth Gallery, Houston, Tex.

*Folk Art of This Century*, Galerie St. Etienne, New York, N.Y.

*Howard Finster, Man of Visions*, Michigan Student Union, University of Michigan, Ann Arbor, Mich.

*Master Artists in Residence* (Workshop), Atlantic Center for the Arts, New Smyrna Beach, Fla.

*Neo-Alchemy: Visionary Works by Trained and Untrained Artists*, Cavin-Morris Gallery, New York, N.Y., and Janet Fleisher Gallery, Philadelphia, Pa.

*Revelations: Visionary Content in the Work of Southern Self-Trained Artists*, Atlanta College of Art Gallery, Atlanta, Ga.

*Rev. Howard Finster*, Berry College, Mount Berry, Ga.

*Rev. Howard Finster*, Claywork, Atlanta, Ga.

*Rev. Howard Finster*, Lucky Street Gallery, Key West, Fla.

*Rev. Howard Finster: Paintings*, Atrium Gallery, University of Connecticut, Storrs, Conn.

*Reverend Howard Finster*, Primitivo, San Francisco, Calif.

*Reverend Howard Finster*, Tangeman University Art Gallery, University of Cincinnati, Cincinnati, Ohio.

*20th Century American Folk Art from the Arient Family Collection*, Northern Illinois University Art Gallery, Chicago, Ill.

*Visionaries: Ten American Folk Artists*, Brigitte Schluger Gallery, Denver, Colo.

*Wheels in Motion: Naive Images of Transportation*, Meadow Farm Museum, Richmond, Va.

1988:
*American Folk Art from the Collection of Herbert Waide Hemphill, Jr.*, The Noyes Museum, Oceanville, N.J.

*Artist of the Month*, San Francisco Day School, San Francisco, Calif.

*Elvis: A Folk Hero*, Primitivo, San Francisco, Calif.

*Howard Finster: Painter of Sermons*, Appalachian Museum, Berea College, Berea, Ky.

*Lo and Behold: Visionary Art in the Postmodern Era*, Edith C. Blum Art Institute, Bard College, Annandale-on-Hudson, N.Y.

*Not So Naïve: Bay Area Artists and Outsider Art*, San Francisco Craft and Folk Art Museum, San Francisco, Calif.

*Outside the Mainstream: Southeastern Contemporary Folk Art*, High Museum of Art, Atlanta, Ga.

*Outsider Art*, Sailor's Valentine Gallery, Nantucket, Mass.

*The Reverend Howard Finster*, Outside-In, Los Angeles, Calif.

*Southern Visionaries*, Clark Gallery, Lincoln, Mass.

*Voices and Visions: Grass Roots Art*, Mia Gallery, Seattle, Wash.

1989:
*Castle of Words*, MSU Kresge Art Museum, East Lansing, Mich.

*The Road to Heaven Is Paved by Good Works: The Art of Reverend Howard Finster*, The Museum of American Folk Art (PaineWebber Gallery), New York, N.Y.

Between his first visit in May 1977 and his second in July 1977, Jeff Camp noticed that Howard had begun numbering his works. To the best of Camp's recollection, he had numbered over three-hundred works, including some that had obviously weathered one winter hanging in the garden.

Although Howard appears to keep meticulous records of his works, charting his art by number and year shows many inconsistencies. For example, a work numbered 1000 285 could have been done in 1978 or 1979. Some of the earliest works are unnumbered. Howard completed work number 9000 876 on December 31, 1988.

## A Note About the Author

J. F. Turner has been documenting folk artists and their environments for eighteen years. He is now Curator of Twentieth-Century American Folk Art at the San Francisco Craft & Folk Art Museum, and works for ABC News. He lives in Berkeley.

A NOTE ON THE TYPE

The text of this book was composed in a film version of Palatino, a typeface designed by the noted German typographer Hermann Zapf. Named after Giovanbattista Palatino, a writing master of Renaissance Italy, Palatino was the first of Zapf's typefaces to be introduced in America. The first designs for the face were made in 1948, and the fonts for the complete face were issued between 1950 and 1952. Like all Zapf-designed typefaces, Palatino is beautifully balanced and exceedingly readable.

Design by Holly McNeely

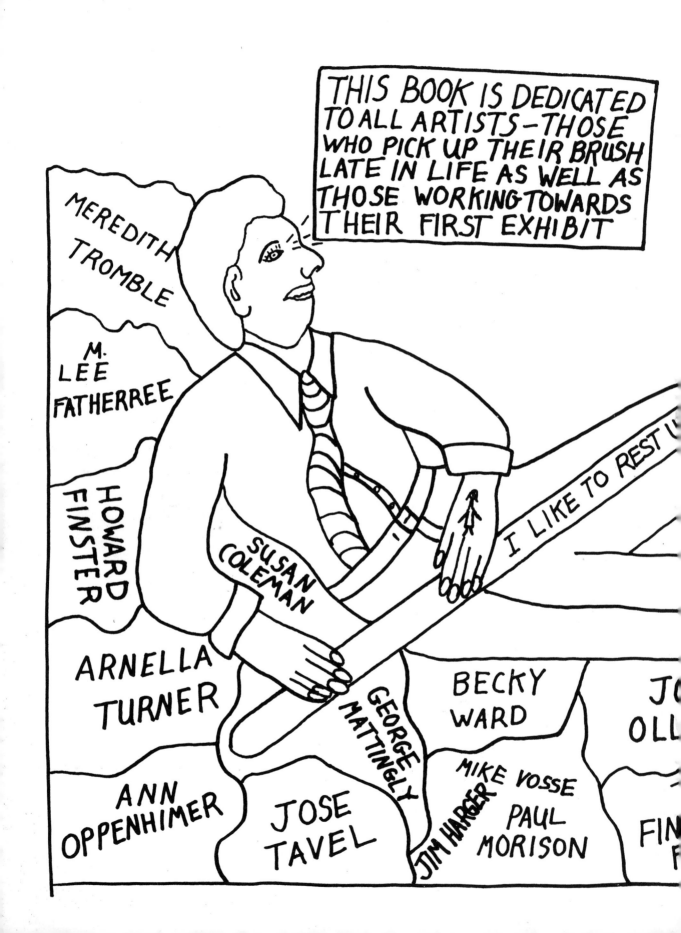